Speaking with

Speaking with the Ancestors

Mississippian Stone Statuary of the Tennessee-Cumberland Region

Kevin E. Smith and James V. Miller

THE UNIVERSITY OF ALABAMA PRESS
Tuscaloosa

Library of Congress Cataloging-in-Publication Data

Smith, Kevin E.
 Speaking with the ancestors : Mississippian stone statuary of the Tennessee-
Cumberland region / Kevin E. Smith and James V. Miller.
 p. cm.
 Includes bibliographical references and index.
 ISBN 978-0-8173-1595-5 (cloth : alk. paper) — ISBN 978-0-8173-5465-7
(pbk. : alk. paper) — ISBN 978-0-8173-8238-4 (electronic) 1. Mississippian culture—
Tennessee River Valley. 2. Mississippian culture—Cumberland River Valley (Ky. and
Tenn.) 3. Figurines, Prehistoric—Tennessee River Valley. 4. Figurines, Prehistoric—
Cumberland River Valley (Ky. and Tenn.) 5. Stone carving—Tennessee River Val-
ley. 6. Stone carving—Cumberland River Valley (Ky. and Tenn.) 7. Tennessee River
Valley—Antiquities. 8. Cumberland River Valley (Ky. and Tenn.)—Antiquities.
I. Miller, James V., 1939–2008. II. Title.
 E99.M6815S67 2009
 977'.01—dc22

 2008019424

To Katherine Flowers Miller and Carol Schrysen Smith
for their patience and support

And for James Victor Miller, my friend and co-author,
who joined his ancestors on April 11, 2008

Contents

List of Illustrations ix

Preface and Acknowledgments xv

1. Mississippian Stone Sculpture 1

2. Tennessee-Cumberland Style Mississippian Stone Statuary 17

3. The Middle Tennessee Heartland 37

4. The North Georgia Heartland 93

5. The Tennessee Periphery 112

6. Ohio and Mississippi Valley Statuary 144

7. The Statuary Complex and Ancestor Veneration 157

Appendix A—Tabular Summaries of Statue Characteristics 181

Appendix B—Two Fakes and Some Odds and Ends 203

References Cited 215

Index 229

Illustrations

FIGURES

1.1. John White, *Mortuary of Powhatan,* 1585–1587 2

1.2. CSS-049, Jefferson statue 3

1.3. CSS-063, "Idol" dug up in Natchez, Mississippi 4

1.4. King Crowley 6

2.1. General distribution of statuary concentrations
and significant outliers 18

2.2. Ceramic figurines from
Brick Church Pike Mounds (40DV39) 19

2.3. Wooden statue, Bell County, Kentucky 19

2.4. Statuary coiffure/headgear types 23

2.5. Typical male hair knot 24

2.6. Typical female hair knot 24

2.7. Statuary seating positions 28

2.8. Negative painted hooded bottle,
Averbuch site (40DV60), front view 35

2.9. Negative painted hooded bottle,
Averbuch site (40DV60), rear view 35

3.1. Middle Tennessee peripheral find spots 38

3.2. Cumberland River drainage showing significant find locales 39

3.3. Sellars site (40WI1), Buchanan map 40

3.4. CSS-001 44

3.5. CSS-002 45

3.6. CSS-002, front view 46

3.7. CSS-002, profile view 46

3.8. CSS-003, front view 47

3.9. CSS-003, rear view 47

3.10. CSS-003, left profile 48

3.11. CSS-003, right profile 48

3.12. CSS-003, top view 49

3.13. CSS-003, base view 49

3.14. CSS-004 51

3.15. CSS-006 54

3.16. Beasley Mounds site (40SM43) 54

3.17. CSS-010, front view 58

3.18. CSS-010, profile view 58

3.19. CSS-011, front view 59

3.20. CSS-011, left profile 59

3.21. CSS-012 60

3.22. CSS-013 60

3.23. CSS-014 61

3.24. CSS-015, front view 64

3.25. CSS-015, right profile 64

3.26. CSS-016, front view 65

3.27. CSS-016, left profile 65

3.28. CSS-017, front view 66

3.29. CSS-017, left profile 66

3.30. CSS-018, front view 69

3.31. CSS-018, left profile 69

3.32. CSS-019, front view 70

3.33. CSS-019 70

3.34. CSS-019, left profile 71

3.35. Castalian Springs site (40SU14) 72

3.36. CSS-008 74

3.37. CSS-009 75

3.38. CSS-069 77

3.39. CSS-030 81

3.40. CSS-031 81

3.41. Duck River cache 84

3.42. Link Farm site (40HS6) 84

3.43. CSS-036 88

3.44. CSS-036 88

3.45. CSS-037 89

3.46. CSS-039, front view 90

3.47. CSS-039, left profile 91

3.48. CSS-039, rear view 92

3.49. CSS-039, right angle view 92

4.1. Etowah site plan 94

4.2. CSS-056 95

4.3. CSS-087 96

4.4. CSS-087 97

4.5. CSS-057 98

4.6. CSS-059, front view 100

4.7. CSS-059, profile view 100

4.8. CSS-059, back view 101

4.9. CSS-060, front view 101

4.10. CSS-060, profile view 102

4.11. CSS-060, back view 102

4.12. Lewis Larson excavating the two statues in Burial 15 103

4.13. Mound C, Burial 15 in the burial book 103

4.14. Elishe Mulkey with his discovery 104

4.15. CSS-074, front view 106

4.16. CSS-074, left profile 106

4.17. CSS-075, front view 107

4.18. CSS-075, left profile 107

4.19. CSS-061 109

4.20. CSS-076, front view 110

4.21. CSS-076, profile view 110

5.1. CSS-062, front view 113

5.2. CSS-062, profile 114

5.3. CSS-020 115

5.4. CSS-021 117

5.5. CSS-021, profile 117

5.6. CSS-023 121

5.7. CSS-065 123

5.8. CSS-032, front view 125

5.9. CSS-032, rear view 125

5.10. CSS-032, profile 126

5.11. CSS-035, front view 128

5.12. CSS-035, profile 128

5.13. CSS-035, back 129

5.14. CSS-050 131

5.15. CSS-044 132

5.16. Long Island of the Holston 133

5.17. Plan view of excavations 135

5.18. CSS-043 135

5.19. CSS-028, front view 137

5.20. CSS-028, profile 137

5.21. CSS-042 139

5.22. CSS-038, in situ 140

5.23. CSS-038 141

5.24. CSS-064, front 142

5.25. CSS-064, back 142

6.1. CSS-041 146

6.2. CSS-051 147

6.3. CSS-052 149

6.4. CSS-052 149

6.5. CSS-053 150

6.6. Angel site 151

6.7. CSS-054, in situ 152

6.8. CSS-054 153

6.9. CSS-063 155

6.10. CSS-078 155

B.1. CSS-045 204

B.2. CSS-046, right front 206

B.3. CSS-046, left profile 206

B.4. CSS-047, front 207

B.5. CSS-047, back 207

B.6. CSS-048 208

B.7. CSS-024 211

B.8. CSS-067 212

B.9. CSS-067 212

B.10. CSS-068 213

B.11. CSS-068 213

TABLES

A.1. Summary of Statuary Characteristics 182

A.2. Statuary Provenance, Curation Location,
and Conditions of Recovery 190

A.3. Radiocarbon Dates 199

Preface and Acknowledgments

Exploring the stories of the late prehistoric stone statuary of the Midwest and Southeast has been an interesting journey—but a much longer one than either of the authors originally imagined.

After having been casually interested in Mississippian stone statues for several years, James Miller started the research for this book in 1987. He had been working with H. C. "Buddy" Brehm, owner of the Mini-Histories Press in Nashville, on a publication titled "The Travellers' Rest Site: A Fortified Prehistoric Middle Cumberland Indian Village." During that collaboration, James asked Buddy what he knew about the statues, and Buddy provided a short list of the ones from the local area.

James then embarked on a letter-writing campaign seeking additional information about the statues—where they were currently located, where they came from, and so on. Over the next several years, the project grew from there with trips to the various sites, the homes of private collectors, interviews with local citizens with some familiarity with one or more statues, and eventually trips to Museums scattered across the eastern United States. One fact quickly apparent was that even the most cosmopolitan of archaeologists seemed unaware of how many statues and fragments had been found over the past two centuries—and few knew any details about even the better known and more widely published examples.

At about the same time James began his research on stone statues, I was in the midst of research on the late prehistory of the Nashville Basin. That research yielded brief mentions of numerous stone statues in the antiquarian literature and even fewer mentions in recent scholarship on the late prehistory of the southeastern United States. While the stone statues from the Nashville Basin intrigued me, most of them were too scattered and poorly documented for me to include much more than a mention of them in my work.

James and I eventually ran into each other in 1991 because of our shared interests in the prehistoric native peoples of the Nashville Basin—and discovered our mutual interest in Mississippian stone statues. By then, James had

finished a manuscript and accumulated dozens of figures and photos. He presented a copy of that typewritten manuscript to me on February 25, 1992, with a request that I glance through it and provide some comments before he tried to publish it locally. When I first perused it, I immediately recognized that the information compiled by James was by far the most comprehensive investigation of the stone statues that had ever been completed. While many antiquarians and archaeologists had created volumes of discussion on this class of artifacts for two centuries, James was the first to devote an intensive effort over many years to create a comprehensive listing of all of them from across the eastern United States.

Looking through the manuscript, I believed that his research deserved to reach a broader audience than a local publication would provide. I recommended that he pursue publishing it through a major press. Unfortunately in some ways, James took me at my word and entrusted editing of what we came to know as "The Book" to me—at a point when my professional career was just beginning. Over the last fifteen years, there have been many delays as I set this project aside, came back to it, and set it aside again. Much of the final writing and editing would not have been possible without the research leave supported by my department colleagues, dean, and provost at Middle Tennessee State University.

The original research on the statues resulted in a manuscript written by James (of Choctaw heritage) for the interested public in Tennessee. What finally emerged is something that we hope will meet at some level both the wide public interest in the Tennessee-Cumberland style statues and the interests of professional archaeologists in "data." Our compromise probably has a bit less data and a bit more stories and speculation than some archaeologists would like. It also probably has a bit less speculation and a bit more data than the interested public would like. While more research remains to be completed on the stone statues of the Tennessee-Cumberland style, we suspect that without our collaboration and compromise, these remarkable objects from the past would continue to languish as poorly known by the general public and undermentioned by archaeologists.

We are most indebted and grateful to H. C. "Buddy" Brehm, Jeffrey P. Brain, Raymond L. Weatherly, the staff of the Tennessee Division of Archaeology (especially Nick Fielder and Mike Moore), and the many private owners of statues who assisted during the research on the topic of statues. Felicia G. Pickering, Ethnology Collections Specialist at the Smithsonian Institution, was of particular assistance in providing access to the statues, casts, and other information curated by that institution.

Others who contributed at an important level include Stephen Williams, Thomas E. Emerson, the staff of the Museum of the American Indian/Heye Foundation (before creation of the National Museum of the American In-

dian), Curator of the Rockefeller Collection at the Metropolitan Museum of Art, Lewis H. Larson, Stephen D. Cox of the Tennessee State Museum, Jeff White, John Dowd, Brian Butler, Jeff Chapman and the McClung Museum staff, Jared Wood and Mark Williams at the University of Georgia, and Samuel D. Smith.

Our thanks also to Tom Emerson and an anonymous reviewer with The University of Alabama Press for their very helpful comments on the first version of the manuscript submitted. Without the equal measures of patience and persistence on the part of the staff at The University of Alabama Press, we would never have worked this through the process.

Speaking with the Ancestors

I
Mississippian Stone Sculpture

In the courtyard of this palace, the Spaniards found two idols as large as a
three-year-old, one male and one female.

—Francisco de Chicora

When European explorers from England, France, and Spain began their ini-
tial forays into southeastern North America in the sixteenth and seventeenth
centuries A.D., they encountered what they described as the "temples" or
"shrines" of native peoples. Among the items decorating many of these
shrines were "idols" in human form sculpted most frequently in wood but
occasionally in pottery and stone. Some of the early chroniclers believed
they were portraits of dead native kings and queens; others perceived them
as statues of native gods (Figure 1.1). While interpretations of the *meaning*
of these idols by early chroniclers may be questioned because of their biased
perspectives toward indigenous worldviews, one thing they all agreed upon
is that these shrines and idols were fascinating and important parts of native
culture. As far as we know, none of these human shrine sculptures were ever
acquired by early explorers through trade or were seized as loot or plunder.
We were unable to find any documents suggesting that shrine statues were
carried back for display in the colonial centers of this New World or home
cities back in the Old World. The idols were fascinating curiosities to write
about, but had no real value to explorers in search of gold or land. Although
recorded on several occasions in the 1500s and 1600s, human figural sculp-
tures disappear from mention in the documentary record of southeastern na-
tive peoples by the early 1700s.

Less than a century later, however, farming colonists began to unearth
stone images in human form as they tilled the fertile river valleys of the fledg-
ling United States. Ranging in height from an inch or so to nearly three feet,
these images of seated and kneeling humans excited the imagination of the
public and scholars alike. The earlier historical records of "shrine statues"
seem to have been forgotten, overlooked, or perhaps were simply unavailable
as American scholars speculated about who might have created these myste-
rious human statues.

The earliest discovery of a stone image that we can document was by an
anonymous farmer plowing his field along the Cumberland River southwest

Figure 1.1. John White, *Mortuary of Powhatan,* 1585–1587, watercolor (Lorant 1946:217).

of Lexington, Kentucky, around July 1790 (Figure 1.2). Harry Innes, judge of the United States court for the district of Kentucky, sent the kneeling female image to Thomas Jefferson with his compliments on July 8, 1790. This nine-and-three-quarter-inch statue became the first of five pieces of Native American figural sculpture in Jefferson's Indian Hall at Monticello. In a letter to Innes, Jefferson admired the sculpture as "the best piece of workmanship I ever saw from their [Indian] hands" (Jefferson 1791). Other distinguished visitors were less impressed. During his visit to Monticello in 1816, the Baron de Montlezun-Labarthette of France pronounced the statues in Jefferson's collection to have been created "by savages—very hideous" (Carrier and Moffatt 1944). We'll return to Jefferson and his statue collection later.

After this first discovery, additional stone images of humans were uncovered throughout the river valleys of the interior Southeast, more often than not by farmers. While Jefferson immediately assumed that ancestors of then contemporary Native Americans created his statues, later discoverers and antiquarians were to look further afield for their sculptors. In the first book-length treatise published on American antiquities, Caleb Atwater

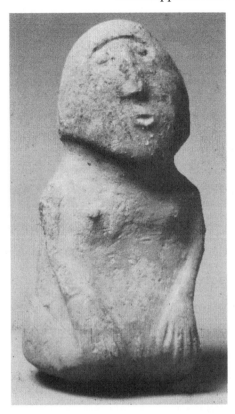

Figure 1.2. CSS-049, Jefferson statue. Courtesy Smithsonian Institution, National Museum of the American Indian, Washington, D.C., Slide #3062.

(1820) proclaimed with confidence that the creators of the statues were "Hindoos" from India. This first publication of the American Antiquarian Society included an illustration of another fine piece of stone sculpture that had been acquired by Winthrop Sargent from a local planter in Natchez, Mississippi (Figure 1.3; Williams 1991:37).

By 1820, several additional stone statues had been discovered in Tennessee—and they were soon to play a significant role in the debates about the prehistory of North America. In 1807, John Haywood moved to Nashville, Tennessee, to establish a law practice in "The Old Southwest." In 1816, after earning a reputation as one of the most eloquent and learned lawyers in Nashville, he was appointed to the Tennessee Supreme Court. Perhaps because of his background as a legal scholar, Haywood also took on the task of writing the first history of the state of Tennessee (created only two decades earlier in 1796). In the absence of organized archives and libraries, he proceeded to create a local version of the American Antiquarian Society to assist in this task. By 1823, Haywood had accumulated sufficient information on the "antiquities of the Western Country" to produce his first volume,

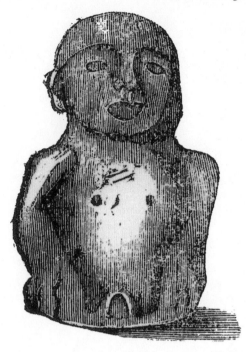

Figure 1.3. CSS-063, "Idol" dug up in Natchez, Mississippi (Atwater 1820:215).

titled *The Natural and Aboriginal History of Tennessee up to the First Settlements Therein by the White People in the Year 1768*. Leaning heavily on the works of Atwater and John Clifford (1820), Haywood presented the notion that "The Hindoo family has branched into the Egyptians, Celts, Goths, Peruvians, and Mexicans, whence came the builders of the mounds, and the worshippers of these images, which are found in Tennessee" (Haywood 1823:140–141). Haywood also included some other startling discoveries from Tennessee that would play an important role in the folklore of the shrine statues decades later; most significantly, he recounted the recent discovery (yet again in the momentous year of 1820) of a race of prehistoric pygmies that had formerly inhabited the landscape of Middle Tennessee.

Despite their rarity, more and more of the stone statues appeared throughout the 1800s as farms expanded and "digging" for antiquities emerged as a new hobby. The objects were of such broad interest that virtually every antiquarian felt compelled to mention them at least briefly in their publications. As time passed, widely divergent interpretations of the origins and meanings of the statues became increasingly common. Many writers found them fertile ground for speculative theories involving Toltecs, Aztecs, vanished races of White Mound Builders, Egyptians, Vikings, and yes, the Hindoos. Other writers followed Jefferson's lead in recognizing them as creations of the ancestors of native peoples, but shifted their focus to equally wild inter-

pretations of the exotic pagan beliefs of "savage Indians." Their book sales were probably substantially better than the handful of scholars who continued simply to admire them as interesting but enigmatic creations of native peoples.

We return briefly to Thomas Jefferson's collection of five statues to illustrate the changing fortunes of the statues over time. In 1800, Thomas Jefferson thanked Morgan Brown, the donor of his second and third statues from the Cumberland River valley (this time from a few miles up the river in Tennessee) by stating: "such monuments of the state of the arts among the Indians are too singular not to be highly esteemed . . . they will furnish new and strong proof how far the patience and perseverance of the Indian artist supplied with very limited means which he possessed" (Jefferson 1800). After Jefferson's death, Dr. James T. Barclay purchased Monticello and presented what he described as a "collection of heathen images" found there to a Dr. Plummer of the Presbyterian Board of Missions. They were quickly but briefly relegated to the rooms of the American Board of Commissions for Foreign Missions in Boston. Their last known resting place was the Andover-Newton Seminary, which subsequently "lost track of them" (Kennedy 1994:223). In a single generation, these two statues had descended from "esteemed monuments" on display in a presidential home to "heathen idols" that may simply have been tossed quietly into a dustbin. In an early lament from his home in Hilham, Tennessee, Moses Fiske wrote that, "Valuable articles are *lost* by being *found*. The finest specimen of statuary, that I have heard of in the country, was knocked to pieces, to ascertain what sort of stone it was made of" (Fiske 1820). These types of stories are all too common for the statues discovered during the first half of the nineteenth century.

By the mid-1800s, however, the collecting of North American "relics" had become a much more common practice on the part of the wealthy elite at both local and national levels. For the first time since their initial recording by explorers over three centuries earlier, the statuary began to acquire a monetary value—their rarity made them eagerly sought after commodities. This new interest was positive in the sense that more of the statues survived their initial discovery and were more likely to be sold than smashed or consigned to the trash pile. At the same time, their status as collectibles also created a market demand for "Indian idols." As noted by W. S. Webb and D. L. DeJarnette, this demand "stimulated some who, having a little ability in stone cutting and more time than morals, decided to satisfy this demand by the manufacture of stone images from limestone, marble and a variety of stones which work well under hammer, chisel and file. . . . It is probable that of these artifacts there has been a greater percentage 'duplication for sale' than any other major artifact not even excluding pipes. . . . It was possible to see in many collections and in some museums stone images made from stones not ordi-

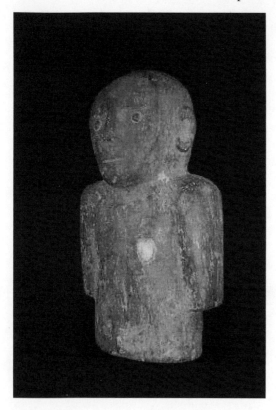

Figure 1.4. King Crowley. Courtesy Arkansas State University Museum.

narily worked by the Indians and showing marks of steel chisels and marks of files" (1942:295). Some of these forgeries were more immediately obvious than others, but even the wildest forgeries were credible to a general public increasingly interested in "Fantastic Archaeology" (cf. Williams 1991). The story of King Crowley is a good case in point.

King Crowley was one of several stone effigies purportedly discovered in a cache near Jonesboro, Arkansas, about 1924 (Figure 1.4). According to the local tradition, Dentler Rowland, a gunsmith and jeweler, found the first of the statues by tripping over it on his property. Digging at the find spot, he discovered a small casket surrounded by other figures of people and animals about ten feet below the first statue. According to Johnson (2004), Bernice "Bernie" Babcock of Little Rock purchased them to place in the Arkansas Museum of Natural History that she had founded in MacArthur Park. She "named the largest piece 'King Crowley' in honor of Crowley's Ridge, the chief geographical feature in the area. His highness weighed in at about forty pounds, stood less than a foot high and his girth was about that, too" (Johnson 2004).

In the 1920s, archaeologists at the Smithsonian Institution examined some

of the statues and reported that all of the pieces were obviously quite recent in origin. According to the catalog cards of the Arkansas State University Museum, which still houses a few of the pieces as Arkansas folk art, they included such obviously modern elements as brass furniture tacks for eyes and inset valentine hearts carved from agate. Some of the animal statues appear to represent monkeys, hippos, and camels.

Despite the arguments of the Smithsonian specialists to the contrary, some local historians remained convinced of their authenticity. In his history of Craighead County, Harry Lee Williams (1930) reported that "these images were made by the Aztecs and placed on Old Town Ridge and on the ridge below Jonesboro, as it is definitely established that the Aztecs once resided in what is now Missouri and Arkansas." Even today, the stories of King Crowley capture the imagination. The byline on a recent article about King Crowley in the *Jonesboro Sun* newspaper read, "It's a Hoax That Won't Go Away" (Hodges 2003). King Crowley is among the most obvious of the forgeries that emerged over the last century and a half, and yet still remains a powerful figure in local legends and folklore.

When we independently began investigating these "mysterious" stone statues in 1987, no comprehensive publication on them was to be found. A few years earlier, Thomas Emerson had completed a survey of Illinois stone images during which he discovered "that few of these items had ever been adequately described, discussed, or illustrated" (Emerson 1982:1). Myths and folklore published in local histories and newspapers like those surrounding King Crowley were far more accessible than any detailed information on the statues themselves. Eventually, our interest in Tennessee statues became a relatively comprehensive survey of similar stone statuary from throughout the prehistoric Southeast. While a significant number of the statuary can be viewed in museums throughout the eastern United States, detailed information on where they were found and how they eventually came to rest in their current homes is often difficult to find.

In the preceding, we have attempted to illustrate some of the difficulties encountered in our survey of stone statuary. The overwhelming majority of the statues were discovered by farmers plowing their fields or through the unsystematic "digging" of collectors and antiquarians during the eighteenth and nineteenth centuries. For centuries, the majority of statues have been valued more as art objects than as artifacts. As a result, detailed archaeological contexts and associations are often difficult or even impossible to extract from the available literature. Many scholars of the nineteenth century were content simply to note the provenance by state or to the nearest modern community in their published works. In other instances, the details of discovery were sensationalized to sell newspapers, books, or the statues themselves, leading to conflicting and contradictory accounts. As a result, unfounded stories, delib-

erate falsehoods, and assumptions have gradually gained the weight of truth after decades of retelling.

Among the many difficulties inherent in reconstructing the stories of the statues is that they were sometimes perceived as heathen idols of little more than passing interest and at other times as rare art objects of exceptional value. As noted above, some statues have vanished because of the former, while the latter has created other problems. Once the statues were recognized as significant art objects in the late nineteenth and early twentieth centuries, many of them began to change hands rather frequently. Given their similarities in posture and other features, brief descriptions in auction catalogs provide few clues as to which specific statue was being sold, and documents recording the purchaser are rarer than the statues themselves. The statues (or casts) we were able to find are currently scattered in private and museum collections across the eastern United States. Like Jefferson's vanished statue pair, there are several others included in our survey that are probably still out there somewhere—perhaps this publication will bring some of them back to light.

The increasing value of the statues as art objects introduced yet another complication in our interpretation of the statues. While King Crowley and his entourage of sculptures were recognized as fakes almost immediately by professional archaeologists, other forgers were more skillful in creating their replicas. While some of these better forgeries have been exposed, others almost certainly have not. Whenever possible, we examined the statues for evidence that they were created with tools unavailable to prehistoric sculptors. In many cases, however, we were only able to examine casts or photographs that do not provide sufficient detail for determination. Even when examining original statues, the evidence is often equivocal. Along with the question of plow marks, their treatment after discovery has left scars, nicks, and marks that complicate interpretations of their authenticity. For most statues, we were unable to conduct the type of detailed examinations that might provide additional clues. In some instances, the timing of the discovery suggests the possibility of forgeries. For example, some statues made their appearance soon after the exhibition or publication of photographs of remarkably similar statues. In other cases, inconsistencies about the discovery or the presence of unique sculpted details presented similar uncertainties. Rather than impose our judgment about the relative authenticity of some statues, we have simply presented the information available to us. As a result, our survey includes an analysis of these fascinating objects, a history of their "lives" after discovery, and the folklore associated with some statues.

During the course of our research, 88 *possible* Mississippian stone statues were documented to varying degrees. Two of these proved to be obvious fakes. In other cases, the only information available was a passing mention of their existence in an early publication—we included these possible or

probable statues in the event that some of them may eventually reappear. For others, better written descriptions were available, but no drawings or photographs. In other cases, only photographs (sometimes not very good ones) or casts were available for examination. Leaving aside several fragments and otherwise unclassifiable eccentric statues, 42 statues comprise the core of our corpus of Tennessee-Cumberland style statuary.

As the name implies, the densest concentration of Tennessee-Cumberland style stone statuary lies in the Cumberland River valley of north central Tennessee and western Kentucky. A smaller but significant concentration is found in northern Georgia centering on the Etowah site. While we expect that surrounding states will yield additional statuary not addressed herein, we think it unlikely that this pattern of geographic distribution will change.

Before examining the Tennessee-Cumberland style stone statuary specifically, a brief examination of the longer prehistory of human figural art in the Eastern Woodlands is warranted. Research to date has not demonstrated a continuous native tradition of human figures, and we will leave connecting these dots in time for future researchers. The oldest currently known three-dimensional human images from the southeastern United States are solid baked loess figurines created by peoples of the Poverty Point culture of the Mississippi Valley (Gibson 2000:151–152). Dating to about 3,500 years ago, these small and simplistically portrayed figures are considered too stylized to be portraits and served an as yet undetermined role in the lives of their creators. A more complex set of three-dimensional depictions of humans appears between A.D. 1 and 400 in the native cultures participating in the Hopewell horizon or Hopewell interaction sphere. While this cultural florescence included societies throughout much of the Midwest and Southeast, figurines and pipes in human form are most numerous at sites within the Ohio River valley (Seeman 2004).

About five centuries after the Hopewell human images were sculpted, the corpus of indigenous art expanded with the creation of the most diverse set of human imagery found north of Mexico. At this time, native artisans of the Midwest and Southeast crafted human (or at least humanlike) images in a wide variety of media, including marine shell, pottery, copper, stone, and wood. An interacting group of societies that archaeologists call *Mississippian* created this remarkable body of anthropomorphic imagery. First appearing around A.D. 900 in the Mississippi Valley south of modern St. Louis, Mississippian lifestyles spread rapidly to include hundreds of societies in a region roughly the size of Western Europe by A.D. 1200 (Griffin 1990:6–7).

Despite broad variations, Mississippian societies throughout the eastern United States shared several common characteristics. The social, political, and economic lives of Mississippian peoples were focused on ceremonial centers and large towns often surrounded by numerous smaller towns, vil-

lages, family-based hamlets, and farmsteads. In the major town centers, large flat-topped earthen pyramids supported town houses, council houses, chiefly residences, and temples or shrines overlooking open public plazas. Smaller flat-topped pyramids supported residences for chiefs, high-ranking warriors, shamans, and other important community members.

These larger more complex towns functioned as administrative and religious centers where chiefs, warriors, and priestly elites formed the apex of Mississippian social hierarchies. Chiefs and other high-ranking officials directed the activities of widespread farming populations, oversaw the construction of monumental public works, regulated trade, and conducted warfare. The elaborate tomb-burials and iconographic depictions of these chiefs suggest a complex belief system involving ancestor veneration, inherited social status, and the manipulation of restricted access to supernatural powers (Knight 1986).

One of the most important transitions accompanying the emergence of early Mississippian culture was the adoption of intensive maize agriculture as the basis of the economy. James B. Griffin noted that "the appearance of maize in the Mississippi Valley between A.D. 700 and 900 is . . . the primary addition which nurtured the growth of Mississippian societies from the eastern prairies to the Appalachians and from the Gulf of Mexico to the Illinois area and to the Ohio Valley" (1990:6–7). Although the introduction and adoption of maize is of great significance in the story of numerous Mississippian chiefdoms, many Mississippian societies also continued to rely on southeastern cultigens of much greater antiquity, such as goosefoot, maygrass, sumpweed, and others. The mixture of old and new domesticates catalyzed the development of a vigorous horticultural system that provided the surplus to support increasingly large and complex societies. Although an emphasis on maize agriculture provided many Mississippian societies with greater opportunities to produce surplus foodstuffs, it also increased their vulnerability to short-term climatic events such as drought or flooding and longer-term problems such as declining field productivity. Perhaps related to this increased vulnerability, the powers and responsibilities of the leaders in Mississippian societies appear to have involved the manipulation of supernatural power to assure agricultural success.

Alongside these other complex Mississippian developments, we also see the creation of what is arguably the most sophisticated of native North American art traditions. Mississippian artisans produced objects that we can recognize today as masterpieces in a remarkably diverse set of media, including basketry, ceramics, copper, feathers, shell, stone, textiles, and wood. Rather than simply being "art for art's sake," these objects more often than not expressed symbolically the complex religious, social, and political beliefs that gave structure to native southeastern chiefdoms. Among the most fasci-

nating expressions of this artistic tradition are images that we generally call "anthropomorphic" or "in human form." The distinction is important since many of these images probably represent mythological or supernatural beings rather than depictions of actual humans—archaeologists are only beginning to be able to sort one from the other with anything resembling confidence. Literally tens of thousands of anthropomorphic images are known in Mississippian art. Two-dimensional anthropomorphs are found etched or engraved in shell and pottery, in petroglyphs and mud glyphs, and in copper cutouts or shallow-relief plates. In three dimensions, anthropomorphs were created in a variety of sizes modeled in clay, carved from wood, and sculpted in stone.

As the Mississippian fine arts tradition developed and expanded, artisans in a few chiefdoms finally turned their attention to sculpting three-dimensional anthropomorphs in native or imported stone—the stone shrine statues. While isolated examples have been found at archaeological sites throughout much of the southeastern and midwestern United States, most of the humanlike images sculpted from stone were created as central elements of the artistic traditions in three regions centering on northern Georgia, southern Illinois, and especially central Tennessee.

Brief Review of Significant Mississippian Statuary Studies

As the largest and most prominent examples of Mississippian art, freestanding stone figures attracted the attention of many antiquarian scholars throughout the nineteenth century. While virtually every southeastern antiquarian mentioned the statues and used at least two or three "idols" as a departure point for discussion, only a handful attempted to survey the known examples.

Joseph Jones (1833–1896) completed the first semisystematic attempt to catalog the stone statuary of the Tennessee-Cumberland region. Born in Liberty County, Georgia, Jones obtained his degree in medicine from the University of Pennsylvania. Prior to the Civil War, he taught chemistry at Savannah Medical College and the University of Georgia. At the beginning of the Civil War, he joined the Liberty Independent Troops, later serving as a surgeon with the rank of major in the Confederate army (Henderson 2000). After the war, Jones served as Health Officer for the City of Nashville from 1867 to 1868. During his two years in Nashville, Jones excavated at several significant local Mississippian sites and published a short report titled "The Aboriginal Mound Builders of Tennessee" (Jones 1869). Eventually, he expanded his careful, scholarly research into a more comprehensive publication by the Smithsonian Institution titled *Explorations of the Aboriginal Remains of Tennessee* (Jones 1876). Jones described several statues that had been discovered prior to the time of his writing, and noted: "these relics indicate that this race possessed a considerable talent for sculpture" (1876:158). Joseph's older

brother, Charles Colcock Jones Jr., was also fascinated with the "idols" of the southern native peoples. In his *Antiquities of the Southern Indians,* C. C. Jones (1873:436) noted: "Tennessee, above all her sister states, seems to be most prolific of [the statues]." Two decades later, Brevet Brigadier General Gates P. Thruston, an antiquarian intimately familiar with the artifacts of the Cumberland Valley, also discussed many of the statues of Tennessee. He concluded that "more images or idols of stone have also been found within the limits of Tennessee than in any other state or section north-east of Mexico" (Thruston 1897:103).

While each of these antiquarian scholars provided significant information on a number of statues, the most significant contributor was William Edward Myer (1862–1923), a native of Carthage, Tennessee. Fascinated with the prehistoric peoples of Tennessee from his boyhood, Myer retired in 1915 from his commercial pursuits to pursue full time his interests in the prehistoric peoples of the Cumberland River valley—eventually holding a position with the Bureau of American Ethnology. Myer's friend John Swanton (Myer 1928b, Preface) explained that "in order to give his work a more thorough scientific foundation, he moved to the National Capital, where he pursued his researches at the Smithsonian Institution with the help and advice of Dr. J. W. Fewkes, Chief of the Bureau of American Ethnology, and other investigators." For the next four years, Myer had an office at the Smithsonian and held the title of special archaeologist. During this tenure, he made numerous trips to Tennessee to conduct fieldwork at major Mississippian sites, including Fewkes (40WM1), Gordontown (40DV6), and Mound Bottom (40CH8). He published a series of short articles and reports on these investigations while working on comprehensive excavation manuscripts. Unfortunately, in the midst of completing his magnum opus that was tentatively titled "Stone Age Man in the Middle South," Myer died of a heart attack at his Washington home on December 2, 1923. Although his colleague and friend John Swanton edited and pursued posthumous publication of two manuscripts that were nearly complete—*Two Prehistoric Villages in Middle Tennessee* (Myer 1928a) and *Indian Trails of the Southeast* (Myer 1928b)—the over one-thousand pages of "Stone Age Man" was considered too incomplete for publication (Neil M. Judd to John R. Swanton, January 19, 1929). Fortunately, these unpublished notes, manuscripts, photographs, and collections were not lost and remain available and accessible in the National Anthropological Archives of the Smithsonian Institution (K. Smith 1998; S. Smith, 1998). In them, Myer provides some of the most detailed information available on the discovery conditions of many of the Tennessee-Cumberland style statuary—a class of artifact that he found particularly intriguing. In addition, Myer purchased or received as gifts several statues addressed in our survey. Following his death, several of these statues were purchased by the Bureau

of American Ethnology in January 1927 and remain in the collections of the Smithsonian Institution. While his informants were often not firsthand observers, their anecdotal information recorded in his notes is often the earliest recorded and closest in time to the original discovery of a large number of the statues. Although Myer's interpretations have been rightfully critiqued on numerous occasions, his *observations* are more often than not presented in such detail that it is quite possible for modern scholars to disagree with his interpretations without challenging the credibility of the information he reported.

Almost two decades after Myer's death, William S. Webb and David De-Jarnette (1942:294–297) discovered a sandstone human image at one of the Pickwick Reservoir sites excavated during the Tennessee Valley Authority federal archaeology relief program. As part of their comparative research, they compiled 29 references by eight authors in their discussion of the distribution of "the stone image." However, they noted that "our immediate interest attaches only to their occurrence. . . . It would have been desirable if possible to have shown type forms, but such information was not readily available in most cases and the wide variation in form prevents any classification into types." Their distribution map included only specimens of "seeming undoubted authenticity" and led them to note that "their distribution seems to center about the State of Tennessee and in that State in the general vicinity of the Cumberland River" (Webb and DeJarnette 1942:Figure 96).

More detailed efforts to analyze and interpret Mississippian stone sculpture emerged within the context of defining the Southern Cult or Southeastern Ceremonial Complex in the 1950s. While contributing some key insights that remain valid today, the majority of these works dealt only peripherally with stone sculpture. For example, Antonio J. Waring and Preston Holder (1945) did not include stone sculpture in their "trait list" for the Southeastern Ceremonial Complex because "the trait of making these figures in stone seems to have been localized to the Georgia-Tennessee subarea." Waring did discuss the statuary in more detail in another work (Williams 1977:58–62):

> At this point it seems worthwhile to digress slightly, if for no other purpose than to scotch an error made by C. C. Jones [1873, p. 433] and reiterated by Willoughby [1932, p. 31], namely that the stone figures from Etowah represented corpses. We cannot answer as to the precise physical or metaphysical state of the individual that the Indians thought they were portraying, but these figures set erect, either with both hands on the knees with the legs crossed or with one hand on one raised knee. The heads are held in an alert and lifelike position. The Jones-Willoughby representation that these are "corpses" is made chiefly on the

basis of the so-called "protruding tongue." ... These figures almost cer-
tainly represent the honored dead (or "departed"), but they do not rep-
resent cadavers.

While again noting their geographic concentration in the Tennessee-
Georgia area, Waring's interest focused primarily on connecting the entire
class of artifacts with historically documented ceremonies rather than on sys-
tematic description or analysis of the objects themselves.

In a comprehensive examination of prehistoric human "figurines" from
the southeastern United States, Nancy Lou Engle updated the 1942 statuary
listing of Webb and DeJarnette to include "effigies that were overlooked or
reported since 1942" (Engle 1957:101). Engle described these sculptures as
follows:

> In an area around Nashville, Tennessee, numerous large stone effigies
> have been recovered. Smaller statuettes, some about 3 inches in height
> appear related to those that range to over 25 inches tall. ...
> The style of the stone effigies ranges from crudely roughed out, usu-
> ally of sandstone, to extremely sophisticated. ... Typical positions are
> sitting with the legs crossed in front, or indicated by stubs, or a block
> forming a lap, or kneeling, usually with the hands on the knees. Some-
> times one hand is turned out and the other in. The heads are many times
> shaped in a way to indicate the possible portrayal of artificial deforma-
> tion. These effigies have been found in stone graves, mounds, plowed
> up in fields, or in caves. They are often in pairs, one figure representing
> a female, the other a male.
> ... The distribution radiating from the Nashville area is obvious. The
> furthest north occurrence of such effigies is in Cahokia, Illinois, and the
> furthest south the Natchez, Mississippi, area [Engle 1957:100–101].

With increasing amounts of detailed archaeological data over the last four
decades, scholars have begun to more thoroughly appreciate and investigate
the complexity of the symbolism represented throughout the Mississippian
fine arts traditions. Scholars have proposed an amazing diversity of geographi-
cally centered styles, each seemingly connected with a single chiefdom or
geographic cluster of chiefdoms (Brown 1985; Muller 1966, 1979; Phillips
and Brown 1978; 1983). As part of this ongoing refinement of typologies
and traditions, scholars of the most recent few decades have generally rec-
ognized two distinctive styles of Mississippian stone sculpture depicting the
human form. While acknowledging that one of the statuary styles is cen-
tered in the Tennessee-Cumberland region, the majority of recent detailed
research focused on the "red stone" figures that have been recovered at Ca-

hokia, Spiro, Moundville, Shiloh, and a few other locales (Emerson 1982, 1989, 1997; Emerson and Hughes 2000; Emerson et al. 2003). Defined as the Cahokia style of stone sculpture, these figures are characterized by "a highly developed, realistic portrayal of human or near-human figures. The emphasis seems to be on portrayal of figures dressed in specific costumes and/or carrying out specific acts or deeds. The specimens occasionally seem to be portraying mythical acts or beings. Such sculptures have been found depicting warriors, sometimes engaged in ritual killings; individuals who may be shamans; chunkey players; and individuals smoking pipes, grinding corn, or occurring in conjunction with animals" (Emerson 1982:2). Recent research has definitively established that the small corpus of Cahokia style statues were carved in the American Bottoms from flint clay obtained in southeastern Missouri (Emerson and Hughes 2000; Emerson et al. 2003). Based on subject matter and other characteristics, the Cahokia style statuary comprise a set of Mississippian artifacts with mythological references (Emerson 1989, 1997; Emerson and Jackson 1984; Prentice 1986; Reilly 2004). F. K. Reilly (2004:132) suggests that the Cahokia style statuary "portray experiences derived from the overlapping mythic cycles that defined the Mississippian cosmic vision."

During the FAI-270 Archaeological Mitigation Project in Illinois, five red stone figures were recovered in secure contexts at two sites only a few kilometers from the heart of the Cahokia Mounds. At the BBB Motor site, two large red stone figures were recovered from a small Mississippian ritual facility. Another three Cahokia style stone images were discovered in solid contexts at the Sponemann site, a larger ritual center. These contexts established a clear link between these statues and ritual facilities. Emerson and others have argued that the Underworld figurines depicting females, serpents, and vegetation were restricted to specialized rural temples, while the male and animal effigy pipes were associated with specific (living) individuals (Emerson et al. 2003:302). Based on associated ceramics, radiocarbon dates, and other information, the Cahokia style images were produced during the Stirling phase, dating to A.D. 1100–1200 (Emerson 1982, 1983, 1989; Farnsworth and Emerson 1989).

Although questions remain, the Cahokia style of Mississippian stone statuary is relatively well defined in terms of its chronology, area of production, and some credible and well-supported hypotheses of initial and later uses. As understanding of the red stone images has expanded, researchers have maintained the contrast between the Cahokia style and Tennessee-Cumberland style of other Mississippian stone images: "[Cahokia style] carvings stood in dramatic stylistic and symbolic opposition to the Mississippian figurines found in the Tennessee Cumberland style clustered in the Georgia, Kentucky, and Tennessee area. Such figurines show squatting or kneeling males and females, focusing primarily on the head and torso with the lower body

only crudely depicted" (Emerson and Hughes 2000:82). This study provides the first detailed examination of the late prehistoric stone statues beyond the Cahokia style discovered throughout the southeastern United States. Some common motifs of posture and hairstyle cross style boundaries and are shared with human figures in many different types of Mississippian art and iconography, including three-dimensional representations in effigy bottles, bowls, and figurines, and two-dimensional representations on shell cups and gorgets, engraved or incised ceramics, stone tablets, and embossed copper. These correspondences are a reminder that stone statuary should not be viewed in isolation, but rather as regional expressions of a much broader body of art, ritual, and belief.

2
Tennessee-Cumberland Style Mississippian Stone Statuary

The distribution of all [human figure sculptures] is concentrated in Tennessee, although some of the most important pieces mark significant outliers (e.g., Angel, Indiana; Natchez, Mississippi; Spiro, Oklahoma).

—James Brown 2001

The remainder of this study will focus on 48 stone statues from the Cumberland River valley of Tennessee and Kentucky, 12 from north Georgia, 23 significant outliers in Tennessee and other states, and three lacking provenance (Figure 2.1). We faced the same limitations encountered by Emerson et al. (2003:301) in their survey of the Cahokia style statuary: "the interpretive potential of this survey is constrained by the fact that so many of the specimens were recovered in poorly documented situations, either through looting . . . or during the early days of archaeological research prior to the introduction of scientific field methods. . . . It is also hampered by the lack of access to figures in private collections and some public facilities."

Within the context of this survey, we have restricted our examination to freestanding human figural sculptures greater than 20 cm (8 in) in height carved from stones other than Missouri flint clay. Although the Mississippian stone images included in our survey are relatively small compared to those of more familiar civilizations such as the ancient Maya or early dynastic Egypt, we refer to them in this study as *statues,* reserving the term *figurines* for the smaller clay (and very rarely stone) images. We use the term *Tennessee-Cumberland style statuary* to refer to the entire body of statuary as a group. We recognize that the Mississippian stone statuary described in our survey represent only a subset of a broader canon that includes freestanding anthropomorphic images of various sizes fashioned in wood and clay. Like the stone sculptures discussed herein, these other human figural sculptures often exhibit the same consistency of "posture and secondary attributes [that] conform to a formula" (Brown 2001:83).

The ceramic (and very rarely stone) *figurines* (usually two to three inches in height) discovered by private collectors and archaeologists from the Tennessee-Cumberland region almost certainly number in the hundreds. For example,

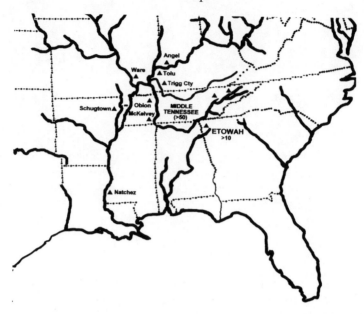

Figure 2.1. General distribution of statuary concentrations and significant outliers.

the floor of a single structure alone at the Brick Church Pike Mounds in Nashville (40DV39; Dowd 1974; 1985) produced a set of eleven whole and partial ceramic figurines (Figure 2.2). In addition to a very widespread distribution at small and large Mississippian sites in the Nashville Basin, similar figurines have also been reported at many other sites, including Kincaid, Illinois, and Etowah, Georgia. Including the vast body of figurines was simply not feasible within the scope of the current study. While we will limit most of our discussion to the 87 whole and fragmentary stone images greater than 20 cm (8 in) in height, a few tentative observations about the relationship between the statues and figurines will be addressed in the closing chapters.

This broader canon of human figural sculpture also extends to the rare wooden examples known from Oklahoma and Kentucky (Figure 2.3). Wooden statues and figurines are extremely rare in the archaeological record, undoubtedly due more to lack of preservation than their original frequency. Most of the known wooden statues (some evidencing paint) came from relic mining in the central chamber of the Great Mortuary at the Spiro Mounds in Oklahoma (Brown 1996:531; Engle 1957:101). The only well-preserved example from east of the Mississippi River was found by a fox-hunter in the cliffs of Bell County, Kentucky, along the Cumberland River during the winter of 1869. Made of yellow pine and standing two feet in height, "its form resembles the stone images" (Young 1910:268–269). Beyond lamenting the likely loss of many similar statues to the vagaries of time and

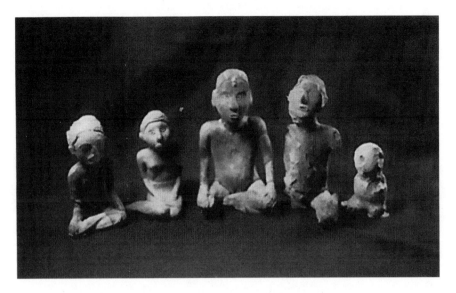

Figure 2.2. Ceramic figurines from Brick Church Pike Mounds (40DV39).

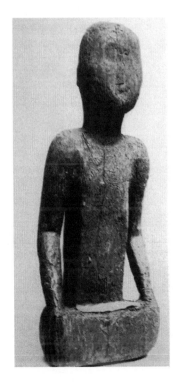

Figure 2.3. Wooden statue, Bell County, Kentucky (Young 1910:268).

preservation at most Mississippian sites, we are fortunate that some prehistoric artisans selected more durable media for their creations.

Unlike the Cahokia style red stone figures, very few of the statues examined during our survey have "nicknames" commonly used in the literature. Rather than attempting to create descriptive labels for the statues, we instead assigned a survey code to each of the images considered herein. The survey code is relatively simple—CSS (Cumberland Statuary Survey) followed by a sequentially assigned number. For example, the first statue is CSS-001, the second, CSS-002, and so on. While some readers may find these code references for the individual statues a bit unwieldy, we anticipate that additional information about several of the statues will surface in the future that may contradict or supersede some of our current interpretations (and any descriptive labels we might create). Tables 1 and 2 (Appendix A) summarize the available information for each of the statues assigned a number during the survey.

The statues documented during the survey came from archaeological sites distributed across a region roughly corresponding to the traditional boundaries of the Mississippian culture area—ranging from Illinois to Louisiana, and Arkansas to West Virginia. Despite this very broad real distribution, only 18 were found at sites outside the Cumberland and Tennessee River valleys and 12 of those are from Etowah and nearby sites in north Georgia. While artisans throughout the Mississippian world *occasionally* created large human figural sculptures in stone, the very significant concentration in Middle Tennessee and secondary concentration in northern Georgia implies a relatively restricted number of societies participating in stone sculpting as common practice.

General Features of Mississippian Stone Statuary

In their attempt to survey the stone statuary from the Southeast, Webb and DeJarnette (1942:294) discovered that "no two [statues] are alike and the range of variation is great." While we agree that the corpus exhibits tremendous diversity, part of the variability is probably influenced by the hardness of stone selected and the abilities of individual stone sculptors. Although detailed stone sculpting has considerable time-depth in the Southeast (for example, Middle Woodland era stone pipes), most of these Mississippian artisans were breaking new ground in terms of sculpting large stone figures. Within this apparent diversity, some general elements of posture and secondary attributes are shared by all of the stone statues documented during our survey, even those that we have not classified as falling within the Tennessee-Cumberland style. Mississippian sculptors participating in this broad regional tradition apparently shared some very key notions of what freestanding stone

figures should look like. Before delineating the specific characteristics that we believe serve to define a Tennessee-Cumberland style, a description of the broader shared elements of posture and secondary attributes is necessary.

Generally speaking, Mississippian stone sculptors of this tradition focused their most detailed efforts in depicting the face and hair with a secondary emphasis on the upper torso. Only on the most detailed and finely sculpted statues are elements of the lower torso fully developed. Similar to interpretations of the Cahokia style statuary, we feel that each feature shown on individual statues is there for a reason. However, in contrast to the red stone sculptures where when "a detail is missing it is a purposeful omission" (Emerson 1989:52), we are less confident in asserting that for these statues. Unlike the Cahokia style statuary, several of the statues in our survey show surviving traces of paints and pigments indicating that details of the pupils, face paint or tattoos, clothing, and other features may often have been depicted in perishable materials. On some statues, drilled holes in earlobes or hair knots suggest that perishable ornaments were attached as well. As a result, some of the common features of the statuary may be obscured on individual statues by differential preservation. Caveats aside, we argue below that many of the consistent details were intended to project gender identity. The diversity was designed to project individuality, to link some depicted males and females into pairs, and to identify a specific supernatural female character as the "Old Woman" (Duncan and Diaz-Granados 2004).

Features of the Face and Head

The eyes, nose, and mouth were clearly features of central importance to the sculptors and are depicted on almost all of the statuary. Ears received less attention and are often omitted or simply roughed in. As a result, we believe that depicting the "face" of each statue as an individual was among the most important goals of the sculptors. Another characteristic of the face noted on many statues is an upward inclination of the facial plane, occasionally described in the nineteenth-century literature as the "face turned upwards towards the heavens." The upward inclination of the face would permit a seated living individual of average size to gaze directly into the face of the statuary without reclining.

The outline of the eyes was sculpted using both incising and relief (sometimes in combination). Although not represented in stone, the pupils were depicted using pigments on at least some of the statues. Two statues (CSS-001, CSS-015) do not include any clearly sculpted depiction of the eyes proper, although prominent eyebrows and depressions highlight this portion of the face.

Along with other projecting features, the nose was often broken or damaged by the plow prior to recovery. When preserved, the amount of detail

generally varies with the overall degree of realism in the individual statue. While generally shown as relatively large and broad, nose forms exhibit a great deal of diversity without any obvious geographic patterning, perhaps lending some support to the notion that they are intended as portraits of individuals rather than an idealized supernatural figure.

The most consistently detailed facial feature is the mouth. The importance of this feature may be related to the concept of "speaking to the ancestors," a topic discussed more fully in following chapters. On all statues where the face is even partially preserved, the lips are shown in relief around a closed or, more frequently, open mouth. On the more detailed statues, additional features are often depicted, including a sculpted tongue between the lips (e.g., CSS-003) or the upper lip pulled back to bare the teeth (e.g., CSS-059). In other Mississippian art, these features (particularly the curled lips and bared teeth) have often been interpreted as indicative of the concept of death and trophy heads. On the Birger image, one of the Cahokia style statues, this feature has been interpreted slightly differently as "implying that the imaged individual belongs to the realm of the mythological rather than the natural world" (Emerson 1982; 1989). On the Tennessee-Cumberland style statuary, these features can be interpreted as implying that the individual represented has been transformed through death to become part of the mythological or supernatural realm.

As peripheral to the face, ears are less frequently depicted in great detail. On some statues, they are omitted or simply roughly blocked in. Where sculpted, ears are depicted using relief frequently in combination with different types of incising. The most unusual variant resembles a slightly lopsided figure 8 and is found only on three statues from Etowah (CSS-056, CSS-059, CSS-060) and one from Smith County, Tennessee (CSS-016). Pierced earlobes are an additional characteristic found on a few of the statues.

Additional features occasionally found on the faces of statues are incised lines or grooves on the forehead, cheek, and/or around the eyes. While they could be interpreted as face paint, they are more likely to represent more "permanent" characteristics such as wrinkles or tattoos. For example, CSS-003 exhibits all of these sculpted features along with designs painted on the face with pigments.

Hairstyle/Headgear. Another significant set of features associated with the face and head are elements of hairstyle or coiffure. Although some of these have occasionally been suggested as helmets or other types of headgear, the distinction is not readily apparent on the statues (Figure 2.4). Many of the statues exhibit a line across the upper forehead marking the hairline. The two most common means of depicting the hairstyle appear to reflect a basic gender variation in coiffure. The "typical male hair knot" (Type B; Figure 2.5; Figure 2.4b) is depicted on the back of the head extending perpendicular

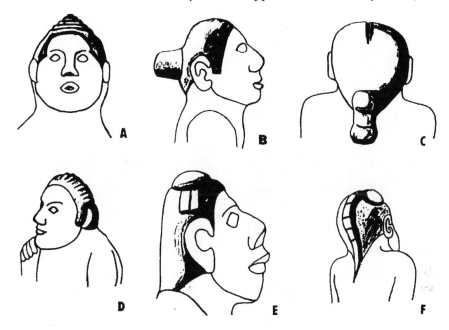

Figure 2.4. Statuary coiffure/headgear types.

to the long axis of the body. Although the length and width of this type of hair knot shows considerable variation, the location is consistent on the male statues.

The "typical female hair knot" (Type C; Figure 2.6; Figure 2.4c) is an elongated hair knot usually depicted on the lower neck and upper back extending parallel with the long axis of the body. On a few statues, this feature is shown higher on the back of the head in combination with rarer hairstyle elements, but is always clearly elongated parallel rather than perpendicular to the torso.

Other less common elements of hairstyle were also identified on the statuary, some of which occur in combination with the basic male and female hair knots. Given their rarity in our sample, they are less clearly interpretable but almost certainly originally had significant messages about a specific status or role held by the individual or character depicted. The most common of these is a hair "roll" extending from ear to ear over the crown of the head found on both males and females (Figure 2.4d). Incised grooves are sometimes incorporated and may depict either braiding or plaiting of the hair. Less common is the depiction of what appear to be "buns" on both sides of the upper head (Type E; Figure 2.4e). Apparently limited to males, this style also occasionally exhibits additional features that may indicate braiding or another binding method.

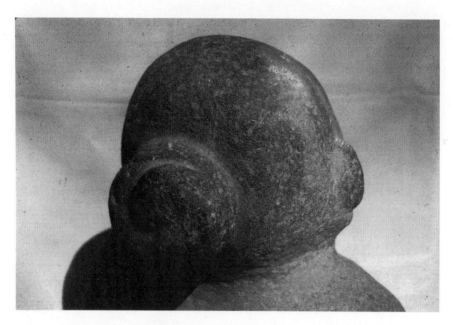

Figure 2.5. Typical male hair knot.

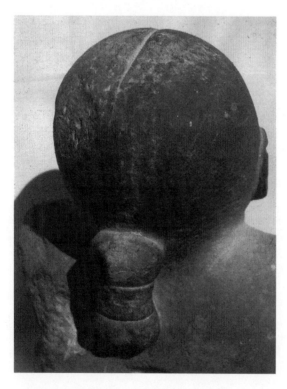

Figure 2.6. Typical female hair knot.

Other elements were identified on only one or two statues. A single braid or ponytail extending from the crown down the back of the head and neck is shown on two male statues (Type F; Figure 2.4f; CSS-003, CSS-030). A tiered or beehive hairstyle was identified on only a single eccentric female statue (Type A; Figure 2.4a; CSS-039). This feature is found more frequently on ceramic figurines and human figural bottles in the Tennessee-Cumberland region. The motif may also have some relationship to the tiered topknot motifs exhibited on blank-faced hooded bottles in the region. The most detailed of the Etowah female statues (CSS-060) appears to show a unique mix of both hairstyle and headgear.

In sum, the most consistent elements of hairstyle are the two types of hair knots that project gender information. The cultural meanings of the other identified elements are difficult to determine from an examination of statuary alone. While beyond the scope of this study, clear insights into their meaning may be possible by examining the broader range of human figures shown in Mississippian art and iconography.

Cranial Modification. While difficult to assert confidently, the sculpted heads of several statues may have been intended to depict artificial cranial modification of the occipital region. In interpreting the stone statue from Angel, Indiana (CSS-054), Glenn Black (1967:249) pointed out that the back of the head "is flat, a characteristic that is probably not accidental. Most of the male skulls found here [at the Angel site] have a flattened occipital." Deliberate deformation of the craniofacial complex was practiced throughout much of the New World with very different cultural meanings and significance. The artificial restructuring of the crania during infancy and childhood is well documented as a practice in the prehistoric Southeast. According to Charles Hudson (1976:322), "most of the Southeastern Indians used the cradleboard to shape the skulls of their infants." While some early historical records suggest that the practice was limited to males (cf. Bartram 1792; Romans 1775), this does not seem to have been the case in all regions. In the Nashville region, analysis of skeletal populations as least roughly contemporaneous with the statues indicates cranial modification on both male and female skeletons (cf. Berryman and Owsley 1984; Moore and Breitburg; 1998; Ward 1972). In instances where the sculptures are detailed in full round, the interpretation of artificial occipital flattening is relatively secure. In other cases, the flattened occipital area may simply be attributed to a lack of detail on the rear of the statue. Given this uncertainty, we offer only some tentative observations with regard to this feature on the statuary. Statues interpreted as both males and females exhibit this characteristic, although it appears to be more frequent on male statues. This apparent lack of consistency in the statues is consonant with the mortuary data from the Nashville Basin, in which no clear patterning for occipital deformation has yet been identified. Occipital

deformation was clearly *not* something attempted or achieved by every Mississippian family in the Nashville region, but whether this distinction was associated with a particular status, ethnicity, or other role remains unclear.

Features of the Torso and Body

Generally speaking, creators of the Tennessee-Cumberland style statuary did not sculpt aspects of the torso and body in great detail. The presence or absence of many characteristics is clearly directly associated with the overall naturalism reflected in the individual statue. As noted previously, this lack of emphasis may also partially reflect the fact that statues were adorned with perishable items such as pigments, ornaments, or even clothing. However, some characteristics of the torso and body provide key elements for interpretation of sex and/or gender.

As noted by Cheryl Claassen (1992:2), "sex, the biological condition, and gender, the cultural condition . . . have different degrees of archaeological visibility." For statuary, the most definitive indicators of the biological condition of sex are depictions of genitals, but these are rare. In relation to the statuary, Brown (2001:83) notes that "figures are sometimes provided with genitalia . . . but gender identification seems to have been more commonly communicated indirectly through coiffure, leg position, and nakedness."

Genitals. Genitals are possibly depicted on seven of the statues included in our survey. Only a single male statue (CSS-051) exhibits sculpted features clearly interpretable as genitals. The penis and testicles are shown in relief on the underside of the base, along with an incised concentric circle in the area of the anus. Three other statues (CSS-009, CSS-015, CSS-030) exhibit features in relief in the groin area that might have been intended to depict male genitals—although that interpretation is far from clear given that all are damaged. In at least one of these instances, the penis may have been defaced by "modest" collectors of the nineteenth century. Gerard Troost reported that the person who plowed up one statue retrieved the "shattered remains [of the penis but] considered it too indecent to be preserved" (Troost 1845:362).

Three statues (CSS-013, CSS-039, CSS-045) include apparent representations of female genitals on the front of the statue. In each of these cases, however, we do not believe the most significant message being transmitted concerns the sex or even the gender of the statue. We believe the sculptors used the vulvar motif on these three statues to assert their identification as the powerful supernatural character of the "Old Woman."

By any measure, clear depictions of genitals were not even of peripheral importance to sculptors of the Mississippian stone statues in our sample. The biological condition of sex has very little—if anything—to do with the messages offered by their sculptors.

Breasts and Nipples. A more common differentiation of the sexes can be

described in terms of secondary sexual characteristics, including representations of the nipples and breasts. Some statues exhibit sculpted nipples while others do not. The presence of these features is strongly correlated with other features interpreted as expressive of female gender, including a specific seating position and skirts. However, two statues interpreted as male (CSS-059, CSS-061) exhibit nipples. In the case of the one male from Etowah (CSS-059), the female of the pair (CSS-060) has sculpted breasts, providing a clear gender contrast in the pair. While unconfirmed, we suspect that the other male exhibiting nipples (CSS-061) was also originally part of a similar male-female pair.

Seating Positions. All of the statues sculpted below the waist appear to have been depicted in one of only three seating positions (Figure 2.7). Two common seating positions were identified for male statuary, while only a single primary seating position is known for females.

Seating Type A (Lotus Position): The most common seating position for male statues can be described as the lotus position. While numerous statues imply this position, seven are sculpted in sufficient detail to determine that the right leg was consistently placed over the left. The hands are consistently shown on or near the knees. Similar seating styles in other Mississippian art are shown on the "Buddha" shell gorgets found in Alabama, Georgia, and southeastern Tennessee (Brain and Phillips 1996:44–50). Over half of the Big Toco style gorgets derive from the Etowah site, where the male statues all exhibit this same posture. Some overlap can be seen in the Cahokia style statuary as well. For example, the famous effigy pipe commonly known as Big Boy (more properly identified as a representation of the mythological character Red Horn) is shown seated in this position (Brose et al. 1985:Plate 98). The wooden mortuary sculptures from the Spiro site are depicted in similar fashion (Brose et al. 1985:Plate 96). Historical paintings and other records suggest that this was a common seating position for chiefs in early historic chiefdoms. For example, the Great Sun of the Natchez is described as customarily sitting with his legs crossed, presumably in the lotus position (Hudson 1976:260).

Seating Type B: A much less common position for male statues (and possibly one female statue) shows the figure seated with the right knee raised and the sole of the foot flat on the ground. The Tennessee statues in this position all show the left leg folded beneath the body (cf. CSS-003), while the examples from Illinois and Indiana (CSS-052, CSS-054) show the left foreleg folded on the ground in front of the body. The right hand is always on the right knee, and the left hand is usually on the left knee.

Seating Type C: The only common posture for females is best described as kneeling with both legs tucked underneath the torso. The normal hand position is on or near the knees.

The vast majority of statues suggest a correlation between seating posi-

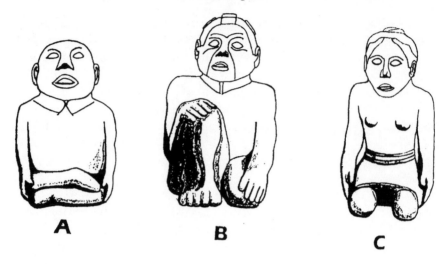

Figure 2.7. Statuary seating positions.

tion and the gender of the depicted figure. Although not all statues are fully sculpted below the waist, we believe this fact underlines the highly restricted nature of these seating positions—if the gender of the figure is otherwise apparent, Mississippian peoples viewing these types of statues assumed the default position of Type A for males and Type C for females. Following the argument that every detail is present for a reason on these statues, we are convinced that the Type B seating position had some significant meaning to Mississippian peoples. Unfortunately, what this distinction symbolized is not readily apparent from analysis of the statues alone.

Appendages. Of the appendages, hands are usually the more detailed and prominent, while feet have little definition if they are sculpted at all. Hands vary from relatively crudely blocked-in to well sculpted. The male statue from Sellars (CSS-003) is the only example with clearly sculpted fingernails. On the majority of statuary, fingers are depicted simply by incised lines. The right feet of Type B males are generally little more than crudely executed blocks (with again, the notable exception of CSS-003). The Sellars female (CSS-002) and the Etowah pair (CSS-059, CSS-060) have simple representations of the feet on the underside of the statue.

The hands are generally sculpted resting on or near the knees. A significant variation from this pattern is found on eight unpaired statues, where the arms are bent and the hands are resting on the abdomen (cf. CSS-004).

One notable characteristic that seems to have some geographic concentration is the arms sculpted separated from the torso. This variant is found on all of the statues from north Georgia. Outside that region, only two statues

(probably) from Smith County, Tennessee (CSS-013, CSS-014) share that trait.

Shoulders, Collarbones, Vertebra, and Abdomen. A few additional features of the torso are occasionally shown on the statues. While most of the statues are sculpted with straight shoulders, a few of them appear to display a feature best described as a "stooped" shoulder sloping downward away from the neck (cf. CSS-048). The upper torso on several statues also includes a feature interpreted as the collarbones in relief (cf. CSS-015, CSS-048). Two statues show apparent representations of vertebra in relief (CSS-048, CSS-054).

Special abdominal representation is rare. The most common method is a depressed area below the bottom of the rib cage. This feature is best represented on the Tolu male (CSS-051), the Long Island male (CSS-043), and the Williamson County pair (CSS-030, CSS-031).

Clothing. None of the male statues exhibit any sculpted characteristics interpretable as clothing. Six females are shown with a waistband usually accompanied by a line above the knees suggestive of a short skirt. All "clothed" statues are either from the Nashville or Etowah regions. As noted elsewhere, other statues may have been "clothed" using pigments or other perishable materials.

Discussion of General Features

Although the creative agency of individual sculptors is evident in the survey statues, several common themes can be noted throughout the corpus. A significant number of features appear to serve as gender markers, including seating position, presence or absence of nipples, presence of short skirts, and specific hairstyles.

Some exceptions to this assertion should be addressed. Although the provenances of the two are uncertain, CSS-030 and CSS-031 share a significant number of features indicating they were sculpted by the same individual (or in the same workshop). CSS-030 exhibits the typical male hair knot, a possible penis in shallow relief, and no nipples, while CSS-031 is shown with the typical female hair knot, nipples, and narrow shoulders relative to CSS-030. Both statues are shown in the Type B seating position with the right knee raised. CSS-031 is the only statue interpreted as female shown in this seating position. One additional statue (CSS-062) appears to be in the "female" seating position, but exhibits the typical male hair knot.

Two statues interpreted on the basis of other features as males are apparently, although not definitively, shown in the Type C "female" seating position. CSS-015 apparently originally exhibited a sculpted penis, a fact that may have obviated the need to clearly exhibit a male seating position. The seating position of CSS-043 from the upper Tennessee River valley is best

interpreted as Type C, although the statue deviates from others in our sample by having a sculpted base or platform.

While this handful of possible exceptions does not clearly challenge our interpretations, some ambiguity in gender-related features is not entirely un-expected in artifacts of this type. Seating positions may also be associated with specific social roles or statuses. When males *usually* hold those roles or statuses, it may become difficult archaeologically to sort distinctions based on gender from those based on other characteristics. For example, while the role of "chief" often appears to have been held by males in Mississippian so-cieties, numerous historic records clearly indicate that this role could and was held by females (DePratter 1991:82–84). If these seating positions were sym-bolic of both gender and social role, and these social roles occasionally over-lapped gender categories, we might expect some variants in which sculptors made choices as to which symbol sets were most critical—those depicting gender or those depicting social position. This factor may be especially sig-nificant in interpretations of the Type B seating position and would resolve the apparent conflicts in CSS-030 and CSS-031.

While not of particular concern given the general consistency of gender markers in the corpus of Tennessee-Cumberland style statuary, apparent am-biguities in gender identity in Mississippian representations of humans may require consideration of alternative explanations. Gender roles beyond those associated with "male" and "female" are well documented in numerous in-digenous North American societies, including the berdache. While less thor-oughly examined in the ethnographic literature, more than two gender roles were also present in at least some southeastern native societies, often associ-ated with shamanism. Thomas Emerson (2003:136–137) argues that,

> It is not unusual for a shaman to become genderless or male/female after their initiation. In the most common form of change, males be-come "soft men" and adopt female dress and behavior, what sometimes was described as the institution of berdache in North America. Such shamans are thought to be the most powerful. Less often women adopt men's dress and behavior. To some extent the frequency of women engaged in cross-gender activities may be related to the tendency of women to engage in shamanic practices when they are postmenopausal and are already in an ambiguous or different gender situation from that of reproductive women.

Assuming Mississippian stone statues were paraphernalia associated with shrines and by implication possibly with shamans, we cannot assume that the apparent male or female gender identity of a statue necessarily equates directly with biological sex. Since genitals are rarely displayed on the stat-

ues, "the most we can say is that *male and female genders* are being portrayed" (Emerson 2003:146).

Beyond gender, we also suspect that several features of the statuary may be symbolic of advanced age or status as "honored elders." Wrinkles, stooped shoulders, sagging breasts, and other physical changes associated with aging may symbolize this status on some of the statues. Incised lines on the forehead, cheeks, and around the eyes have been noted on several statues. While some may reflect tattoos, many may symbolize the wrinkled face of elders (cf. CSS-002, CSS-003, CSS-018, CSS-019). The skin "flap" accompanying the lines on CSS-002 and CSS-003 (see also CSS-008) can also be interpreted as symbolic of advanced age. CSS-002 includes the additional feature of apparently sagging breasts. The stooped shoulders, collarbones, and vertebra shown on several male and female statues can also be interpreted in this context.

Defining the Tennessee-Cumberland Style of Stone Statuary

In developing the defining characteristics of the Tennessee-Cumberland style statuary, we focused initially on the largely undamaged statues with either good provenance or relatively early discovery dates prior to presumed larger-scale forging of these artifacts. Considering the rarity and simplicity of features on the statues in our survey, it is no surprise that some of them are too idiosyncratic, poorly documented, or fragmentary to readily classify.

The statues classified in the Tennessee-Cumberland style include realistic portrayals of sitting or kneeling human or near-human figures sculpted from locally available stones. Unlike the Cahokia style figures where the emphasis is on specific costumes or mythological events, Tennessee-Cumberland style statues portray individuals in simple attire and at rest. In our definition, the Tennessee-Cumberland style images include two different (but probably interrelated) types of statues: (1) males and females created in pairs representing real or mythological lineage ancestors, and (2) depictions of an ancient, widespread, and complex supernatural female figure known historically across North America by various names such as Old Woman, Old Woman Who Never Dies, Grandmother, Corn Mother, and Earth Mother (among others). In order to differentiate these types of statues, we have identified them as two "themes" within the Tennessee-Cumberland style—the Ancestral Pair and Old Woman. Outside the Middle Tennessee and north Georgia regions, the practice of producing statuary pairs is not attested and the bulk of the available evidence suggests otherwise. While we have included these statues within the Tennessee-Cumberland style, we have left the theme undesignated at this point.

Unlike the Cahokia style figures that were seemingly produced in a re-

stricted geographic area in the American Bottoms and later dispersed to more distant locales to enter the archaeological record, we do not offer the argument that all of the Tennessee-Cumberland style statues were created in a restricted geographic area. For the most part, we believe that the Tennessee-Cumberland style statues probably entered the archaeological record not too distant from their place of manufacture. From this perspective, our use of the term *style* does not have the same connotation as applied to the Cahokia red stone figures.

As discussed more fully in the closing chapters, we believe that all of Mississippian stone images in the Tennessee-Cumberland style, Cahokia style, and undesignated statues served *broadly* similar functions as shrine statues. While their specific meanings and messages varied, all of these objects were part of the set of holy relics that provided the foundation of chiefly power in many Mississippian chiefdoms.

Statuary Pairs

Although the statues examined in our survey are diverse, some statues exhibit clusters of traits suggesting that the same sculptor created them (or at least sculptors in the same workshop). According to our interpretation, each of these statuary pairs contains a depiction of a male and female.

Five pairs of statues have very strong associations since they were discovered at the same time. These include three pairs from Tennessee (Beasley Mounds, CSS-010, CSS-011; Martin Farm, CSS-018, CSS-019; Link Farm, CSS-036, CSS-037) and two pairs from Etowah (CSS-059, CSS-060; CSS-057, CSS-058). Four of these pairs include statues that are clearly male and female, with the exception being the pair discovered by Warren K. Moorehead at Etowah. This pair includes a clear male, but the remains of the second statue are too fragmentary to permit any clear identification of gender. One additional set of statues from Etowah has been presented as a statuary pair (CSS-074, CSS-075), but their current location is unknown. If they are indeed genuine statues, they would constitute a third pair from the Etowah site.

Three additional sets of statues from Tennessee share sufficient clusters of traits to suggest male-female pairing, including a pair from the Sellars site (CSS-002, CSS-003), the Troost pair from Smith County (possibly Beasley Mounds, CSS-015, CSS-016), and the Brentwood pair (CSS-030, CSS-031). While these three pairs cannot be directly associated with the available documentary information, each pair shares a cluster of characteristics of face and torso that permit their association on a stylistic basis.

Four additional statues and/or fragments can be interpreted as possible pairs, but the available information does not permit any firm assertion of that identity. The statue and fragment from Natchez, Mississippi (CSS-063,

CSS-078) appear to represent a female and male respectively. If both did indeed come from the Grand Village of the Natchez, it seems plausible that they also represent a statuary pair. The two well-documented fragmentary statues from the Castalian Springs site in Tennessee represent a male and a female (CSS-008, CSS-009). Carved from the same type of stone, these fragments are of similar size and exhibit some similarities in sculpting style that suggest they might represent an intentional pair. Unfortunately, their fragmentary nature does not permit any definitive statement.

While impossible to prove, we suspect that numerous other statues included in our survey were also originally created as male-female pairs—particularly those from the Middle Tennessee and north Georgia regions. Outside of those identified as representations of the Old Woman (see discussion following), we infer that statues exhibiting sets of characteristics associated with male or female gender identity were once part of a pair.

Based on the currently available information, the tradition of producing Ancestral Pair statues may be limited to Middle Tennessee and north Georgia. Outside of this area, statuary pairs have not yet been firmly identified. The only possible exceptions in our survey are the two Natchez statues, although the limited contextual evidence does not really provide substantive support for such an interpretation.

Old Woman

A subset of the statues in our survey is interpreted as representing a theme distinct from that of ancestral pairs. While sharing most of the general characteristics marking female gender, these statues include two additional traits that appear to significantly set these apart from the statuary pair females: (a) hands resting on an often projecting abdomen; and/or (b) sculpting of the vulva.

The core examples of "female" statues exhibiting the hands on the abdomen are from the Sellars site (CSS-004), Pipers Ford (CSS-020), Terry Farm (CSS-023), most of those from the Cumberland Mountain cache (CSS-024, CSS-025, CSS-026), Sequatchie Valley (CSS-028), and one from the Clark collection (CSS-046).

A different portrayal shows the hands in the traditional female position, but includes sculpting of the vulvar motif between the parted knees. Core examples of this variant include one from Beasley Mounds (CSS-013), Big Bigby (CSS-039), one from the Jones collection (CSS-045), and two from the Clark collection (CSS-047, CSS-048).

With no documented male counterparts, these statues appear to be depictions of the Earth Mother supernatural figure. This female supernatural is a central and widespread figure in the mythology of agricultural peoples across eastern North America. Although the details vary by cultural group, gener-

ally speaking, she is the mythological womb from which all life emerges and to which all life returns at death. As summarized by Prentice (1986:250), "The Earth-Mother is variously identified as 'Old Woman' or 'Grandmother'; she is mother or grandmother of the creative boy twins; she is frequently associated with the underworld and a death goddess; and is also identified as a lunar deity." The Old Woman is well represented in the Cahokia style statuary, particularly those from the "rural shrines" at the outskirts of the central Cahokia precinct.

These two statue variants mirror recent interpretations of an interrelationship between female-related motifs in Missouri rock art and the Old Woman. James Duncan and Carol Diaz-Granados (2004) make a strong argument that the vulvar motifs in Missouri rock art serve consistently as a metaphor for the Old Woman. Although the connection is less certain, "the puerperal or birth figures . . . may be associated with the Old Woman, as she is said to have borne anywhere from two to many supernatural offspring" (Duncan and Diaz-Granados 2004:198). As early as 1791, Thomas Jefferson described the first Tennessee-Cumberland style statue acquired for his collection (CSS-049) as a woman in labor: "the artist had, if not intentionally, very happily hit on the representation of a woman in the first moments of parturition" (Jefferson to Innes, March 7, 1791). Although no clear connections to the Missouri rock art can be demonstrated, this model of female-related motifs on the (apparently) unpaired statues provides a tentative framework for future research.

Assuming this interpretation is correct, the Old Woman or Earth Mother statues appear to have a broader distribution within Tennessee than the known ancestral pair statues. Given that both statuary pairs and depictions of the Old Woman appear to have been buried in relatively close proximity at some of the Middle Tennessee sites, some shrines may have included at least three statues as part of the sacra.

Depictions of the Old Woman are even more evident in negative painted and "hunchbacked" effigy bottles found throughout the Nashville region that appear to range chronologically from the thirteenth through the late fifteenth centuries A.D. (Figure 2.8; Figure 2.9). Recent interpretations of Mississippian symbolism centered on the Tennessee-Cumberland region additionally suggest an emphasis on Underworld motifs that may be linked to the Earth Mother or Old Woman. George Lankford (2004) proposes that the central motifs on the Nashville Style marine shell gorgets are a locative or metaphor for the Beneath World—a realm clearly associated with the Old Woman. Interpretations of the Thruston Tablet found at or near the Castalian Springs site in Middle Tennessee tentatively suggest a complex representation of the mythological story of Lodge Boy and Thrown Away, the

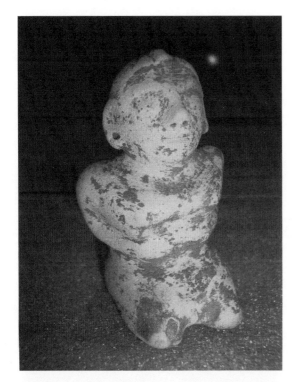

Figure 2.8. Negative painted hooded bottle, Averbuch site (40DV60), front view.

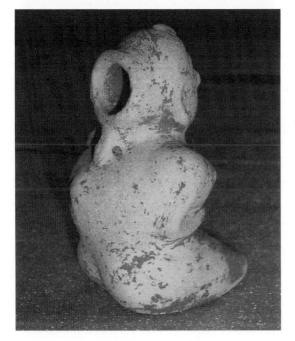

Figure 2.9. Negative painted hooded bottle, Averbuch site (40DV60), rear view.

twin children or grandchildren of the Old Woman (Robbins 2005; Steponaitis et al. 2005). Although still in preliminary phases, recent examinations of the broader corpus of Mississippian art from the Nashville Basin suggest that a significant proportion of the motifs related thematically to recorded story cycles of the Old Woman (Smith 2005).

3
The Middle Tennessee Heartland

In an area around Nashville, Tennessee, numerous large stone effigies
have been recovered. Smaller statuettes, some about 3 inches in height
appear related to those that range to over 25 inches tall.

—Nancy Lou Engle 1957

The Tennessee-Cumberland region, or what is more properly described today
as Middle Tennessee (one of the three official political divisions of the state),
has long been recognized as a major center of Mississippian development.
John Walthall (1980) goes so far as to identify the Tennessee-Cumberland
drainage as one of the three core regions of Mississippian development along
with the American Bottoms of Illinois and the Caddoan region of Okla-
homa. The greatest concentration of statues is in the Middle Cumberland re-
gion with four additional sites yielding significant statues (Figure 3.1).

Middle Cumberland Statues

Scholars have long acknowledged the existence of some form of distinctive
Mississippian culture along the Cumberland River in Tennessee and Ken-
tucky (cf. Bushnell 1920; Holmes 1903; Phillips et al. 1951; Thomas 1894;
Walthall 1980). While initially described as the Stone Grave culture, Ten-
nessee-Cumberland phase, or Gordon culture, more recent researchers have
used the term *Middle Cumberland culture* (Ferguson 1972; Smith 1992a). Fol-
lowing Willey and Phillips (1958:22, 47–48) and recent treatments of Lamar
(Hally 1994), Middle Cumberland culture is used in this context as a taxo-
nomic unit encompassing a number of phases and possessing traits sufficiently
characteristic to distinguish it from all other units similarly conceived. Based
primarily on the distribution of diagnostic ceramic traits, the boundaries of
the culture area have been designated to include sites within the Cumberland
River drainage between the confluence of the Caney Fork and Cumberland
rivers on the east, and the confluence of the Red and Cumberland rivers on
the west (Moore and Smith 2001).

The number of phases and sociopolitical units (chiefdoms) subsumed under
this Middle Cumberland culture designation remains uncertain, but two
regional periods corresponding broadly to Early Mississippian and Middle

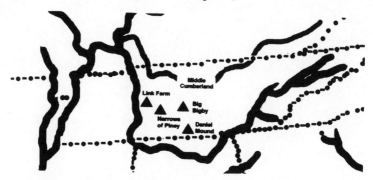

Figure 3.1. Middle Tennessee peripheral find spots.

Mississippian have been used over the past two decades. The Dowd regional period (before A.D. 1000 to A.D. 1225) remains inadequately documented, although recent excavations at the Fewkes site (40WM1), Brick Church Pike Mounds (40DV39), and Moss-Wright Park site (40SU61) promise to yield substantial new information on this early period. Regionally, the assemblage from this period is dominated by plain, shell-tempered wares with loop and narrow intermediate handles, fabric-impressed pans, some exterior cord marking on jars; coarse paste blank-faced hooded bottles, and cylindrical neck bottles.

Between A.D. 1000 and 1225, several Mississippian chiefdoms emerged in the Nashville Basin. After 1225, a more complex and probably considerably more fluid political landscape emerged, with several simple and complex chiefdoms dominating different portions of the Nashville Basin and surrounding highland rim. The Thruston regional period (A.D. 1225–1475) is significantly better documented. Early in this period, narrow and wide intermediate handles on jars replace loop handles. By the middle of this time frame, wide intermediate handles and parallel-sided strap handles are the norm. Negative painting on bowls, plates, and bottles seems to have been established during the early part of this period and reached the peak of its popularity by approximately A.D. 1300. During the latter half of the Thruston regional period, a number of significant diagnostic ceramic traits are found at sites throughout the region, including jars with incised and punctate shoulder motifs (Beckwith Incised and Matthews Incised), the ubiquitous semihemispherical bowls with notched appliqué rim strips, plain-surfaced pans; structural and rim-rider effigy bowls; fine paste hooded bottles and hooded effigy bottles; and carafe-necked bottles. Common appendages are single pairs of bifurcated rim lugs, wide intermediate handles, and most commonly, wide strap handles.

Most of the currently known Tennessee-Cumberland style statuary were found within the geographic area proposed for the Middle Cumberland cul-

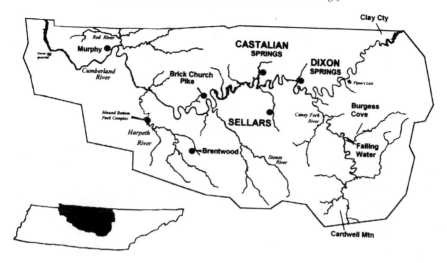

Figure 3.2. Cumberland River drainage showing significant find locales.

ture (Figure 3.2). As currently known, the production of statuary seems to
have been focused in the eastern portion of a geographic region including
three major mound sites—Sellars, Beasley Mounds, and Castalian Springs.
In addition, the core set of statuary from this area provides the most coher-
ent body of this style. With a few exceptions, the farther from this heartland
of the Tennessee-Cumberland style, the more isolated and variant are the
statues.

Sellars (40WI1) Statuary

As the likely discovery spot of "Sandy," the most frequently illustrated of the
Tennessee-Cumberland style statuary, the Sellars site is an appropriate place
to begin our discussion. Sandy (CSS-003) has been featured in so many dif-
ferent publications over the past five decades that it would be virtually im-
possible to list them all. In addition to serving as the icon for the Tennes-
see Archaeological Society for almost fifty years, Sandy's list of appearances
include *Time* magazine (1941), the cover of a Time-Life Books publication
(1992), and most recently, a United States postal stamp in the series "Art
of the American Indian" celebrating the opening of the Museum of the
American Indian. Oddly enough, out of the hundreds of published photo-
graphs of Sandy, all that we are aware of depict the statue only from the
front.

Sellars, also known as "the Earthworks near Lebanon" (Putnam 1878) and
the Greenwood site (Brain and Phillips 1996), consists of a single platform
mound, large plaza, habitation area, and a palisade embankment and ditch
enclosing approximately eleven acres (Figure 3.3). Situated 4 miles south-

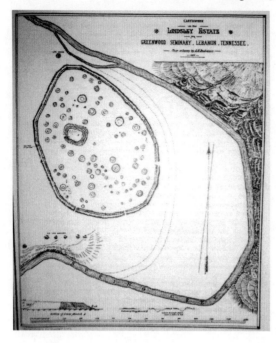

Figure 3.3. Sellars site (40WI1),
Buchanan map (Putnam 1878).

east of the modern city of Lebanon, Tennessee, on the rim of an old terrace in a prominent bend of Spring Creek, Sellars is unusual in that it is the only major Mississippian site in the Nashville area located in the cedar glades of the inner basin. Cedar glades, consisting of dense stands of red cedar interspersed with open rocky areas, do not appear to have nearly the same level of resource potential as the local mesophytic forests dominating the outer portions of the Nashville Basin, and this environmental zone was never densely occupied after the adoption of intensive horticulture. However, the Spring Creek drainage comprises a strategic and relatively direct overland route from the Cumberland River southward to the Eastern Highland Rim (and thence to northern Georgia). The location of Sellars may have been significant as a frontier, border, or gateway town for peoples living in the Nashville Basin (Butler 1981:59).

The central platform mound measures 37 m in length, 36 and 29 m wide on the east and west ends respectively, and reaches a height of 4.5 m (Butler 1981:38–40). According to Putnam's interpretation (1878:341–342), the platform mound was built in stages to heights of 1, 2, 8, and eventually 15 ft. The platform mound faced eastward across a plaza. Located 90 ft to the southeast of the primary mound at the southern edge of the plaza was a smaller mound. Although the description of this low mound (labeled C on the Buchanan map) "implies that there was a structure associated" (Butler 1981:40), Putnam focused on investigations of approximately 60 stone graves placed

on the flanks of the mound in three tiers (Putnam 1878:342). Putnam also excavated 19 of the approximately 100 low circular ridges of earth scattered throughout the village. As Butler (1981:40) noted, "like many other early excavators, [Putnam] failed to perceive that they were square instead of round."

All of these features are enclosed by a palisade embankment and ditch some 900 ft (274 m) north–south and 650 ft (198 m) east–west. Although surface evidence of most of the surrounding embankment has been destroyed by cultivation, a segment approximately 45 m long is still visible on the western side of the site. The inner embankment is about 5 m across at the base and about 30 cm above the interior ground surface. The outer embankment, separated from the inner by a shallow ditch, is about 2.5 m wide and about 20 cm in height. Each end of the preserved remnant sports a bastion, 33 m apart center-to-center and 25 m apart edge-to-edge (Butler 1981:38).

After its acquisition in 1974 by the State of Tennessee for preservation, limited test excavations were conducted at the site in 1974 and 1977 (Butler 1981:37–60). Additional excavations were undertaken in 1981 by Carl Kuttruff (Tennessee Division of Archaeology, unpublished field notes). These excavations focused on examinations of palisade features, several domestic structures, and a possible low mound located on the north side of the plaza. Excavations to date suggest that Mississippian peoples first occupied the site by around A.D. 1000 and eventually abandoned the site sometime before A.D. 1400.

During the initial Euro-American colonization of the Nashville area, the archaeological remnants of Sellars were included in a 1786 Revolutionary War land grant to Nathaniel Lawrence. Eventually, the tract passed to his heirs, the Lindsley family, who established the Greenwood Seminary. In 1877, Mrs. N. Lawrence Lindsley invited Frederic Ward Putnam of the Peabody Museum at Harvard to excavate at the site after the meeting of the American Association for the Advancement of Science in Nashville (*Daily American,* Sunday, September 23, 1877). Putnam limited his work at the "Earthwork on the Lindsley Estate near Greenwood Seminary" to the main platform mound, a secondary mound, and some of the house "rings" still visible within the earthworks around the grove. A. H. Buchanan, a professor at Cumberland University, prepared an accurate map of the site at that time. Putnam's report of investigations was published in the *11th Annual Report of the Trustees of the Peabody Museum* (Putnam 1878:339–360).

After changing ownership several times, the site was eventually purchased by James W. Sellars in 1909. James and his sons, Ray and Clyde, cleared the timber about 1915 and began cultivating the site. On June 8, 1922, Clyde Sellars struck what he thought was a boulder while plowing. No doubt to his surprise, the stray stone proved to be the first statue discovered at the site

(CSS-001). Immediately recognized as an excellent conversation piece, the statue was placed on display in the show window of the Goodbar's Men's Clothing store on the south side of Lebanon square.

While visiting the Lebanon Rotary Club in the 1920s, J. Walter Fewkes of the Smithsonian Institution saw the statue on display and sought further information about its discovery. P. E. Cox, the first official state archaeologist of Tennessee, forwarded information about the figure to Fewkes in March 1925 (Cox 1925), and arranged to have the statue exhibited in the State Museum, where it remained from March 1, 1926, until October 9, 1937. According to Cox, "the idol was plowed up by Clyde Sellars . . . and the gentleman to whom we [Cox and Fewkes] talked was Mr. Ray Sellars . . . the idol was plowed up about 75 yards southeast of the mound on June 8, 1922" (Cox 1925). Clyde Sellars eventually reclaimed the artifact, and soon afterward sold it to Guy Stack, a prominent amateur archaeologist and relic collector from Nashville. The statue passed into another private collection upon Stack's death in 1963.

In late 1938 or early 1939, a tenant farmer and his son struck another "stone" while plowing in the eastern field. When they stopped to remove it, they discovered yet another stone statue (CSS-002). According to knowledgeable local residents, the Sellars family heard of the discovery and took possession of the statue in exchange for an old horse. The family afterward sold it to Lillard Yeaman, sheriff of Smith County and an amateur archaeologist, who displayed the find at his service station in South Carthage. According to a short report published in the *Tennessee Archaeologist*,

> Mr. Stack has submitted the following statement secured from Clyde Sellars of Wilson County, pertaining to stone images owned by himself and Mr. Lillard Yeaman of Carthage: "My father bought this farm on which we live 40 years ago. Four years later he bought a strip of land along Spring Creek. On this strip of land was a large mound, several small mounds and other extensive ancient earthworks. The timber was cleared from this land in 1915, 4 years later the stone image (Mr. Stack's image) was found 70 yards east of the large mound. It had been struck by farm implements several times and was thought to be an ordinary boulder, so that its original position is not known. In 1939 Jeff Rogers found another image in the same field and I believe at the same spot. This image is now owned by Mr. Lillard Yeaman at Carthage" [Lewis 1948b:16].

Armed with the knowledge that two statues had appeared in roughly the same spot on the Sellars' farm, Jeff Rogers apparently kept his eyes open for evidence of others in the same location. J. T. Arrington, a neighbor from

across the creek, indicated that Rogers diverted the interest of other collectors by telling them he found the second statue about 300 ft southwest of the village site. In late 1939, Rogers is believed to have discovered two additional statues (CSS-003, CSS-004) at the same location where the first two were found (70 yd east-southeast of the platform mound). Allegedly unwilling to surrender these two additional statues to the Sellars family, Rogers packed his family and possessions (including the statues) and moved to the Floyd Lester farm, located east of Lebanon and Spring Creek and north of Carthage Pike. Soon after the move, he claimed to have found the statue at Lester's place while digging a tobacco bed on December 14, 1939. Rogers took CSS-003 to Hugh Walker at the *Lebanon Democrat* newspaper office, who named it Rogo the Chief in honor of its finder. In later years, the figure was renamed Sandy.

Hugh Walker (1947) eventually published a story about the statues, placing their origin at the Lester farm. Although local tradition suggests that the find spot is inaccurate in this article, the published details of the discovery are the most accurate available. While digging, Rogers struck the male statue Sandy (CSS-003). The stylistic similarities of CSS-002 (definitely found at Sellars farm) and CSS-003 suggest that both were created by the same sculptor and were probably created as a statuary pair. After removing Sandy, he continued to dig and at "about two feet" beneath it found the female figure, CSS-004 (Walker 1947:14). The presence of plow damage on the male statue and its absence on the female provides some corroboration of this description.

In February 1940, Jeff Rogers sent photographs to Professor T. M. N. Lewis at the University of Tennessee along with an offer to sell the statues. After several months of negotiation during which Rogers claimed private offers of as high as $200, an agreement was reached. Lester signed a release and the university purchased the two statues from Rogers for $150 in December 1940.

For many years, Rogers continued to assert that the statues were found in a mound on the Lester farm, 1/2 mile east of Spring Creek on the slope of a steep hill near the mouth of a sinkhole (Walker 1947:14). In other instances, he claimed they were discovered in a cave, near a village site, and near a stone box cemetery (Lewis 1948a:16). After Rogers's death, several local residents claimed that the two statues actually came from the Sellars's farm. Although the precise find spot of these two statues will probably never be confidently established, circumstantial evidence supports the assertion that they were discovered at the Sellars site rather than the Lester farm, which has yielded no other evidence of a Mississippian occupation.

Assuming that all four statues were discovered at Sellars, the available descriptions suggest they were buried beneath or around the structures on the southern edge of the plaza 70 or 75 yd to the southeast of the main platform

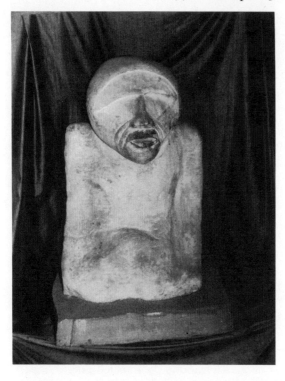

Figure 3.4. CSS-001.

mound. The Buchanan map shows an unusually large "hut ring" in this general vicinity that could represent the surface remnants of a public structure.

Statue CSS-001 (Figure 3.4). Statue CSS-001 exhibits three parallel incised lines at either side of the mouth and an unusual forward stooping posture. The statue does not exhibit eyes or ears, although the eyebrows are prominently sculpted. A semicircular hairline is indicated across the brow terminating in a typical male hair knot on the back. The flare of nostrils is indicated at either side of the nose, but the openings are not sculpted. The occipital region shows flattening. Although the exact position of the legs is not clear, an indentation at the front of the base and a raised section in the lap area can be interpreted as the right leg crossed over the left. In places where the soft siltstone has chipped, the reddish brown color characteristic of the statues from the Sellars site is visible.

CSS-001 does not appear to have been designed to sit upright on a flat surface. The original base was irregular and rounded, and Guy Stack added a concrete stand for display purposes. Other apparent modern additions to the statue include the cream-colored paint coating the base and the pale pink/purple lips. While several statues exhibit evidence of aboriginal painting, the paint on the statue base ran onto the concrete stand. A final modern feature is the plow scarring on the statue's back. Each of these scars extends diagonally

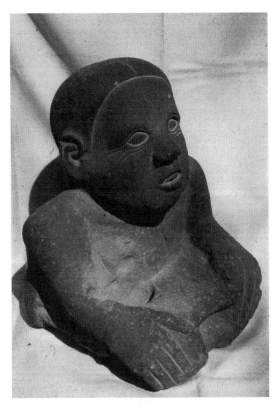

Figure 3.5. CSS-002.

from the lower left to the upper right of the figure, cross-cutting the hair knot. CSS-001 has sometimes been identified as female in the literature, but the hairstyle, seating position, and absence of nipples suggest that the figure represents a male.

Statuary Pair CSS-002 (Figures 3.5, 3.6, 3.7) and CSS-003 (Figures 3.8, 3.9, 3.10, 3.11, 3.12, 3.13). Although CSS-002 and CSS-003 were not discovered at the same time, the two statues exhibit so many stylistic similarities that we are confident in asserting that the same individual sculpted them. Details of the eyes, ears, throat, and the overall symmetry all contribute to a visual sense of pairing. From our perspective, this anonymous native artisan should be considered among the greatest of the Middle Cumberland sculptors. Along with the pairs from Etowah, Georgia, and Beasley Mounds, Tennessee, they comprise the most intricately and realistically portrayed Tennessee-Cumberland style statues discovered to date. Their naturalistic pose and features are rare, and the detail reveals an appreciation for anatomical features. The facial expressions of both these statues are easily capable of evoking an emotional response in modern viewers and communicate a strong sense of the humanity of these long-vanished people.

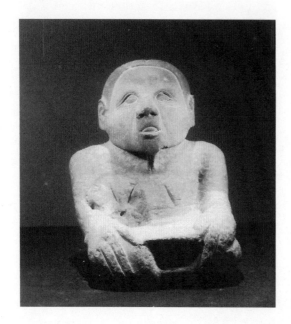

Figure 3.6. CSS-002, front view.

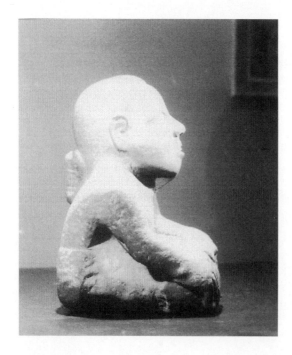

Figure 3.7. CSS-002, profile view.

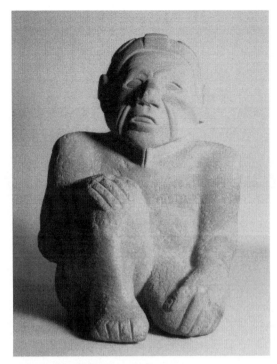

Figure 3.8. CSS-003, front view. Frank H. McClung Museum, University of Tennessee, Knoxville.

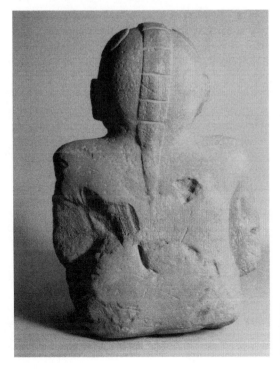

Figure 3.9. CSS-003, rear view. Frank H. McClung Museum, University of Tennessee, Knoxville.

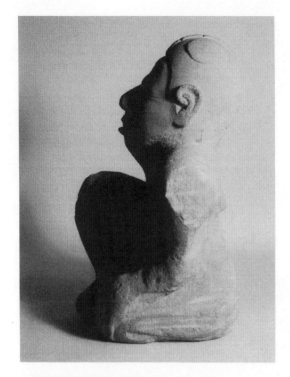

Figure 3.10. CSS-003, left profile. Frank H. McClung Museum, University of Tennessee, Knoxville.

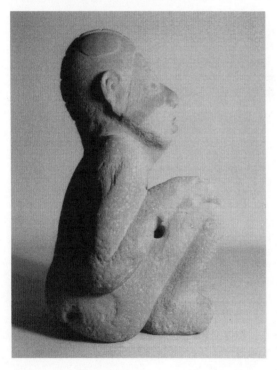

Figure 3.11. CSS-003, right profile. Frank H. McClung Museum, University of Tennessee, Knoxville.

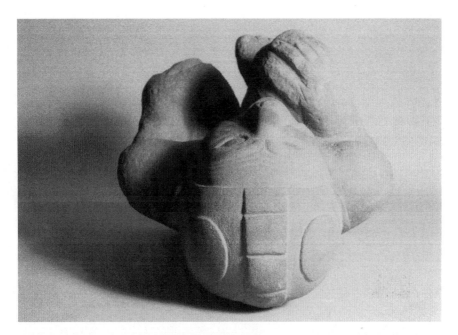

Figure 3.12. CSS-003, top view. Frank H. McClung Museum, University of Tennessee, Knoxville.

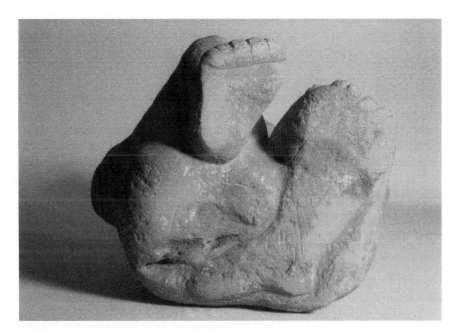

Figure 3.13. CSS-003, base view. Frank H. McClung Museum, University of Tennessee, Knoxville.

Both statues exhibit incised lines (wrinkles?) beneath and on the outer edge of the eyes, and a "flap" or fold of skin is sculpted beneath the chin. The incised lines radiating from the outer edges of the eye could also be interpreted as a variant of the forked eye surround. The carefully sculpted faces of both statues incline backward at a 17-degree angle.

The female (CSS-002) exhibits "sagging" breasts in shallow relief with an incised line near the bottom indicating nipples. Ears, flared nostrils, and an open mouth with tongue pressed against the upper lip are shown in great detail. Hair treatment is also detailed, with a part in the middle extending backward from a straight, raised hairline into a typical elongated female hair knot. Two incised lines sculpted at the end of the braid appear to reflect the tying of the braid at the ends. The arms are contiguous with the body, and are depicted extending down the sides. Hands are extended around the knees, and the right wrist shows a wrist knot, although the left was destroyed through plow damage. The base indicates a kneeling position with the legs folded beneath the body and the toes turned inward. Clothing is shown as a short skirt with the front and rear edges indicated by the knees. The top of the skirt is also indicated across the lower back of the figure. Pigment was applied to parts of the head and face of the figure, including red (ocher?) on the tongue, and a darker (probably originally black) pigment on the face, eyes, and hair.

Plow damage is evident on the left rear from the head down to the buttocks. Erosion of the soft siltstone is identifiable through the right arm and body, with a hole in the right portion of the lap. Similar to CSS-001, advanced age may be indicated on CSS-002 in the form of wrinkles, sagging breasts, and skin flap beneath the chin.

In addition to the incised lines around the eyes, the male (CSS-003) also includes incised lines extending downward across the cheeks. Care was taken to realistically depict the raised knee and foreleg, along with the ankle and shinbone in relief. The hands and feet are also more thoroughly sculpted than on most statues, including toes and even fingernails. The most unique feature of CSS-003 is the depiction of hairstyle or headgear. The stylized hair lock extends as a ridge from the straight hairline over the top of the head and down the back. The hair lock is evenly divided by seven incised grooves, perhaps indicating a plaited hairstyle. On either side of the head are circles in relief, representing hair buns. The face appears to have been coated with a pale yellow pigment. Overlying the yellow pigment, additional pigments were applied to two features—black markings on the face and red on the mouth—but are not preserved in as much detail as on the female. Plow damage is indicated on the right side and rear, with the lower portion of the right ear missing.

Statue CSS-004 (Figure 3.14). The second statue discovered by Rogers (CSS-004) includes numerous unique features, probably as many as any statue covered in this study. Although the first impression is one of crudeness, closer

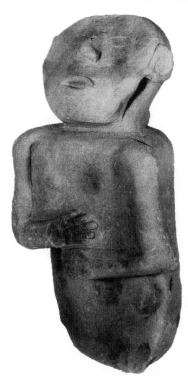

Figure 3.14. CSS-004. Frank H. McClung Museum, University of Tennessee, Knoxville.

examination suggests instead an abstract simplicity. The facial figures and hair received the greater emphasis, but they are simplistic and unrealistic almost to the point of being schematic.

The lips are in a distinct open, oval relief. The large simple nose shows no openings and rises from the flat plain of the face, while the almond eyes are simply incised. The raised ears have incised lines to indicate details. At 38 degrees, the inclination of the face toward the back is the greatest of any known statue. The face shows an applied dark pigment that was probably originally black. The back of the neck shows the classic female hair knot, which is not pierced but rather drawn together in the middle by a single binding element.

Unlike most female statuary, the hands are shown with the right hand over the left. The fingers are crudely indicated by incised lines, and a wrist knot is present. The shoulders are thrown forward, but no hump is evident on the back. Breasts are indicated by large nipples.

The treatment of the lower torso is unusually simplistic. No attempt was made to indicate legs, and the torso actually tapers downward to the slightly eroded base. In the absence of a base, the statue must have been displayed in an earthen depression or other type of stand in order to remain upright.

The Gilliam Statue (CSS-005)

On a farm about 10 miles south of the Sellars site, another statue was found in March 1823. In 1813, Charles Gilliam (also recorded as McGilliam) purchased over 300 acres at this location near the junction of Fall and Jug creeks. He began farming the fertile and well-watered bottomlands, ultimately leaving his legacy in the name Gilliam Spring. John Haywood provides the only description of the Gilliam statue, CSS-005, which he recorded from a Mr. Rucker (Haywood 1823:151–152). Although we have already addressed some of Haywood's fanciful interpretations, his descriptions of artifacts appear, in general, to have been relatively accurate. Since the current location of this statue is unknown, Haywood's record contains the only available description:

> In March 1823, a rude piece of sculpture was dug up on the farm of Mr. McGilliam. The farm lies on Fall Creek, near Quarles in Wilson County. The figure is cut out of a hard stone, of what kind Mr. Rucker could not determine. It was designed for a female statue. The legs were not drawn. It only extends a little below the hips. It is fifteen inches long, and thick in proportion. It has a flat head, broad face, a disproportionately long aquiline nose, low forehead, thick lips, and short neck. The chin and cheek bones are not prominent, but far otherwise. On the back part of the head is a large projection, so shaped as to show, perhaps, the manner of tying and wearing the hair. The nipples are well represented, though the breasts are not sufficiently elevated for a female of maturity. The hands are resting on the hips, the fingers in front, and the arms akimbo. Around the back, and above the hips, are two parallel lines cut, as it supposed to represent a zone or belt. The ears project at right angles from the head, with holes through them. . . . It was found a few inches beneath the surface of the earth. No mounds are near, but an extensive burying ground of apparently great antiquity.

Although no Mississippian sites have been recorded on the Gilliam property, local oral tradition and vague nineteenth-century records suggest that a low mound located somewhere north of Gilliam Spring yielded the skeletal remains of a large water bird. Haywood described an "extensive burying ground of apparently great antiquity" at the same location, and another large burial site to the east. No reference to either of these sites has been made in any known literature since 1823, preventing interpretations of the Gilliam site in terms of site-specific information. Since this information was published before the widespread creation of forged statues and the details are quite acceptable for genuine statues, we have included it here.

The Dodson Farm Statue (CSS-006)

In the 1950s (probably 1954 or 1955), another anonymous farmer plowing with his mules on the old Dodson farm struck a sculpted head without a body (CSS-006). The Dodson farm was located about 15 miles west of the Sellars site across Cedar Creek from the modern communities of Beckwith and Silver Springs. Not long after the discovery, the farmer took it across the creek to a small store owned by Jim Smith, who accepted the artifact in exchange for a grocery bill and subsequently displayed it on his counter.

Hugh W. Gilliam, a milk deliveryman from Nashville, saw the head and purchased it for a quart of gin, a locally rare commodity since Wilson County was still a dry county at the time. Gilliam gave the head to his son, Willis, who told of his "stone Indian head" at the Nashville Children's Museum during a field trip to look at arrowheads. Upon request, the Gilliams loaned the piece to museum personnel for display in the old University of Nashville building. Several months later it was returned coated with plaster of paris from casting.

No systematic archaeological surveys of the farm have been conducted. However, several extensive Mississippian stone box cemeteries have been reported near the find spot, indicating the likely presence of small Mississippian settlements in the vicinity.

Statue CSS-006 (Figure 3.15). The head was created from a hard dark gray-brown siltstone and appears to have been broken from a complete statue (although efforts to discover other parts of the statue were fruitless). The broken edges appear to have been of some antiquity and show considerable wear, suggesting that the head was separated from the statue a considerable time prior to its discovery. Extrapolating from the basal break, the face would have been inclined backward, similar to other statues.

The head exhibits a raised hairline pointed at the temples. On the back of the compressed head is depicted a typical male hair knot, 1/2 inch in relief and generally 2 1/2 inches in diameter. The ears protrude with an unusual incised spiral design. The diamond- or almond-shaped eyes are in relief with an incised diamond in the right eye, but not in the left.

Beasley Mounds (40SM43) Statuary

The Beasley Mounds site and its vicinity have produced more stone statuary than any other area of comparable size in Tennessee. Unfortunately, Beasley Mounds is also one of the most poorly documented Mississippian mound centers in the Middle Cumberland region. Located near the western boundary of Smith County on a triangular projection of land at the confluence of Dixon Creek and the Cumberland River, the area has produced many intriguing but poorly documented artifacts since the late eighteenth century.

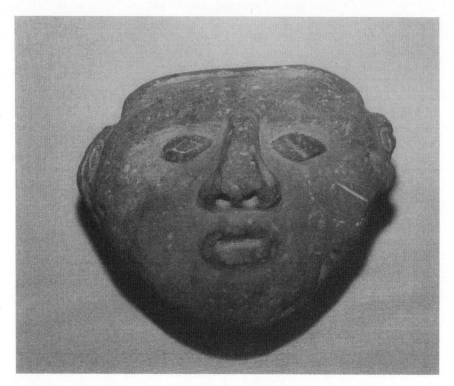

Figure 3.15. CSS-006.

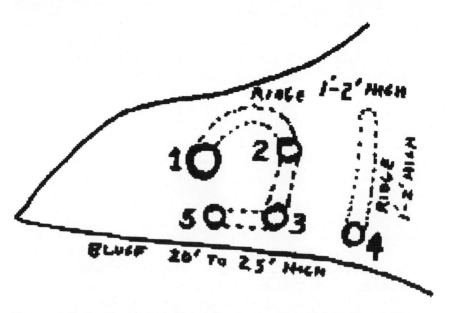

Figure 3.16. Beasley Mounds site (40SM43). Sketch map presumably by William E. Myer. Courtesy Smithsonian Institution, National Anthropological Archives, Washington, D.C.

William Edward Myer (1923a:397) provides the only available detailed description of the site prior to extensive cultivation and land-leveling activities (Figure 3.16). According to Myer, the Beasley Mounds site consisted of "one large mound and three smaller ones, and some ridges in the cultivated field. These are doubtless relics of the ancient fortifications. . . . There is a fine spring of never failing water about 300 yards from the large mound." Mr. Sam Stone Bush, an acquaintance of Myer who shared interests in transportation development and prehistory, excavated extensively at the site in 1895. His wife, Mary Allen, was born at Dixon Springs, providing his connection with the site (Kerr 1922).

Located 660 ft from the confluence of Dixon Creek and the river, the "village area" was dominated by a large mound 8 ft (2.5 m) in height and approximately 180 ft (55 m) in diameter. Bush excavated portions of this mound and identified several burials. Three hundred feet east of the main mound was a second mound, 3 ft (1 m) high and 125 ft (38 m) in diameter. To the south and southeast of these two primary mounds were three other smaller mounds 2 to 3 ft in height and averaging 100 ft in diameter. Along the eastern side of the village, between the river and the creek, were earthworks originally 4 to 6 ft in height. Toward the creek, Bush claimed to have observed remnants of the fortification with an opening, along with another small earthwork inside. Support for this observation is found in a brief description provided by Haywood (1823). Bush also noted nine low "elevations" about 125 ft (38 m) apart that may have been the bases of bastioned towers along the palisade (Myer 1923:398–410). Outside the fortifications were a steep bluff along the river, a large stone box cemetery, burial caves, and two small stone mounds. Small stone mounds have also been identified at the nearby Sellars and Castalian Springs mound sites, although their function remains undetermined. Unfortunately, no modern excavation data permit verification or amplification of the preceding information.

During his investigations, Bush recovered about "one dozen earthenware vessels," several pipes, and a quartz discoidal about 3 inches in diameter. Five vessels from the site illustrated in a period photograph include a variant of jars known to archaeologists as Matthews Incised variety Matthews. These types of decorated jars were generally produced between A.D. 1275 and 1425 in the Nashville Basin. Among the other pots illustrated is a compound vessel combining a bowl with notched appliqué rim strip and cylindrical neck bottle form. Compound vessels generally appear in post–A.D. 1325 phases in the Southeast. Although appearing infrequently earlier, bowls with notched appliqué rim strips peak in frequency during the post–A.D. 1325 phases in the Nashville Basin. While this small and unsystematic collection of mortuary artifacts probably does not reflect the full occupation span of the site, they do indicate that people were being buried at the site during the 1300s and early

1400s. Unfortunately, no modern detailed archaeological information is currently available.

In 1898, Rufus Taylor plowed up five statues and a head fragment at Beasley Mounds that were either donated to or purchased by William Myer (Myer 1923a:374). Myer described the statues and their discovery (numbers refer to Myer's personal catalog):

> No. 523, 14 inches in height, was standing upright, with the head so near the surface that the plow struck it under the chin. It was about thirty feet west of the base of Mound No. 1. Images Nos. 524 and 521 were found about 30 feet north of 523. 524 was standing upright, within 8 inches of the surface of the soil. No. 521 was about 5 feet from No. 524; it was lying on its side, and within 6 or 8 inches of the surface of the soil. Nos. 520 and 522 were found within 10 or 15 feet of 523. No. 520 is 12 inches in height. The head, no. 525, was ploughed up about 50 feet from 523. A careful search was later made for the body belonging to the head, 525, but so far we have never been able to find it [Myer 1923a:374–375].

The Bureau of American Ethnology purchased four of these statues (CSS-010, CSS-011, CSS-012, and CSS-013) from Myer's widow in January 1927. The disposition of the fifth statue and the head fragment is unknown. Unfortunately, Myer's original catalog numbers do not appear to have been accurately transmitted to the bureau with the artifacts in 1927, so we cannot confidently match individual statues with Myer's locational descriptions (for example, the Smithsonian catalog cards for both CSS-010 and CSS-012 record the original number as "522"). Some "educated speculation" outlined below suggests the possibility that the missing statue is No. 523.

Despite the uncertainties about which statue belongs with which number, the description clearly suggests that all six of the Rufus Taylor statues and fragments were found within an approximately 50-ft–diameter area located some 30 ft west of the primary platform mound. In fact, the five large statues and fragments were discovered within a 30-ft–diameter area, presumably not far from their original burial spot. The smaller head fragment is more likely to have been displaced as a result of plowing. While impossible to determine, these dimensions could potentially reflect a large public building similar to that proposed for the Sellars site.

A seventh statue (CSS-014) in Myer's collection was also plowed up at Beasley Mounds sometime prior to 1923. According to Myer, "our no. 602 . . . was also ploughed up in this old field. It was presented to the author by his friend, Mr. Joseph Eason. The exact spot in this field where 602 was ploughed up is not known" (Myer 1923a:375).

Statuary Pair CSS-010 (Figures 3.17, 3.18) and CSS-011 (Figures 3.19, 3.20). Statues CSS-010 and CSS-011 share several similarities that suggest a pair created by the same sculptor. CSS-010 exhibits substantial plow damage on the face and upper head (including obliteration of the nose), suggesting the possibility that it was sitting upright with the head near the surface. The eyes are depicted in relief while the open mouth and ears are executed in detail. The face is inclined backward and the back of the head exhibits both cranial flattening and the typical male hair knot. The rest of the statue shows little detail, and is out of natural proportion to the head. The hands are represented on the knees in simple sculpting, and the feet are not represented. The spine is incised and extends to the base between the buttocks.

CSS-011 shows less damage on the upper head and face from the plow but more on the left side of the torso, the lap, and the chest, suggesting the possibility that it was lying on its side. The head and body are similarly disproportionate with little bodily detail other than an incised spine and buttock treatment similar to CSS-010. The head, showing backward inclination and cranial flattening, has an elongated (female?) hair knot on the back of the neck. While the data are far from conclusive, evidence from the plow damage on these two statues could match the description provided for Myer's number 521 and 524, found about 5 ft apart with one sitting upright and the other lying on its side. CSS-010 matches the "14 inches" described for Myer's No. 523, but lacks signs of having been struck beneath the chin by the plow.

Statue CSS-012 (Figure 3.21). The headless torso of CSS-012 leans forward much like Sellars CSS-001. Most of the chest and left arm are destroyed, and the bodily detail is simple, showing only the hands on the knees of legs that appear to be in a lotus position. Given the general configuration of the lower torso, the statue probably depicted a male. Again, while the conflicting information is difficult to sort out, the height of CSS-012 is the closest match in the surviving four statues to the "12 inches" described for Myer No. 520.

Statue CSS-013 (Figure 3.22). The second headless statue (CSS-013) shows the unusual trait of arms sculpted separate from the body (with most of the left arm broken away). The hands are shown on the knees, which are separated to expose detailed female genitals. Nipples are shown in relief. The base has a somewhat strange appearance with protruding masses on the sides that presumably depict legs turned beneath the body. The back is flat and without detail. To stretch our educated guesswork even a bit further, CSS-013 seems to correspond best with Myer's No. 522.

Statue CSS-014 (Figure 3.23). The headless figure found by Joe Eason exhibits only a few distinct features, including crudely sculpted arms and hands along with a broadly incised line separating the buttocks. Similar to CSS-013

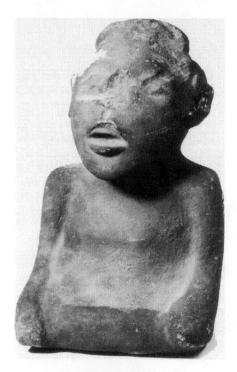

Figure 3.17. CSS-010, front view. Smithsonian Institution, Department of Anthropology, Washington, D.C., 87-13490.

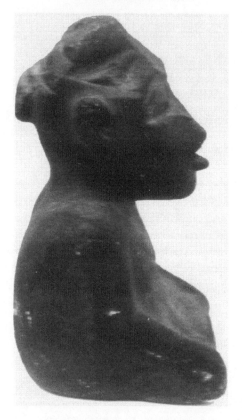

Figure 3.18. CSS-010, profile view.

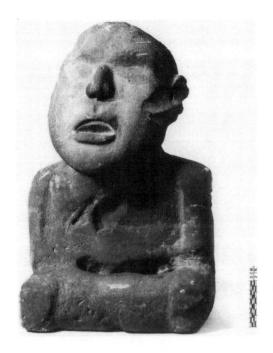

Figure 3.19. CSS-011, front view. Smithsonian Institution, Department of Anthropology, Washington, D.C., 87-13492.

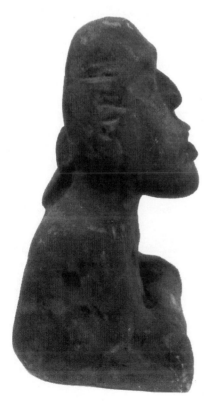

Figure 3.20. CSS-011, left profile.

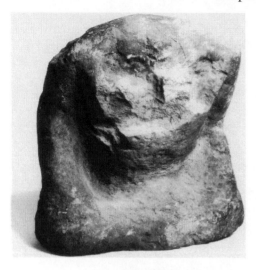

Figure 3.21. CSS-012. Smithsonian Institution, Department of Anthropology, Washington, D.C., 87-13493.

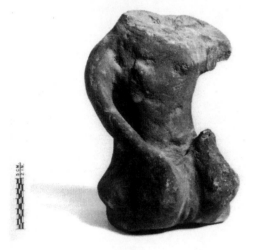

Figure 3.22. CSS-013. Smithsonian Institution, Department of Anthropology, Washington, D.C., 87-13485.

but rare on the Tennessee statues, the upper arms were sculpted separated from the body. The wrists exhibit knots above blocky hands. Incised lines on the hands appear to represent an uncharacteristic depiction of eight fingers on the right hand and six on the left. However, these lines do not exhibit the same pattern of weathering as the rest of the statue, and we believe they are a relatively modern addition. In the absence of these incised fingers, the blocky hands would be more in keeping with the rest of the details on the statue (and would be similar to CSS-013). The absence of nipples or breasts is suggestive of a male statue, although the placement of the hands is somewhat uncharacteristic for male statuary.

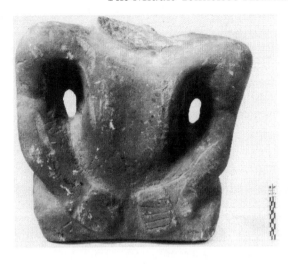

Figure 3.23. CSS-014. Smith-
sonian Institution, Department
of Anthropology, Washington,
D.C., 87-13494.

A Misplaced Trio? (CSS-015, CSS-016, CSS-017)

The provenance of three statues examined in our survey has often been pub-
lished as Kentucky, but our research suggests that all three probably origi-
nated in Smith County, Tennessee. Although we cannot tie all three specifi-
cally to the Beasley Mounds site, we suspect that they either came from this
chiefdom center or a nearby related settlement.

In 1898, Thomas Wilson published a nearly 350-page examination of
"Prehistoric Art" in the Annual Report of the U.S. National Museum, in-
cluding a discussion of prehistoric sculptures and numerous illustrations of
stone statues. The caption of Plate 46 reads "Three Stone Statues. Kentucky.
Originals in Louisville Public Library. Casts, Cat. Nos. 30251-52, 61259,
U.S.N.M. 1/4 natural size." The text (Wilson 1898:472) reads: "Plate 46
shows three stone statues, all of which are represented in the United States
National Museum by casts. The originals (Cat. Nos. 30251, 30252, U.S.N.M.)
are in the Louisville Public Library. They are of sandstone and were found
within the state, the precise locality being uncertain. The third statue (Cat.
No. 61259, U.S.N.M) is from the same general locality, but, like the former,
the details concerning its finding are unknown."

In 1910, Colonel Bennett H. Young published a lengthy examination of
Kentucky prehistory including a discussion of the "images and idols" found
in the state. He reported that:

> The best three of these [Kentucky stone images] were in the Louis-
> ville Public Library, and if they have not been lost they are mislaid, so
> that they could not be found for purposes of photographing. The pre-
> cise locality of their discovery is uncertain, and the details of their find-

ing have now been lost. . . . It is a source of great regret that these have been lost to public exhibition. It is hoped that they may yet be restored to their original place in the Louisville Public Library. . . . The illustrations on page 263 are not satisfactory representations of the originals. They were made from halftones of casts in the United States National Museum [Young 1910:267].

The caption of Young's illustration (1910:263) reads: "Three Stone Images from Kentucky. Made from plate in Doctor Thomas Wilson's 'Prehistoric Stone Art.'" Many subsequent publications relying on one or both of Wilson (1898) and Young (1910) have reiterated the Kentucky provenance of these three statues.

The statue designated CSS-017 in our survey is the leftmost of the three illustrated in the Wilson and Young plates. According to the catalog card on file at the Smithsonian Institution, it was not sent for casting by the Louisville Public Library but rather by the Tennessee Historical Society in 1883. An illustration of CSS-017 appeared in Thruston's *Antiquities of Tennessee* in 1897 (Plate IV). He indicates that the "idol" was "in the collection of the Tennessee Historical Society" and "is from Smith County" (Thruston 1897:104). Myer (1923a:516) further indicates that CSS-017 originated "either at or not far from the fortified town at the mouth of Dixon's Creek." Unfortunately, CSS-017 now has the questionable honor of having not only vanished from the Tennessee Historical Society collections, but also from the collections of the Louisville Public Library where it probably never resided.

The remaining two statue casts featured in the Wilson and Young plates (CSS-015 and CSS-016) achieved their Kentucky provenance more honestly— but still in probable error. During the early 1800s, a Dutch geologist named Gerard Troost taught at the University of Nashville and was one of the earliest collectors of aboriginal artifacts in Middle Tennessee. His collection drew national attention and included a number of stone statues from the region. In an article in the *Transactions of the American Ethnological Society* published in 1845, Troost describes the statues in his collections and includes "drawings made of them by Mr. Heiman, in which they are perfectly represented" (Troost 1845). One of these is clearly the original for one of the casts (CSS-016) at the Smithsonian (Troost 1845:362). Troost notes that "two of these images, a male and a female, are the largest I have seen, being sixteen inches high; they were found in Smith County" (Troost 1845:361–362). Although it is unclear whether he is simply citing from Troost's publication, Joseph Jones also comments on the Smith County origin: "Two of these sandstone images found [by Dr. Troost] in Smith County, representing a male and female, were sixteen inches in height" (Jones 1876:135).

After Troost's death, at least part of his collection was sold in 1874 to the

Louisville Polytechnic Society in Kentucky, which exhibited them in the museum of what was then known as the Louisville Free Library (Rooker 1932:11). In 1877, the library sent three statues from their collection to the Smithsonian for casting (CSS-015, CSS-016, CSS-028). The incorrect provenance of Kentucky became loosely attached to the figures at that time. We are confident in identifying the source of CSS-016 and CSS-017 as Smith County, Tennessee. While the identification of CSS-015 as the male of Troost's pair is less confident since he did not illustrate it, the size and other characteristics suggest that it was part of a male-female pair with CSS-016.

Statuary Pair CSS-015 (Figures 3.24, 3.25) and CSS-016 (Figures 3.26, 3.27). Both CSS-015 and CSS-016 exhibit a facial inclination of 25 degrees, protruding ears, oval lips in relief, a straight hairline with a hair roll and a hair knot on the flattened occiput. The male (CSS-015) exhibits crudely sculpted hands on the knees. The knees are displayed on either side in a rare male seating position, apparently designed to allow depiction of the male genitals. Troost wrote that the statue "seems to be a rude imitation of an ancient Priapus" because of the exaggerated erection (Troost 1845:362). Troost noted that the plow had struck and "broken a large *membrum generationic virile in erectione,*" the chin, and the end of the nose. The base of the genitals remains, but the implied length of the penis is uncertain, since the person who plowed it up apparently retrieved the "shattered remains . . . [but] . . . considered it too indecent to be preserved."

The mate, CSS-016, did not suffer as much plow damage, with scars only on the right breast and the lower abdomen. Based on the location of the plow damage, the figures appear to have been buried on their backs. CSS-016 is depicted kneeling with more finely sculpted hands on her knees. Her breasts are unusually prominent and the collarbone is also depicted. Two unique features are the ears and the mouth. The protruding ears are shaped like the figure 8 with an incised interior 8, similar in many respects to the Etowah statues (CSS-059, CSS-060). The mouth is in oval relief with a second oval surrounding a central depression separated from the outer by an incised circle. An elongated hair knot with a narrow pierced middle is located on the flattened occipital region. In addition, she exhibits a pointed hairline at the temple. On the back, shoulder blades are in relief, while an incised line defines the buttocks.

Statue CSS-017 (Figures 3.28, 3.29). Several unusual features are represented on CSS-017. A horizontal 8 seems to surround the prominent nipples, but upon closer examination, it appears to represent the collarbone at the top (similar to Castalian Springs CSS-008) and the lower rib cage on the bottom. These two features frame the protruding abdomen that appears to indicate pregnancy. Thin arms emerge from stooped shoulders and end in small hands exhibiting incised fingers and a horizontal incised line across the

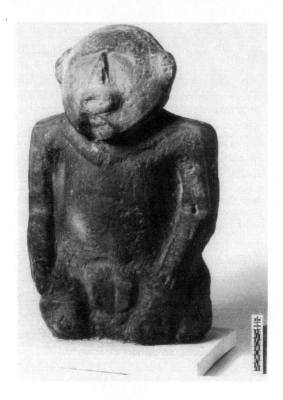

Figure 3.24. CSS-015, front view. Smithsonian Institution, Department of Anthropology, Washington, D.C., 83-9346.

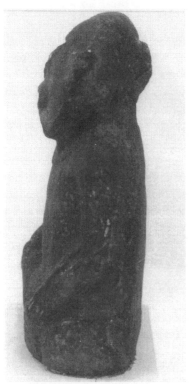

Figure 3.25. CSS-015, right profile.

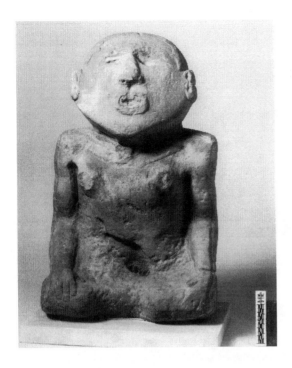

Figure 3.26. CSS–016, front view. Smithsonian Institution, Department of Anthropology, Washington, D.C., 83-9348.

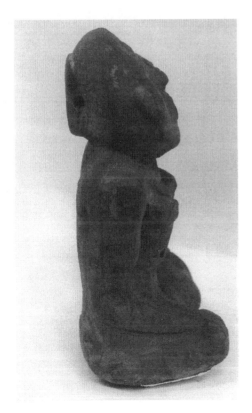

Figure 3.27. CSS–016, left profile.

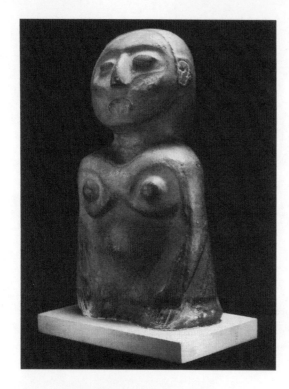

Figure 3.28. CSS-017, front view. Smithsonian Institution, Department of Anthropology, Washington, D.C., 89-1963.

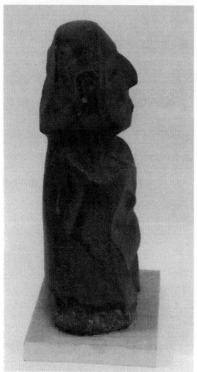

Figure 3.29. CSS-017, left profile.

knuckle region. The figure is kneeling with the hands on the knees. A hawk-like nose, pronounced eyebrows, eyes in relief, prominent cheekbones, and an oval mouth dominate the face, which is slightly inclined backward. Details of the ears are indicated by incised lines. The hairstyle seems to be a hair roll with a straight hairline. The back of the flattened head appears to have been struck by the plow, and thus the presence or absence of a hair knot cannot be determined.

Martin Farm/Riddleton Statues

While the majority of the statues in our survey were discovered at sites containing mounds (and presumably associated public buildings), others seem to have been buried at nearby settlements without mounds. The Martin Farm or Riddleton pair (CSS-018, CSS-019) is a good example.

In 1905, Ernest Henry "discovered" a pair of sandstone images with a mule team on the Jennie Cage Martin farm. Henry hit the male on the front with his plow, buried about six inches beneath the surface. After identifying it, he found a stick in the nearby woods, and began to probe for other artifacts. His efforts produced the female that had also been struck on the front, suggesting the pair were buried either seated facing toward the plow or on their backs. However, the pattern of plow damage tends to suggest they were lying on their backs. Bones, teeth, and projectile points were also found (*Carthage Courier* 1972), but no evidence of a human grave or burial was identified.

According to Jane Whitley, Henry was later killed in an accident and the statues passed to his sister, Lucille Henry Wilburn. The female was sold to William Myer for $50 and a shotgun and eventually was sold by his widow in 1927 to the Smithsonian Institution. The male, nicknamed "The Head," remained in use as a doorstop by the Wilburn family for many years, but was eventually sold to a private collector.

Myer provides the only known description of the site:

> About two miles up Cumberland River from the old town at the mouth of Dixon's Creek is a small village site on the land of Mrs. Martin and an adjoining farm. Here the soil shows the usual black earth and decayed mussel and periwinkle shells found on village sites. Nearby are a few stone slab graves, where the bodies were buried at full length. In a cache on this village site were found two images. One of these is our No. 519, 13 inches in height. . . . These two images were found side by side about 6 inches underneath the surface of the soil, and were brought up by the plow. They were wrought from sandstone [Myer 1923a:377].

While no professional archaeological investigations provide additional information on this site, it is possible and even likely that this "small village" lo-

cated only about 4 miles from the Beasley Mounds site was within the sphere of influence of that chiefdom center during its occupation.

Statuary Pair CSS-018 (Figures 3.30, 3.31) and CSS-019 (Figures 3.32, 3.33, 3.34). These two statues were discovered together, supporting the hypothesis that statues were often created as male-female pairs. Both statues have identically detailed ears, incised almond eyes in slight relief, and open lips with a protruding tongue. Both lack any indication of a hairline. The similarities in multiple details of sculpting also strongly suggest that these two statues were created by the same individual.

The face of the male, CSS-018, is inclined backward at a 30-degree angle, and exhibits a fold of skin beneath the chin. The male hair knot includes an incised counterclockwise spiral to indicate the method of twisting the hair into a projecting knot. His legs, right over left, are sculpted on both the top and the bottom. Hands with wrist knots in relief grasp the thighs just above the knees. In profile, the chest is thrust forward and the waist is indicated across the back.

Unlike the male of the pair, CSS-019 exhibits details only on the head. Breasts are vaguely indicated, but the legs and hands are simply blocked in, and only the arms are identifiable. The base exhibits no details. The elongated hair knot extends from the middle of the head to the back of the neck. Similar to the male, there is an indication of the waist on the back.

Castalian Springs (40SU14) Statues

Castalian Springs is the largest of the four Mississippian mound centers on the eastern periphery of the Nashville Basin of Tennessee. Similar to most of the major Mississippian period mound centers in the eastern portion of the Nashville Basin, the site is located several miles from the Cumberland River on a large upland creek terrace. Selection of these locales was probably influenced by a number of factors, including the poorly developed terrace system of the Cumberland River through this section, about 80 acres of creek bottomland and terrace along Lick Creek, a series of mineral springs along the interface of the Nashville Basin and Highland Rim, and a potentially preexistent native trail system (Myer 1928b; Smith and Moore 1996).

Castalian Springs was a large and complex Mississippian mound center with fortifications enclosing approximately 16 acres (Figure 3.35). Within the earthworks was a large platform mound (200 ft in length by 11 ft in height) with flat-topped conical addition (22 ft in height and 90 ft in diameter). To the south and slightly west of the principal mound, the (probable) plaza was flanked on the west by another large platform mound (Mound 3—90 ft in diameter and 7 ft in height). A large burial mound (120 ft in diameter and 8 ft in height) bounded the eastern edge of the presumed plaza. Outside the earthworks to the south and southwest were a series of mineral springs and an additional stone mound (Mound 4—60 ft in diameter and 5.5 ft in height) on

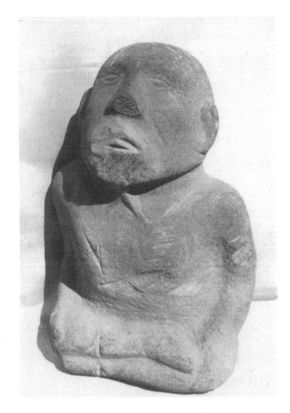

Figure 3.30. CSS-018, front view.

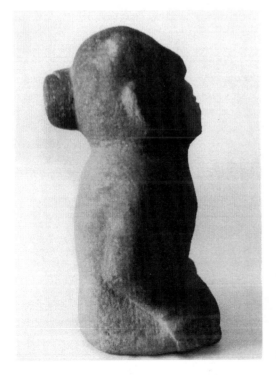

Figure 3.31. CSS-018, left profile.

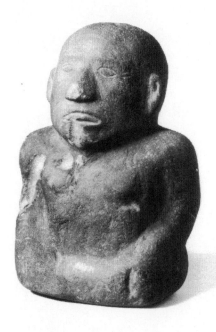

Figure 3.32. CSS-019, front view. Courtesy Smithsonian Institution, Department of Anthropology, Washington, D.C., 87-13491.

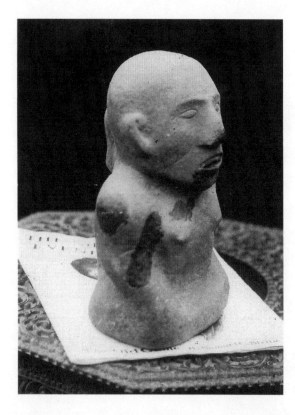

Figure 3.33. CSS-019. Photograph presumably by William E. Myer. Courtesy Samuel D. Smith.

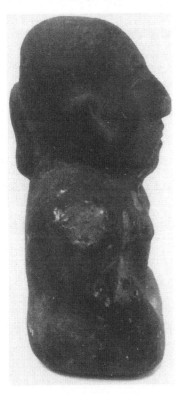

Figure 3.34. CSS-019, left profile.

the bank of Lick Creek. The hillsides surrounding the palisaded enclosure included several presumably associated stone box grave cemeteries and a small (possible) mortuary cave. Adjacent creek drainages have also yielded evidence of scattered stone box cemeteries, mortuary caves, and other features that may be contemporaneous with occupation of the Castalian Springs site.

While modern archaeological investigations at Castalian Springs did not begin until 2005 (Smith and Beahm 2006), the site has long been recognized as a significant participant in the Mississippian interaction sphere. The site was first described in detail by Ralph E. W. Earl, a prominent artist who conducted rather substantial digging at the site in about 1820. Earl's description of the village plan for the site was extensively quoted in *Natural and Aboriginal History of Tennessee* (Haywood 1823). According to the description, the site consisted of a round palisade with bastioned towers enclosing a 16-acre area, including a large mound with an unusual raised platform, several domiciliary mounds, and a large burial mound.

In 1891, William Myer conducted the first of three excavations at the site, returning in 1893 and the winter of 1916–1917 (Myer 1894; 1917; 1923a). Although Myer produced a summary report (Myer 1894) of his investigations, additional primary data can be found in his unpublished manuscript

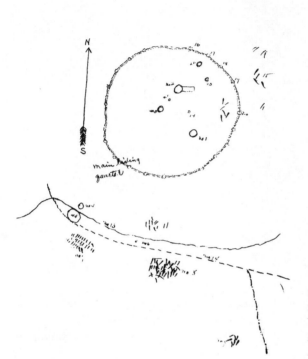

Figure 3.35. Castalian
Springs site (40SU14).
Sketch map presumably by
William E. Myer. Courtesy
National Anthropological
Archives.

Stone Age Man in the Middle South. The manuscript included a lengthy sec-
tion on the Castalian Springs site, but Myer's death in 1923 prevented its
completion. Although few details have previously been published on the site,
Castalian Springs has nonetheless played a prominent role in discussions of
the chronology of shell gorgets and the Southeastern Ceremonial Complex.
The five gorgets in the Braden A/Eddyville, Cox Mound, and Nashville/
Springs styles recovered from Burial 34 in 1891 by William Myer are fre-
quently cited as a critical assemblage in interpreting chronology. Phillips and
Brown (1978:181) describe the grave lot containing these gorgets as "about
as close an archaeological association as it would be possible to invent." Brain
and Phillips (1996:253) further suggest that this assemblage was "the single
most valuable grave lot, not only at Castalian Springs but in our entire study
of gorget distributions."

The discovery of the first Castalian Springs statue must have occurred after the first permanent settlers arrived in 1799 and before 1823, when Haywood first described statue CSS-007. Although Haywood averred that the figure was "plowed up" on top of the main mound (Haywood 1823:120), he may have been referring to the raised platform attached to the main mound. According to local informants, on the one hand, the summit of the conical portion of the primary mound was not successfully plowed until the modern era. On the other hand, the large flat-topped platform attached to the mound has been plowed for many decades and has often been described as part of the "main mound." In his 1909 description of what appears to be the same statue, Edward Albright indicated that "it was not taken from the mound above described, as has been alleged, but was ploughed up from a neighboring field" (Albright 1909:7).

A second statue was apparently plowed up at Castalian Springs in the summer of 1888. The head and upper torso of statue CSS-008 was acquired by Dr. John E. Younglove of Bowling Green, Kentucky, who loaned it to the Smithsonian Institution on November 21, 1888, through Tiffany and Company of New York City. After exhibition at the Tennessee Centennial Exposition held in Nashville in 1897, W. V. Cox returned the artifact to Dr. Younglove. In 1890, Gates P. Thruston stated that the figure had been plowed up "near the earthworks and stone graves of Castalian Springs" (Thruston 1890:104), although the Smithsonian catalog card indicates only that it was from "a mound in Tennessee." Based on Thruston's statement, the most likely area of recovery was from "the Bottom," the habitation area between the fortifications and Lick Creek, where several other presumed high-status artifacts have been recovered, including the engraved Eagle Warrior stone found at about the same time as the statue (Myer 1923a:256).

The discovery location of a third statue (CSS-009) provides some support for the notion that all three might have been recovered from the Bottom. William Rufus Anglea (pronounced "angel") was a woodworker and coffin maker and had a shop on the western edge of the Castalian Springs village east of the Wynne property. Anglea is known to have collected artifacts from the habitation area, including the Eagle Warrior stone given to Myer in 1891. His son, "Rube," continued the family tradition.

An avid fisherman, Rube passed through the Bottom on his way to local fishing spots and always carried an artifact bag with him. George Wynne, the last private owner of the log stagecoach inn called Wynnewood, stated that Rube found the statue across the creek in the Bottom (Wynne 1973). Since Anglea gave the statue to the Wynnes, it can be inferred that it was found on their property, which included the main spring but not the area of the fortified village. Although the date of discovery cannot be specifically determined, the statue apparently surfaced after Myer's death in 1923, since Myer

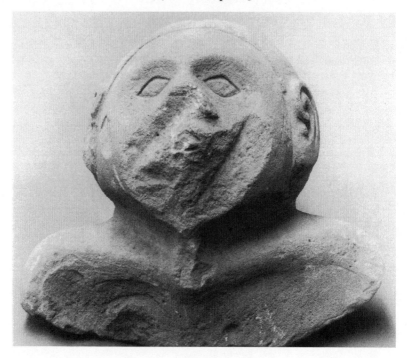

Figure 3.36. CSS-008. Courtesy Smithsonian Institution, National Museum of the American Indian, Washington, D.C., Catalog #3/5337. Photograph by David Heald.

was well acquainted with Anglea but did not mention the statue in any of his works. From this information, it appears possible that both CSS-008 and CSS-009 were recovered from the habitation area outside the fortifications, as suggested by Thruston.

Statue CSS-008 (Figure 3.36). CSS-008 shows damage caused by the plow, especially to the lower face and nose. Only a small portion of the incised mouth remains, and the chin is also missing. The eyes are diamond shaped and in relief, while the ears are executed in details remarkably similar to those of the Sellars statues CSS-002 and CSS-003. Other similarities include the straight hairline with a center part, and the fold of skin beneath the chin, a portion of which remains. Two-thirds of the elongated hair knot on the back of the neck is missing. Distinct characteristics of the statue are the depiction of the breasts. The distinct collarbone and portions of the breasts are similar to those on CSS-017 from neighboring Smith County.

Statue CSS-009 (Figure 3.37). CSS-009 is sculpted in a kneeling position with the right knee raised, the right foot forward, and the left knee on the ground with the foot beneath the buttocks. The left hand is shown on the knee with a wrist knot in relief. The right hand is missing, but appar-

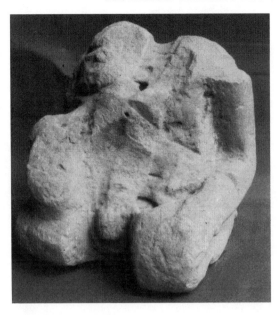

Figure 3.37. CSS-009.

ently rested on the right knee, as indicated by the position of the arm. The right foot is not sculpted in detail, but the partially damaged groin area depicts what might represent male genitals.

Unlike the fine-grained stone of the statues from Sellars, the Castalian Springs pair are of much coarser siltstone, possibly hampering the sculptor from depicting refined details. CSS-009 shows some erosion at the top in addition to the plow damage. Extrapolating from the proportions of the Sellars statuary, CSS-009 appears to have been approximately 18 to 20 inches in height, while the female would have been 16 to 17 inches in height. Although the precise relationship of the two pairs cannot be determined, their stylistic kinship is difficult to deny.

Statue CSS-007. The current whereabouts of CSS-007 is unknown, and no illustrations of the statue have yet been discovered. However, from the written descriptions, it appears to have exhibited most of the common characteristics of the Tennessee-Cumberland style statuary. Haywood described the statue in some detail:

On one cheek was a mark resembling a wrinkle passing perpendicularly up and down the cheek. On the other cheek were two similar marks. The breast was that of a female, and prominent. The fact was turned obliquely up towards the heavens. The palms of the hands were turned upwards before the face, and at some distance from it, in the same direction that the face was. The knees were drawn near together,

and the feet, with the toes towards the ground, were separated wide enough to admit of the body being seated between them. The attitude seemed to be that of adoration. The head and upper part of the forehead were represented as covered with a cap, or mitre, or bonnet; from the lower part of which came horizontally a brim, from the extremities of which the cap extended upwards conically. The color of the image was that of a dark infusion of coffee. If the front of the image were placed to the east, the countenance—obliquely elevated—and the uplifted hands in the same direction would be towards the meridian sun [Haywood 1823:123–124].

Haywood's description of the position of the hands and arms is somewhat difficult to decipher, but the other details would seem to match other statues known from nearby sites. In his *Early History of Middle Tennessee*, Albright provides what may be a second discussion of this statue: "Near the door of a storehouse at Castalian Springs there lay for many years the carved sandstone image of a human form. This was about two feet in length, the arms of which, though partially broken off, seemed to have been raised in supplication. The shape of its head and the expression of its rude features were foreign, being entirely unlike those of the Indians. It was probably an idol once used in some form of heathen worship. It was not taken from the mound above described, as has been alleged, but was ploughed up from a neighboring field" (Albright 1909:6–7).

The description shows some clear similarities to that of Haywood, and we have assumed herein that both descriptions are of the same statue. Neither description can possibly refer to either of the two known statues from Castalian Springs, so we have assigned a survey number to it in the hopes that additional information will be available in the future. Myer does not mention this statue in his thorough review of significant artifacts collected from Castalian Springs. Given this fact, we can only speculate that this statue vanished sufficient years before the 1890s that Myer's local informants had forgotten of its existence.

Statue CSS-069 (Figure 3.38). In *Antiquities of Tennessee,* Thruston illustrated a statue from the Tennessee Historical Society collections reportedly originating in Trousdale County (Thruston 1897:Plate IV). Society records indicate that it was found "in an Indian Grave" near the Castalian Springs site and donated in June 1890 by Colonel Thomas Boyer Jr. of Gallatin (Tennessee Historical Society Minutes, June 10, 1890). Although the Castalian Springs site lies in Sumner County, the border with adjacent Trousdale County lies only 2 miles to the east. Since the statue has since vanished from the society collections, we could not examine it. Stylistically, the details seem more in keeping with the North Georgia region than Middle Ten-

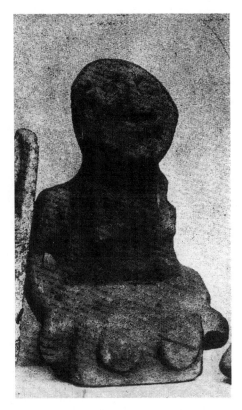

Figure 3.38. CSS-069 (Thruston 1897: Plate IV).

nessee. Ten years earlier before the "discovery" of CSS-069, Statue CSS-056 from Etowah was exhibited by the Tennessee Historical Society in Nashville. The purported Tennessee statue appears to be a cruder replica of that statue. Although we suspect that it was a modern replica, we do not deny the possibility that it was produced by a Mississippian sculptor.

Harpeth River Statuary

In addition to the statues found concentrated in and around the major mound centers of Sellars, Castalian Springs, and Beasley Mounds, two and possibly three additional statues have been recorded from the Harpeth River, a tributary of the Cumberland draining the southwestern half of the Nashville Basin.

The Brentwood Statuary (CSS-030, CSS-031)

Until recently, the statue CSS-031 was thought to have been discovered on the Brentwood farm of Dr. W. H. Jarman, who donated the statue to the

Tennessee Historical Society: "in 1883 a roughish stone image was found on the farm of Dr. W. H. Garman [*sic*], seven miles from Franklin, Williamson County. This is the image of a person sitting with limbs drawn close to the body and hands upon knees, and with the features resembling somewhat the supposed appearance of the Mound Builders. This image is now in possession of the Tennessee Historical Society at Nashville" (Goodspeed et al. 1887:54). Historians generally consider the accuracy of the Goodspeed publications to be highly variable since the information (submitted by private contributors) does not appear to have been subject to any sort of journalistic or editorial verification. Evidence in support of this particular passage, however, was an antiquarian photograph of the stone statue from the Tennessee Historical Society collections (Thruston 1897:102–103; Plate IV; also see Hudson 1985:36). Thruston indicates this statue was discovered in Williamson County by a "Dr. Frost."

Given that the Jarman house was built atop a large Mississippian town now known as the Jarman Farm or Brentwood Library site (40WM210), there was little reason to reject the assertion that CSS-031 was discovered at this locale until a 2002 research trip to the Peabody Museum of Archaeology and Ethnology at Harvard University (Smith and Moore 2005).

At Dr. Jarman's invitation, Frederic Ward Putnam directed excavations at his farm in 1882. Included with Putnam's unpublished field notes were plan and profile sketches of a stone statue recovered by Dr. Frost. Of considerable importance is that these sketches illustrate the Tennessee Historical Society statue pictured in Thruston. More importantly is the notation accompanying the sketches: "Image of grey sandstone found by Dr. Frost near Brentwood while plowing his field 1881. Another similar image was ploughed up in his field a few years before" (Putnam Field Notes 1882; Accession File 82-35E, Folder 2, Peabody Museum Collections Department, Harvard University).

Putnam's notes also provide general dimensions for this particular artifact—12.5 inches high, 6.0 inches wide across the shoulders, and 7.5 inches wide at the base. William Myer (1923b:135–136) provides an additional reference to Dr. Frost in a brief passage: "Graves 2 miles southeast of Brentwood on farm known as Dr. Frost's place," in his unpublished catalog of Tennessee prehistoric sites.

The Putnam and Goodspeed accounts differ in both the year and location that the image(s) were found. Putnam's 1882 information was obtained shortly after the image discovery, and he must have viewed the image in person to draw the front and side sketches. Putnam states that by 1881 two (similar) stone statues had been discovered near Brentwood, and that Dr. Frost found both stone images (several years apart) in his (Frost's) field. The 1878 D. G. Beers map of Williamson County shows the estate of Dr. S. B. Frost to be about 2 miles northeast of the Jarman Farm.

The Goodspeed text, in contrast, indicates that one stone image was found in 1883 on the Jarman (misspelled Garman) farm. In addition to the later date, there was no mention of a second image. Given the relatively close proximity of the Frost and Jarman estates, the (unknown) source of the Goodspeed information may have misunderstood the true location of the find. Putnam's direct experience with the image along with his academic training, credentials, and reputation must be held in higher standing that the secondhand account in Goodspeed. Although inaccurate, the Goodspeed passage did serve a useful purpose in drawing attention to the fact that the stone statuary had been recovered in the area.

Although no hard evidence can currently be mustered, stylistic similarities suggest that the most likely candidate for the second statue from the Frost farm is statue CSS-030. By the late 1860s, CSS-030 had been discovered somewhere in the "valley of the Cumberland" and acquired by Joseph Jones. While none of Jones's publications identify the find spot more precisely, the numerous similarities of CSS-030 and CSS-031 suggest they were probably created by the same artisan and constituted a statuary pair. Jones directed excavations at numerous nearby sites along the Harpeth River, providing some additional indirect support for this interpretation.

While not directly pertinent to the Brentwood statuary, we would be remiss not to include a mention of a discovery by William Myer at the mound center of Fewkes (40WM1). Located only a few miles from the Frost farm, Myer investigated Fewkes in October 1920 under the auspices of the Bureau of American Ethnology. The site was named in honor of Dr. J. Walter Fewkes, director of the Bureau of American Ethnology, after his visit to Nashville (Myer 1928a:559).

During his excavations of Mound 2, Myer uncovered portions of a structure or structures on the summit of the earliest mound construction stage. In the southwestern portion of the mound, he

came upon the ruins of a structure to which we have given the name of Sacred Image House. This was a very small building, and apparently of great sanctity. Here were found traces of what was probably an ancient sacred image or idol, the remains of their sacred maize and maize meal, a peculiar arrangement of stones probably belonging to a shrine, and traces of some of their ancient fire ceremonies . . .

In what appeared to be the north wall of this structure was a rectangular Cavity . . . it measured 10 inches across the top, 14 inches in height, 10 inches across the bottom, and was 3 1/2 inches deep . . . there was a layer of mingled ashes, charcoal and earth immediately below this Cavity, and also undisturbed layers of ashes just above the top of the cavity. The photograph shows faint traces of these undisturbed layers

of ashes immediately over this cavity, showing clearly that the wooden object which caused the formation of this cavity was placed in the wall before the stratified and undisturbed ash beds were formed above it. Therefore it is not of white-man origin. It belongs to the first stage of the mound. Both the diagram and the photograph show very clearly that this wooden object was in the line of wall. It was, beyond question, an object of importance, and was placed in a prominent place. . . . A plaster cast was made of a portion of the cavity and the decayed wood therein, which proved to be red cedar, was saved. The size and shape faintly suggest an image or idol with a rectangular base, somewhat similar to the wooden image found in Bell County, KY., formerly in the collection of Col. Bennett H. Young, and now in the Museum of the American Indian. From the accounts of early white visitors to the southern tribes of the Mississippi Valley it is known that such images were often placed in somewhat similar positions on the sides of the walls of sacred structures [Myer 1928a:564–565].

Whether this represents one of Myer's imaginative interpretations or the actual remains of a wooden statue is difficult to assess. However, Myer's detailed description and familiarity with a number of statues lends some credibility to the discovery.

Statuary Pair? CSS-030 (Figure 3.39) and CSS-031 (Figure 3.40). Sculpted from sandstone, CSS-030 exhibits large oval eyes, a prominent (damaged) nose, ears and mouth in relief with interior detailing, and a straight hairline in relief. The statue exhibits a depressed abdomen with arms and legs indicated primarily by deep grooves. A probable penis is shown in shallow relief. A hair roll and pigtail reminiscent of the Sellars male (CSS-003) is indicated but without the buns on each side. Broad shoulders are shown, with plow damage on the left side and rear.

Sculpted from the same type of stone, CSS-031 shares almost identical facial features, including large oval eyes, prominent nose, mouth in relief with incised straight openings, a straight hairline in relief, and ears in relief with identical interior detailing. Both share depressed abdomens, while the arms and legs are indicated on the sides by deep grooves. Unlike CSS-030, CSS-031 exhibits nipples. The female has a typical elongated hair knot on the compressed occiput. The final distinction is that the female has narrow shoulders in contrast to the broad shoulders of CSS-030. Plow damage is most severe on the female, whose head was severed and several segments broken. Both seem to display plow damage to the same regions of the body, the left side and rear, indicating that they may have been buried together. If CSS-031 does represent a female, it is the only female statue to exhibit the raised right knee.

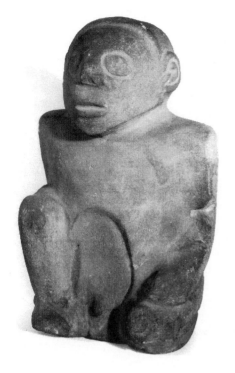

Figure 3.39. CSS-030. Courtesy Smithsonian Institution, National Museum of the American Indian, Washington, D.C., Catalog #7227.

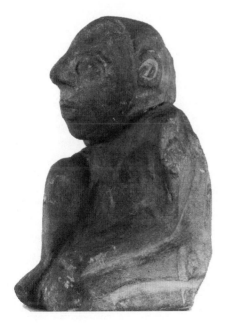

Figure 3.40. CSS-031. Courtesy, Tennessee State Museum.

Mayfield Station Statue? (CSS-029)

A third possible statue (CSS-029) also appears to have originated not far from the modern town of Brentwood in the Harpeth River valley. Although the original is now lost and no drawings or photographs are available, the very early discovery date suggests the possibility that it was a genuine artifact, although it may have been a ceramic figurine rather than a statue. The artifact was found in 1803, soon after the Euro-American settlement of the area. Haywood is the only source of information for this statue; he placed it at Mayfield Station near the base of a mound (1823:151).

CSS-029 is described as seated "upon her hams," reflecting a normal seating position for statuary (and figurines). However, the description of "both hands under her chin" and "elbows upon her knees" departs substantially from the placement of the arms on any known stone statue.

Additional difficulties prevent the placement of this statue at a specific find spot. The first relates to a lack of historic documentation for the precise location of Mayfield Station, a civilian fort established by local militia. The most likely spot for Mayfield Station is a spring feeding Mill Creek, a minor tributary east of the Little Harpeth River. Dr. Rush Nutt, an early traveler through Tennessee in 1805, described a fortified prehistoric site "upon the little harpeth & mile creek" (Nutt 1947:57). Nutt's designation at "mile creek" may be an inaccurate reading of the original "mill creek." Joseph Jones later described a similar site "about ten miles from Nashville, near Brentwood, on the banks of a small rivulet issuing from a cool never-ending spring of water" with earthworks (Jones 1876:37). These accounts may describe the same site and are the most likely to correspond with Haywood's "mound." Although Haywood located the mound in Davidson County, the probable location of Mayfield Station is only 1/4 of a mile from the county line.

After discovery, the artifact was taken to Nashville and exhibited at the tavern of John Boyd on Market Street (now Second Avenue), between Union and Church Streets (Thomas 1897:39). Boyd was one of the original settlers of Nashville, having arrived in 1780 with the John Donelson flatboats (Clayton 1880:23). Although CSS-029 may or may not represent a stone statue, we have included it in our survey in the event that additional documents may surface to clarify some of the mysteries surrounding it.

The Duck River Statues

South of the Cumberland River drainage, Middle Tennessee is drained from east to west by the Duck River, a tributary that eventually feeds into the Tennessee River. Along the Duck River, four statues have been identified.

Link Farm Site (40HS6)

The Link Farm site is probably best known as the source of the Duck River cache, a single assemblage of 46 ceremonial objects made from Dover chert or flint (Figure 3.41). Although Dover chert is only available from a restricted area along the Cumberland and Tennessee rivers, ceremonial forms such as bi-pointed swords, hooks, disks, batons, and axes manufactured from this material have been found at major centers throughout the Mississippian world (including Spiro, Cahokia, Etowah, Moundville, and others). Less well known is that the Duck River cache was also closely associated with a pair of stone statues in the Tennessee-Cumberland style.

Although situated 8 miles to the east of the main valley of the Tennessee River, the Link Farm site is strategically located at the confluence of the Duck and Buffalo rivers that drain most of the southern portion of Middle Tennessee. The central mound complex and associated residential areas extend for over 1 1/2 km (Figure 3.42). During the era of federal relief programs, Charles Nash and Georg Karl Neumann of the University of Tennessee directed limited excavations of several burial mounds and structures (Charles Nash, Field Report, 40HS6). They also produced thorough and extensive maps of the visible surface features. The mound complex includes at least two large platform mounds (Units 14 and 15), three conical mounds (Units 12, 13, and 17), and one loaf-shaped mound (Unit 16) enclosing a central plaza measuring approximately 250 m north-south by 150 m east-west. At various distances, the central complex is encircled by several small irregularly shaped mounds (Units 18, 21, 51, and 52). The most significant concentrations of residential structures were identified on the ridgetop southeast of the central mound complex. Although artifacts from the WPA (Works Progress Administration) investigations provide some insights into chronology, no radiocarbon dates or more systematic modern investigations are yet available. Overall, the diagnostic artifacts from the WPA investigations at the Link site tentatively suggest a lengthy occupation range beginning perhaps as early as A.D. 1000 and ending as late as A.D. 1400 (Bass 1985).

Based on extensive interviews, H. C. "Buddy" Brehm determined that the cache and associated statues were not recovered from the mound complex proper, but rather from the cluster of residential structures atop the ridge to the south (Brehm 1981). William J. Seever (1897) provided the most detailed contemporary description of the discovery:

> In December, 1894, an employee of Mr. Links, while plowing in this field, turned up several implements. Their form and size being unusual, time was taken to dig, and the objects . . . were found. According to

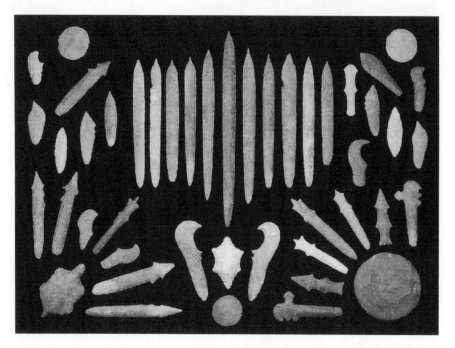

Figure 3.41. Duck River cache. Frank H. McClung Museum, University of Tennessee, Knoxville.

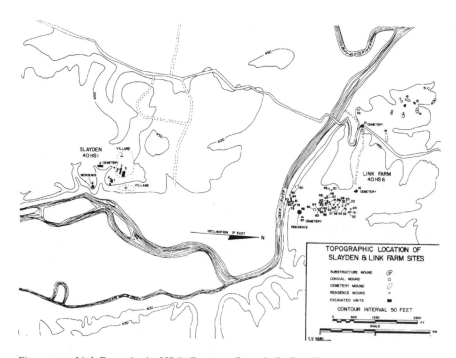

Figure 3.42. Link Farm site (40HS6). Courtesy Quentin R. Bass II.

the words of the finder, they were simply "in a bunch"; nothing un-
usual in the manner of the deposit was noted. The find was talked of
and commented upon for several months. The precise spot having been
carefully noted, further digging was done in the following March. At a
depth of a foot or two below where the flint objects had been deposited,
the two images or Idols . . . were found. Whether the deposit had been
associated with human remains, it was impossible to determine. From
appearances and accounts of the discovery, the images were placed in
the ground side by side, in an upright position, the flints in a compact
"bunch" immediately above. On all sides were remains of graves, but
so many of these graves having been disturbed and the stones removed
in cultivation, that with certainty it cannot be said that the find was a
deposit with the dead, although the writer inclines to the opinion that
they were and that the stone cist lay immediately above the cache of
objects. The Images represent a male and female. "Adam and Eve," they
were christened by the finders. Both are fashioned out of a soft rock
and what is locally known as Claystone (soft limestone), of a yellowish
color and coarse texture [Seever 1897:141].

After their discovery on March 23, 1895, "Adam and Eve" were removed
and transported on a ground sled or "stone boat" to the Link home about
1/2 mile away. Excited to hear of the discovery, the three daughters of
Mr. and Mrs. William Henry Rogers, whose farm adjoined the Link prop-
erty, visited the place where the two statues were found. Little Ollie Brownie
Rogers, age six and one-half years at the time, was the youngest of the three
girls. For some reason, this incident stuck firmly in her memory and she was
still able to identify the approximate location of the find on Link Hill some
83 years later when interviewed by Buddy Brehm.

After Adam and Eve were removed from their tomb atop Link Hill they
resided as guests in the Link home for several weeks. But for a twist of fate, the
Duck River cache and statues might have ended up in the collections of the
Peabody Museum of Archaeology and Ethnology. Edwin Curtiss, a Nash-
ville resident, worked for Frederic Ward Putnam of the Peabody Museum
collecting artifacts from throughout Middle Tennessee from 1877 until his
death in 1880. Curtiss was a close friend of Banks Link and acquired a
number of artifacts from the site for the Peabody Museum prior to his death.
Although the find spot is unclear, Curtiss mentions that from somewhere
in the vicinity of Link's farm, "there is a stone image two ft high that Gov.
Porter and Dr. Clark bought but never got" (Smith and Moore 2006). James
Porter was governor of Tennessee from 1875 until 1879. The "Dr. Clark"
is probably W. M. Clark, a collector from Franklin, Tennessee, who was also
acquainted with Edwin Curtiss. Unfortunately, Curtiss died not long after

passing this information to Putnam, and there is no evidence that the statue was ever acquired.

By September 1, 1895, the Duck River cache and the two "idols" were in the possession of W. H. Meadow and R. W. Childs of Waverly, Tennessee. This was the first, last, and only time the entire cache and accompanying statues were all together (Brehm 1987:30). Virtually nothing is documented about the transaction between the Links and the two Waverly residents. The only information available again comes from the eyewitness account given by Mrs. Ollie Rogers Baird, age 90, in 1979. As recorded by Brehm (1987:37): "Without any prompting other than the question: 'Do you recall ever seeing Adam and Eve?' she unhesitatingly said 'Oh, yes, I was there the day somebody took them to Waverly or Nashville or somewhere in a wagon. I climbed up on the side and looked at them in the wagon bed.'" The acquisition of the cache and idols appears to have been a short-lived business venture on the part of Meadows and Childs. Adam and Eve were carried to their new home in Waverly and very shortly thereafter were photographed by Mr. R. A. Brugger.

Within two weeks of being photographed, Meadows and Childs sold Adam and Eve to an unknown party. While not recording the name, Seever identified the purchaser as a "speculator," presumably a reference to an antiquities dealer. The next probable owner (and possibly the same speculator referenced by Seever) was Edward Waldron Payne, the millionaire collector from Springfield, Illinois. After his death in 1932, Payne's collection was auctioned starting on August 15, 1935. Many prestigious collectors from all over the country were on hand the first day to purchase the choicest specimens.

Donald O. Boudeman, of Kalamazoo, Michigan, was among the bidders at the auction. Although his massive collection contained all types of antiquities, Boudeman was a discriminating collector with a special interest in stone images. Although the precise number is unclear, Boudeman clearly purchased some of the stone figures in Payne's estate. Among them was the figure Adam, who appears to have been renamed Tennessee Man by this point. Whether Eve was also auctioned at this time is not documented.

Early in 1948, research by Thomas M. N. Lewis indicated that Adam was still in the Boudeman collection, but if Eve was present among the many statues in his collection, she went unrecognized. If Boudeman owned both, they were definitely separated sometime after his death on February 27, 1949. In the early 1950s, the Tennessee Man was purchased from Mrs. Boudeman by the artist Ulfert Wilke, who kept the figure at his home in Louisville, Kentucky, until about 1957. Nelson Rockefeller eventually purchased the Tennessee Man and placed him on display in the Museum of Primitive Art in New York City. After Rockefeller's death, Adam's complicated jour-

ney ended in 1982, when the Metropolitan Museum of Art absorbed the collections of the Museum of Primitive Art. The whereabouts of Eve remains unknown.

Statuary Pair CSS-036 (Figures 3.43, 3.44) and CSS-037 (Figure 3.45). The male, CSS-036, is represented in a kneeling position, with his right knee raised. While his right hand is depicted on his knee, the left forearm is depicted in a unique position horizontally across the abdomen. The eyes and mouth are in relief with lips slightly parted. The statue exhibits a straight hairline, hair buns on either side of the crown of the head, and long hair on the flattened occiput. The face has little upward inclination.

Fortunately, CSS-037 was photographed soon after discovery, since it has disappeared. The photograph shows a more oval mouth and detailed ears in relief, flattened occiput with a hair roll, and a shallow hourglass-shaped elongated hair knot on the back of the neck. Her lower body is not as well proportioned as the male's, but with the hands on the knees, the body rests between the kneeling legs while the feet are indicated on either side with toes down at the rear. Breasts are difficult to detect, if they are indeed present.

Seever provided the following detailed description of the two statues:

> The female is about 24 inches high and weighs probably 50 pounds. . . . The male is about 30 inches in height; weight probably 80 pounds. . . . The female in a kneeling position with both arms down and hands clasping the knees; the male in a half kneeling or squatting position, the right limb drawn up to the body on a line with the shoulder, the right arm resting thereon, the left limb under the body and left arm and hand clasping the knee similar to [the female]. . . . Although rude and somewhat clumsy, the workmanship is better than usual in sculptures of this class, the form of the body in both being exceptionally well modeled and all features, especially about the head, very bold and clear.
>
> The hair on the female is drawn closely behind the ears, terminating by a peculiar paddle-shaped fillet down the back; on the male the hair is shown by a well-defined ridge across the forehead, covering the ears, and cut square on a line with the neck. On either side of the head, just above the ears, the hair is shown drawn together in a circular knot, a feature frequently noted on terra-cotta images from Missouri and Tennessee. The eyes of the male are very prominent, the reverse being the case in the female, where the eyes are designated by shallow, oval lines.
>
> The mouth of the female is open, with thin, well-cut lips, while the male is shown with tightly closed mouth and exceptionally thick, protruding lips [Seever 1897:142].

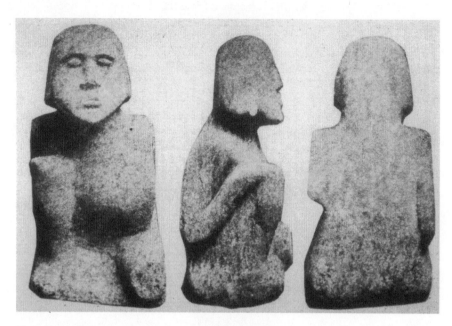

Figure 3.43. CSS-036. Ca. 1895 photograph by R. A. Brugger (Brehm 1984).

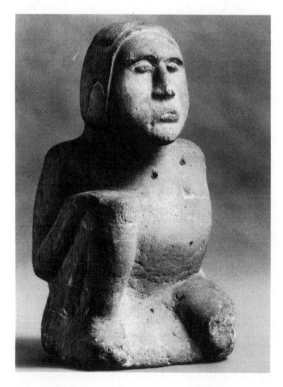

Figure 3.44. CSS-036. Courtesy
The Metropolitan Museum of
Art, The Michael C. Rockefeller
Memorial Collection, Bequest
of Nelson A. Rockefeller, 1979
(1979.206.476).

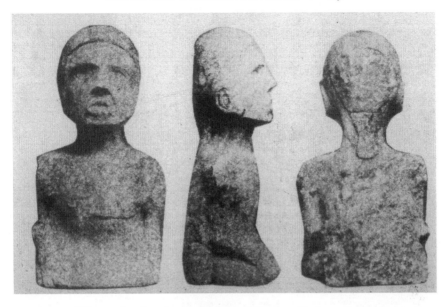

Figure 3.45. CSS-037. Ca. 1895 photograph by R. A. Brugger (Brehm 1984).

Although locally known as claystone, the source material is identified by the Metropolitan Museum of Art as quartzite sandstone. Mr. Wilke also identi- fied the source material as "sandstone" (Lewis 1955:87).

Narrows of Piney (40HI36) Statue

The so-called Fortress at the Narrows of the Piney (40HI36) was a large mound center located 20 miles to the southeast of the Link Farm site at a strategic close convergence of the Duck and Piney rivers. Although most of the site has long since been destroyed, a detailed map of visible surface fea- tures was produced in August 1917, by T. C. McEwan, an engineer. The map illustrates extensive fortifications on the two landward approaches, a single large pyramidal mound, and several conical mounds, along with cemeteries and "dwelling sites."

The current whereabouts of statue CSS-040 is unknown and the only details available were recorded by William Myer: "I found the image about 20 rods east of the mound. The broken head lay between the furrows where the plow had turned it up. I was lucky enough to find the body by digging a little. It was within 1 1/2 feet of the surface. Its height is 16 1/2 inches. The head was so badly broken, and so much of it destroyed, that a new head was cut by me out of stone. It is a true copy" (Fred Butler of Albion, Michigan, to Myer, cited in Myer 1923a:547). Assuming the description by Mr. Butler is accurate and that he is referring to the main platform mound, "20 rods east"

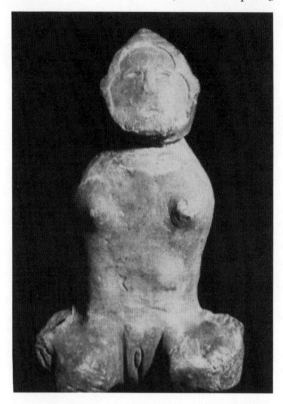

Figure 3.46. CSS-039, front view. Courtesy Mike Bunn, Columbus Museum, Columbus, Georgia.

(330 ft, 100 m) would place this in the area described on the map as "dwelling sites."

Big Bigby Statue

On a tributary many miles up the Duck River from the Link Farm site, another stone statue was found. To the west of the Mt. Pleasant community in Maury County, Tennessee, Big Bigby Creek flows northward into the Duck River. Somewhere in the bottomland of the creek on the Acuff farm, Statue CSS-039 was found prior to 1931. Although the circumstances of the discovery are not available, the statue was probably turned up during farming operations, since it shows extensive damage of the sort usually caused by plowing. No Mississippian sites have been officially recorded in this vicinity, but extensive phosphate mining during the 1940s destroyed many of the archaeological sites in this valley (Webster 1945).

The earliest known owner of the statue was W. H. Jackson of Columbia, Tennessee, who loaned it to the Tennessee State Museum on August 4, 1931, for the purpose of restoration and exhibition (State Museum of Tennessee

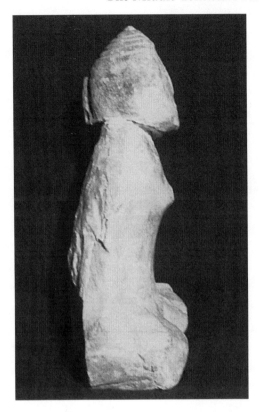

Figure 3.47. CSS-039, left profile.
Courtesy Mike Bunn, Columbus
Museum, Columbus, Georgia.

Contract of Loan 1931). Parmenio E. Cox, keeper of archives and museum, contacted the Smithsonian Institution to see if the head could be restored to the body, but received a negative reply (Cox 1931; Wetmore 1931). Subsequently, Hugh Lee Webster, a Columbia attorney and judge, contacted John Trotwood Moore, Tennessee state librarian, requesting the return of the statue so that it could be exhibited in Columbia at a new Museum (Webster 1931). Eventually it was added to Judge Webster's personal collection (Lewis 1945). Although the circumstances are not clearly recorded, the statue ultimately ended up in the collections of the Columbus Museum in Georgia.

Statue CSS-039 (Figures 3.46, 3.47, 3.48, 3.49). CSS-039 was damaged by the plow on the left side and back, and the arms were destroyed, leaving only the hands on the hips. When found, the arms were missing and the head was broken from the body. The hair is shown with a pointed hairline and five tiers to a point on the crown of the head. An elongated hair knot is shown on the back of the head. The eyes, ears, and mouth with parted lips are in low relief. Nipples are in relief and the vulva is incised between the parted knees. In addition, a possible artifact of sandstone the same size and in the same basic shape as the head was found about 50 ft away (Lewis 1947b).

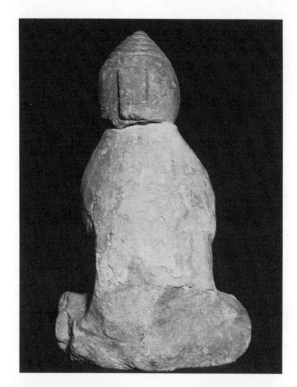

Figure 3.48. CSS–039, rear view. Courtesy Mike Bunn, Columbus Museum, Columbus, Georgia.

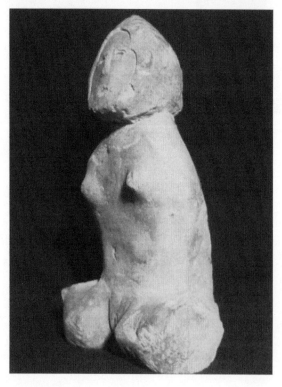

Figure 3.49. CSS–039, right angle view. Courtesy Mike Bunn, Columbus Museum, Columbus, Georgia.

4
The North Georgia Heartland

...well executed human effigies in stone have been recovered from the
Etowah group or its vicinity.... In addition to these, fragments of several
others have been found in or near the mounds.

—Charles C. Willoughby 1932

Outside of the Nashville Basin, the only significant geographic concentra-
tion of Tennessee-Cumberland style stone statuary is found at the Etowah
site (9BR1) and nearby sites in North Georgia.

Etowah Mounds (9BR1) Statuary

Etowah is the only major Mississippian center outside the Nashville region
yielding more than two Tennessee-Cumberland style stone statues. Located
on the Etowah River in Bartow County, Georgia, the Etowah site is a large
multimound town, including six known mounds arranged around an open
plaza with the whole surrounded by a defensive ditch (Figure 4.1). Excava-
tions at Etowah over the past two centuries also provide the most detailed
archaeological contexts and chronological information for statues examined
during our survey. At the same time, the widely publicized discovery of spec-
tacular Mississippian artifacts from Etowah, including the two famous marble
human statues, has encouraged the attribution of many more questionable ar-
tifacts to that site. Prior to its preservation as a park, the Etowah site was sit-
uated on the Tumlin Plantation, where it was subjected to plowing and ex-
tensive relic collecting both before and after the Civil War.

Statue CSS-055

The first recorded discovery of a statue (CSS-055) took place prior to 1859.
Charles C. Jones provides the only detailed description of the statue: "In the
possession of Colonel Lewis Tumlin, in 1859, the writer examined an idol
which had been ploughed up near the large mound on the Etowah River,
upon the plantation of that gentleman. It was made of a coarse dark sand-
stone, and was twelve inches high. It consisted of a male figure in a sitting
posture. The knees were drawn up almost upon a level with the chin, the
hands resting upon and clasping either knee. The chin and forehead were re-

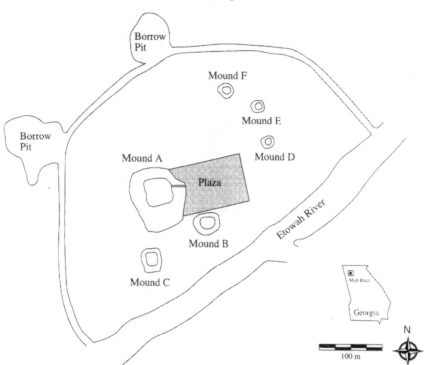

Figure 4.1. Etowah site plan (King 2003:Figure 5). Courtesy Adam King and The University of Alabama Press.

treating. The hair was gathered into a knot behind. The face was upturned and the eyes were angular" (Jones 1873:432). Unfortunately, CSS-055 was either lost or destroyed during Sherman's March to the Sea through Georgia in 1864 (Jones 1873:432).

Statue CSS-056 (Figure 4.2)

The second statue reported from Etowah (CSS-056) was discovered not long after the Civil War. Charles Jones (1873:432–434) described the original:

> It was ploughed up on Colonel Tumlin's plantation, near the base of the large tumulus located within the area formed by the moat and the Etowah River, and is certainly the most interesting idol thus far discovered in this State. . . . It is a female figure in a sitting posture. The legs, however, are entirely rudimentary and unformed. Its height is fifteen inches and three-quarters, and its weight thirty-three and a half pounds. Cut out of a soft talcose rock, originally of a grayish hue, it has been in time so much discolored that it now presents a ferruginous ap-

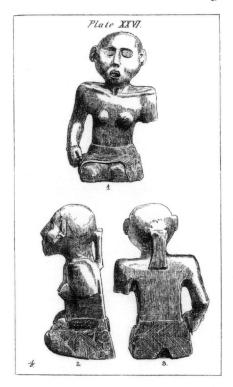

Plate XXVI.

Figure 4.2. CSS-056 (Jones 1873).

pearance. Below the navel, and enveloping the buttocks and rudimentary thighs, is a hip-dress, ornamented both on the left side and behind by rectangular, circular, and irregular lines. The ears are pierced, and the head is entirely bald. In the centre of the top of the head a hole has been drilled half an inch in depth, and five-tenths of an inch in diameter. This probably formed the socket in which some head–ornament was seated. . . . Springing out of the back of the head and attached at the other end to the back midway between the shoulders, is a substantial handle by means of which this image could have been securely suspended or safely transported from place to place. The mammary glands are sharply defined and maidenly in their appearance. The ears, hand, and navel are rudely formed. The impression conveyed is that of a dead, young, flat-head, Indian woman. Unfortunately, the left arm has been broken off.

CSS-056 exhibits one feature unique among all of the statuary examined—the navel. Her skirt is decorated with painted designs as are the upper arms. Similar to many other statues, the face is inclined slightly backward. In addition to the "socket" on top of the head, the ears are pierced for the ad-

Figure 4.3. CSS-087 (Thomas 1894:Figure 193).

dition of presumably perishable jewelry. The eyes are in relief and the oval mouth is open with the upper teeth visible. The feature described by Jones as a "handle" is the typical elongated hair knot, four and a quarter by two and a quarter inches, which is pierced and in an hourglass shape. The collarbone is shown in relief, as is the nipple on both breasts. The arms were sculpted with the hands in a fist attached to the sides of the skirt, although the left was broken midway down the upper arm with the remainder of the arm and left hand missing. A wrist knot is shown in relief on the right hand.

This statue was in the collection of the Tennessee Historical Society in 1880 with the mistaken provenance of northern Alabama (Tennessee Historical Society 1880 catalog). According to Willoughby (1932:29), it was later in the Georgia State Museum in Atlanta. Eventually, it ended up in the collections of the National Museum of the American Indian.

Statue CSS-087 (Figures 4.3, 4.4)

During his excavations in March 1884, J. P. Rogan discovered a coarse marble fragment including the face and upper part of the chest and shoulders in "one of the small mounds" (Wilson 1898:487). Willoughby (1932:21) indicates

Figure 4.4. CSS-087.

it was "found in one of the low mounds now nearly obliterated, to the east of the Great Mound." The statue fragment separated along fault lines in the stone. As a result, the face with sculpted eyes, nose, and partially separated lips is broken from the rear section, which shows ears in low relief. A segment of stone between the front and rear is missing. Whether this was originally part of a freestanding statue or simply a "bust" is difficult to interpret. However, the break at the bottom suggests the former. The dimensions of the fragment are roughly the size of those on the other marble statues from Etowah.

Statuary Pair CSS-057 (Figure 4.5) and CSS-058

During the period from 1925 to 1927, Warren K. Moorehead directed excavations at Etowah. In 1925, while excavating portions of Mound C, a scraper refilling excavation trenches exposed two statues, CSS-057 and CSS-058 (Moorehead 1932:75). Perhaps because of the rush and confusion created by the circumstances of discovery, the context is not entirely clear. However, the statues are reported to have been found about 2 ft below the surface in a "stone box, two feet long, a foot wide and twelve or fourteen inches deep." According to Willoughby (1932:29),

> The male effigy . . . was taken by Dr. Moorehead from a carefully constructed stone slab grave, about 20 inches below the surface, on the western side of the summit of the temple mound. The grave had apparently been made expressed as the final resting place of the statue, which had evidently been intentionally broken, probably by invaders from a

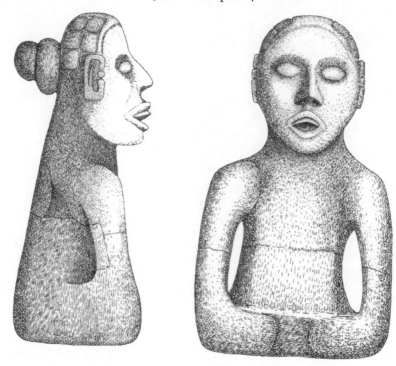

Figure 4.5. CSS-057. (Moorehead 1932:Figure 3) ©Yale University Press.

hostile tribe, and the pieces subsequently deposited in a small grave constructed for them, perhaps by one of the Etowah priests after the destruction of the temple. The height of the statue is 17 1/2 inches. In the grave was also a portion of a second statue crudely fashioned from a soft stone, the head of which was missing.

The male, CSS-057, shows less realism and detail than most of the Etowah statues. The face is relatively vertical with eyes in relief, a well-sculpted nose, open lips with a protruding tongue, and stylized ears. The hairstyle or headgear is relatively complex and unique among the statues in our survey. A hairline is depicted in relief. A raised ridge crosses the crown above the forehead with segmented squares on each side. In addition, an unusual stacked double hair knot is shown on the back of the head. The upper torso shows the collarbone in relief. The torso and arms terminate in a simplified base with hints of legs at the front but only hints of hands on the knees. The arms are sculpted separated from the body, a trait found in all of the known Etowah statues. CSS-057 was broken across the middle of the arms and the torso.

The second fragmentary statue, CSS-058 was also broken across the head in the area of the mouth and apparently near the base. Both the upper head and lower base are missing. The back of the statue shows evidence of fire

damage, creating unanswerable questions about its destruction and the circumstances surrounding it. The remaining fragments appear to show evidence of a chin and the upper parts of both arms. The possible remnants of the elongated female hair knot are preserved on the back of the neck. Given the heavily damaged nature of the statue, firm identification of gender is not possible, but the limited features remaining are generally suggestive of a female. The long, narrow torso is reminiscent of the primitive female CSS-004 from the Sellars site, and it too probably had to rest in a depression in the ground in order to stand upright.

Statuary Pair CSS-059 (Figures 4.6, 4.7, 4.8) and CSS-060 (Figures 4.9, 4.10, 4.11)

The pair of white marble statues (CSS-059, CSS-060) was uncovered in a log tomb labeled Burial 15 at the northern side of the eastern ramp of Mound C (Figure 4.12). Located in the final mantle of the stratified burial mound, the tomb was 9 ft long, 4 ft wide, and 3 ft in depth. The sides were constructed using vertically set poles with additional poles comprising a "roof" or top. The scattered contents of the tomb included the disarticulated bones of four individuals, stone and clay pipes, copper-covered wooden ear discs, fragments of a copper head ornament, a mica disc, a shell pendant, and some red ocher (Figure 4.13). Amid the conglomeration of bones and artifacts were two marble statues (Figure 4.14). The female was sitting upright near one end and to her left the male was lying down on his right side. A portion of the female's left arm lay to her rear, apparently broken when the male, who also suffered damage, was dropped into the tomb (Larson 1971:65). Overall, the haphazard placement of the contents suggests an event conducted in haste and with little ceremony, unlike the majority of similar log tombs documented from Mound C. Shortly after Burial 15 was completed, a deposit of human bones and other objects (Larson's Burial 1) was scattered down the face of the ramp. The objects included a stone palette, shells beads, copper-covered wooden ear discs, a pipe fragment, antler projectile points, broken ceramic vessels, and whelk and oyster shell. While not enclosed in a log tomb, the contents of Burial 1 are very similar to those in more carefully constructed burials in Mound C. In concert with the at least roughly contemporaneous burning of the Etowah palisade, this sequence of mortuary events may well represent the hasty burial of at least some of the contents of a charnel shrine atop Mound C (Burial 15) sometime prior to an attack and sacking of the remainder of the shrine contents (Burial 1). Based on radiocarbon dates and associated artifacts, these events are believed to have taken place during the late Wilbanks phase (A.D. 1325–1375; King 2001:7). Assuming the statuary were in use for some period of time prior to their hasty burial, a likely time span for the creation of the sculptures would be somewhere between A.D. 1250 and 1375 during the early and late Wilbanks phases.

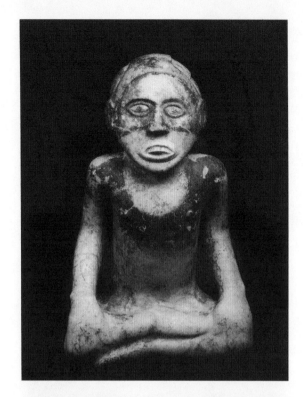

Figure 4.6. CSS-059, front view. Photograph by David Dye.

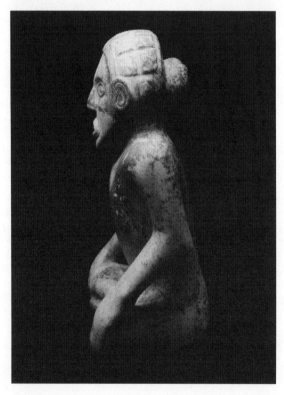

Figure 4.7. CSS-059, profile view. Photograph by David Dye.

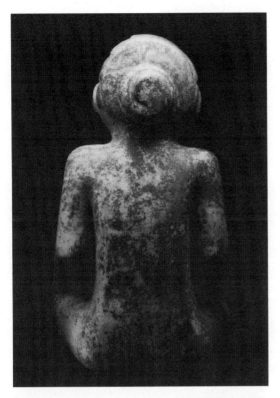

Figure 4.8. CSS-059, back view.
Photograph by David Dye.

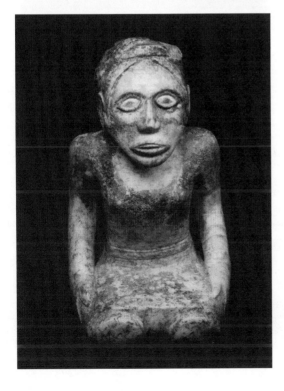

Figure 4.9. CSS-060, front view.
Photograph by David Dye.

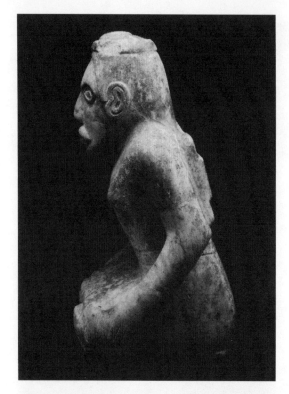

Figure 4.10. CSS-060, profile view. Photograph by David Dye.

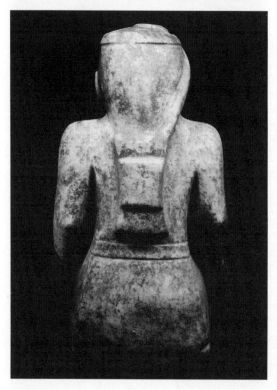

Figure 4.11. CSS-060, back view. Photograph by David Dye.

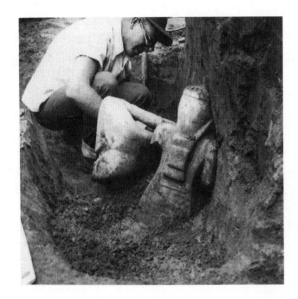

Figure 4.12. Lewis Larson excavating the two statues in Burial 15, June 19, 1954. Courtesy George E. Stuart.

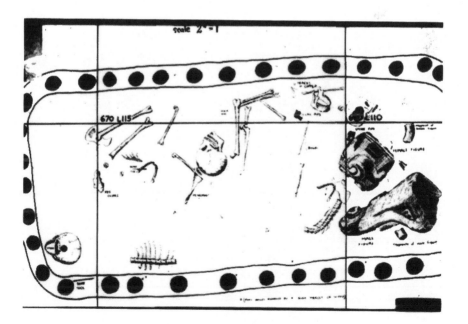

Figure 4.13. Mound C, Burial 15 in the burial book, 1954. Courtesy George E. Stuart

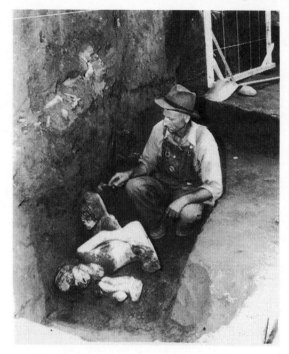

Figure 4.14. Elishe Mulkey with his discovery, June 19, 1954. Photographer unknown. Courtesy George E. Stuart.

CSS-059 is among the largest statues discovered to date. With the face looking forward, his features appear rigid and stark. All facial features are sculpted in detail with the mouth open and the upper teeth visible. The only features that are not realistically rendered are the ears, which exhibit the curious incised 8 like those on the Beasley Mounds female, CSS-016. The hairstyle is like the Etowah male, CSS-057, except the hair knot is a single piece rather than "tiered" or "stacked." The arms are separated from the torso terminating in hands (with wrist knots) on the knees. The legs are crossed, right over left, and are sculpted on the base as well as the top. The most unique features of the statue are the nipples. Only two statues interpreted as male show this feature and both are from Etowah.

CSS-060, the female of the pair, sits in the kneeling position with a short skirt starting with two incised lines at the waist and extending to her knees. Her hands, exhibiting wrist knots like the male, are to the sides of her thighs like CSS-056 and not in the usual position on her knees. Her legs are folded back under her body, visible from the sides and also sculpted on the base. Unlike most female statues she exhibits no nipples, but the breasts are shown (when contrasted with CSS-059). Her facial features and ears are identical to those of her mate. One unique feature is a packlike object on her back consisting of two stacked rectangles slightly pinched in the middle. A straplike object running from the "pack" to her forehead may represent either braids

of hair or a tumpline supporting the pack (Prentice 1986). Above this feature on the crown of the head is another unique feature that can be interpreted as a turbanlike "hat" or layers of braids. In addition to these unique features, the typical elongated female hair knot is shown on the back of the head.

Both statues were liberally decorated with pigments. The eyes were white with black pupils, the ears red, and a greenish black and carbon black were also used on other details (Kelly and Larson 1957:43). The male's face has pigment down to the level of the nose, and both have lines painted between the teeth. Color was applied around the shoulders, upper arms, and across the chest and breasts on both, but not from the neck downward where a necklace or other perishable adornment might have been hung. In some places, the pigments appear to have been applied and reapplied on several occasions.

Statuary Pair CSS-074 (Figures 4.15, 4.16) and CSS-075 (Figures 4.17, 4.18)

Another statuary pair is reported to have been found in 1885 on the Tumlin property. The following documentation was reportedly attached to the backs of figures when Margaret Perryman (1966) examined them:

> Dr. W. G. Hinsdale collected idols while investigating mound in Bartow Co. Ga., in the summer of 1885, on property owned by Tumlin Family. He dug into remnants of a small mound which had previously been excavated. Investigations of remaining mound yielded two burials and parts of other skeleton which had been turned side by side and had lost their heads and shoulder by the construction of another grave in aboriginal times. In this grave was found many artifacts, the most important of which were two idols. One male and one female still retain much of original painted decorations. Female idol being the smaller of the two. Eleven inches tall weighing 19 pounds. Male being somewhat larger, over entire skeleton had been covered with 6000 freshwater pearls, various other relics were found.

Assuming the information to be accurate, these investigations would have taken place soon after J. P. Rogan's excavations for the Bureau of American Ethnology at Etowah (Thomas 1894:292–312). Although the extent of Rogan's work is not entirely clear, he did excavate portions of Mound C where the other statues were recovered.

In 1966, both of these figures were reported to be in a private Georgia collection. CSS-075 was later donated to the Museum of the Cherokee Indian by a private collector. The location of CSS-074 remains unknown. An article by a Dr. W. G. Hinsdale titled "Onondaga Archaeology" is referenced in the New York State Library Special Collections (Index to William M. Beauchamp Scrapbook 1897–1902). Similarly, a W. G. Hinsdale is listed as a doc-

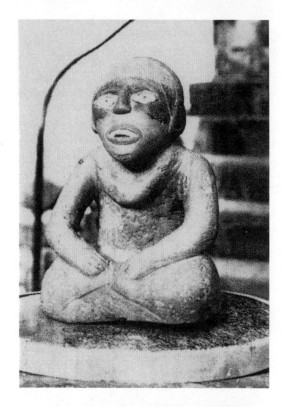

Figure 4.15. CSS–074, front view (Perryman 1966).

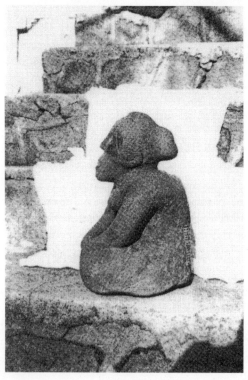

Figure 4.16. CSS–074, left profile (Perryman 1966).

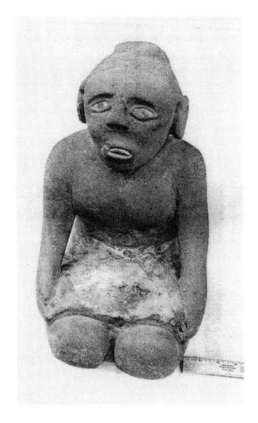

Figure 4.17. CSS-075, front view (Perryman 1966).

Figure 4.18. CSS-075, left profile (Perryman 1966).

tor in the New York State hospital system in 1935. Although we cannot confirm whether all of these are the same individual, the discovery of a W. G. Hinsdale with some connection to archaeology lends some credence to the label text.

Perryman records the following additional information about the two statues: "The female figure is 11 inches high, weighs approximately 19 pounds and is well made of what appears to be a hard type of stone. Evidences of color can be found on the face. The male figure is 17 inches high and weighs about 59 pounds. It does not appear to be as well made as the female figure. Some slight evidences of paint can be seen on it. These figures were reported to have been in the Payne collection for a long number of years." The apparent lack of notice paid to these two statues between 1885 and 1966 is somewhat surprising given the interest in the Etowah site. The fact that they surfaced only a few years after the discovery and publication of CSS-059 and CSS-060 (Kelly and Larson 1957) may be coincidental, but their authenticity appears somewhat questionable.

Stilesboro/Raccoon Creek Statue (Figure 4.19)

About 7 miles down the Etowah River from Etowah, another male statue (CSS-061) was found in either 1886 (Willoughby 1932:31) or 1888 (Wilson 1898:468). The statue is probably from what is now known as the Raccoon Creek site (9BR26), a small mound and village site. Although no excavations have been conducted, surface collected materials suggest a lengthy occupation with the main components during the early and/or late Wilbanks phases (A.D. 1250–1375; King 2003:41).

CSS-061 shares a number of traits with the Etowah statues, including the open mouth with visible upper teeth. The square-sectioned hairstyle is evidence on both sides of the head along with a large hair knot. This statue and the Etowah male (CSS-059) are the only two male statues that exhibit nipples. Although generally similar to the Etowah statues, the statue has some unique details. The legs are crossed with the right over the left, but they are represented in low relief on the front of a squared base, and the right foot is pointed down toward the ground. The most unique feature is the right hand. While resting on the right knee, it is turned with the palm outward and the fingers bent upward.

Catoosa Springs Statue (CSS-088)

Charles Jones mentioned another male statue, said to have been in the sitting position and 16 inches high, found "a few miles" from Catoosa Springs,

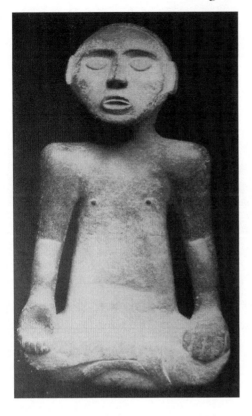

Figure 4.19. CSS-061 (Thomas 1898).

Georgia, in 1860 (Jones 1873:432). No additional information, including its current whereabouts, is available.

Haralson County Statue (Figures 4.20, 4.21)

Margaret Perryman (1969) provided the following short paragraph on an additional statue from Georgia (CSS-076): "This male effigy of stone is 15 3/4 inches in height and the width at the base is 8 3/4 inches. It weighs 19 pounds. The figure appears to have once been painted and is now a dull brownish color. Reported to have been found by W. L. Hubbs in 1901 in Haralson County, Georgia. It is now in a private collection in Atlanta, Georgia. It was found in a low mound on the Murphy Farm on the banks of the Tallapoosa River." Although sharing some general characteristics with the Etowah and Raccoon Creek statues, no additional information on its whereabouts is currently available. The statue is very similar in many details to a small sandstone figurine recovered in 1937 from the Kincaid site (Cole et al. 1951). Without examining the statue, it is impossible to determine whether the statue is a modern large-scale copy of the figurine or not.

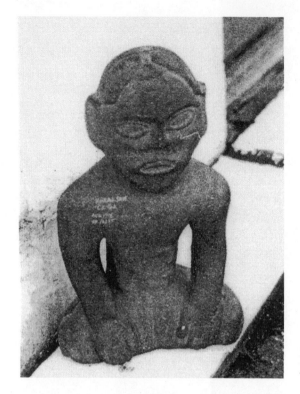

Figure 4.20. CSS–076, front view (Perryman 1969).

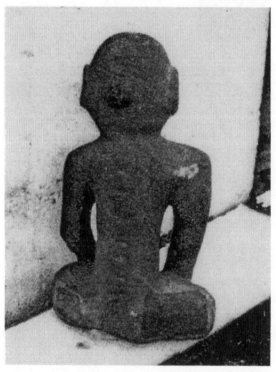

Figure 4.21. CSS–076, profile view (Perryman 1969).

Assuming the statue to be authentic, one possible candidate for the find spot is 9HR255, a minimally documented site recorded as lying on the "Murphy property" along Lassetter Creek in Haralson County. While not tested during the archaeological survey, a possible eroded remnant of a small mound was recorded (Georgia Archaeological Site Form, 9HR255).

5
The Tennessee Periphery

I regretted my indiscretion, and was determined henceforth to be as
careful about interfering betwixt a man and his pigmies as I would be
betwixt a man and his wife.

—George W. Featherstonhaugh 1844

While the most significant geographic concentrations of statues are found
in the Middle Cumberland and North Georgia regions, several statues were
found as outliers in the Cumberland and Tennessee river drainages in Tennes-
see and Kentucky. While widely scattered, these outliers as a group underline
the assertion that stone statuary production was most common in the river
drainages radiating outward from Middle Tennessee.

The Eastern Periphery of the Nashville Basin

Outside of what we have called the Heartland triangle encompassing the
Sellars, Beasley Mounds, and Castalian Springs sites, at least ten and possibly
as many as fifteen statues have been documented from sites within the Cum-
berland River drainage on the eastern periphery of the Nashville Basin. Most
of these statues are apparently from sites in the Caney Fork River drainage, a
major tributary of the Cumberland River draining the southern portion of
the Cumberland Plateau, with only two possible outliers on the far eastern
portion of the Cumberland River drainage in Tennessee.

Clay County Statues

Two statues were reportedly found in Clay County, Tennessee, along the
Cumberland River. Located about 75 miles east of the Sellars site, this area
comprises the easternmost occurrence of stone statues in the Cumberland
River valley. The precise find spot was not provided in the published de-
scription:

In February 1983, James Capp of Celina, Tennessee, found a surface
artifact that would excite the most jaded archaeologist. Near the Cum-
berland River in Clay County, he noticed a portion of a rock sticking
up in a plowed field. . . . What Mr. Capps had found was a Mississippian

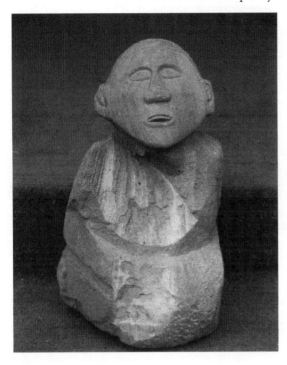

Figure 5.1. CSS-062, front view. Courtesy Nick Fielder.

Period carved stone human figure like those that were found on some large sites when plowing first began in the nineteenth century.

The figure is 43 cm high, and 20 cm wide at the base and weight approximately 40 pounds [Tennessee Archaeological Society 1984:10].

The evidence for significant Mississippian occupation in the region is limited. However, similar to much of the Cumberland Plateau, Clay County has not been the focus of substantive archaeological survey in recent decades.

According to anecdotal information, a different private collector reportedly found a second statue (CSS-077) at or near the same location. No information has been published on this statue, and we were unable to gather any more specific documentation.

Statue CSS-062 (Figures 5.1, 5.2). The face and head are relatively finely detailed including the eyes, nose, ears, and mouth. The upward inclination of the facial plane is also well defined. On the back of the head is a typical male hair knot.

While the torso of CSS-062 shows extensive damage from plowing, the seating position is most readily interpreted as Type C. The position of the surviving fragments of arms and the overall impression of the basal region would tend to suggest a female.

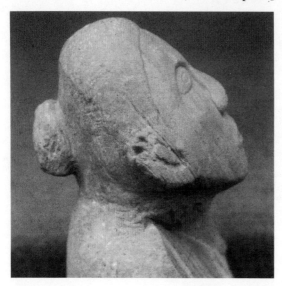

Figure 5.2. CSS-062, profile. Courtesy Nick Fielder.

Piper's Ford Statue (CSS-020)

While the precise discovery site cannot be confidently identified, William Myer indicates that CSS-020 was plowed up prior to 1880 in a cultivated field "one mile south of the old town at the mouth of the Caney Fork" (1923a:273), a reference to a small possible mound center (40SM25) located at the confluence of the Caney Fork and Cumberland River in Smith County. Myer's description would place the discovery area of the statue near Piper's Ford (eventually known as Piper's Ferry) on the west bank of the Caney Fork. Myer conducted excavations of a small Mississippian village and associated stone box cemetery at Piper's Ford, which could be the discovery site of the statue:

> Piper's Ford immediately across the river from the Town of Asylum on Hell's Bend, is a small village site and cemetery. . . . In a small stone slab grave was the body of a child, from one to two years of age. On its breast was the unique gorget No. 207 . . . Near its head were found two dumbbell shaped ear ornaments. . . . Near the head was the earthenware bowl . . . inverted in this octagonal edged plate was the earthenware pot No. 211 . . . On the opposite side of the head was an inverted pot exactly like No. 211. There were fragments of two other pots in this grave and also a small arrow-head. A small stone slab grave, 4 1/2 feet long by 18 inches wide, was found within about 19 feet of the above mentioned child's grave. This contained the body of a child, extended full length. On the breast was the gorget No. 30. . . . In the same grave

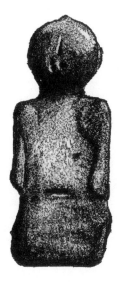 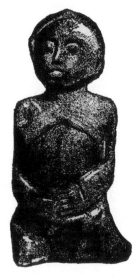

Figure 5.3. CSS-020 (Thruston 1897:Figure 28).

was a bear's claw pierced for suspension, and a spoon made from a mussel (Unio) shell. In one corner of the grave a small earthenware pot . . . was inverted over a pot of similar shape. The lower pot contained a few periwinkle shells. The earth of this grave contained a great many periwinkle shells scattered through it [Myer 1923a:311–312].

Myer's "gorget No. 30" is a fenestrated Nashville style triskelion very similar to those recovered from Castalian Springs. The other artifacts described suggest an occupation date for Piper's Ford somewhere between A.D. 1250 and 1450. One additional mystery surrounds this statue: "The cutting of the figures '1619' appeared to be old at the time it was presented to us in 1880, but not as old as the surface of the image. The finder was probably not aware of the existence of this '1619,' as he never called our attention to it" (Myer 1923a:273). For unknown reasons, Myer (or possibly John Swanton?) later marked out this entry in the draft manuscript. Unfortunately, the statue was lost in the fire that destroyed Myer's home in the 1880s. However, photographs of the statue that survived were used by Gates P. Thruston to prepare an engraving (Thruston 1897:Figure 28). The statue appears to be genuine in all other respects, but the mystery of this deleted entry leaves some uncertainty.

Statue CSS-020 (Figure 5.3). CSS-020 appears to be a representation of the character we have identified as the Old Woman. The elongated hair knot at the back of the head is pierced. Thruston suggested that the piercing served as a suspension point for the statue "to keep it in a vertical position" (1897:108), but Myer probably more accurately interpreted this feature as "intended for

holding feathers and other decorations for the hair" (1923a:274). The hands exhibit a horizontal incised line over the knuckles, while the shoulder blades are in low relief.

The hands are together, fingertips to fingertips, and on the abdomen. The eyes are in relief and the mouth is shown open. Some type of garment appears to have been depicted across the front (similar to the hooded negative painted bottles) but not across the back. The face appears to have been inclined backward.

Falling Water Statue

Several miles up the Caney Fork River from Piper's Ford, another statue was plowed up prior to 1898 near the confluence of the Falling Water River. As recorded by Myer: "About 1898, the author, after considerable endeavor, obtained a rude, much weathered image of hard limestone, which had been plowed up on the smaller of the two village sites in the bottom, on the point between the rivers, at the junction of Falling Water and Caney Fork . . . it appears to be of considerable age" (Myer 1923a:360).

This region was inundated by impoundment of Center Hill Lake in 1948 with only minimal archaeological survey, so no modern archaeological information is available on the site. During the River Basin surveys of the 1940s, one site at the mouth of Falling Water River was identified as consisting of scattered evidence of habitation areas, a stone box cemetery, and a low stone mound.

Statue CSS-021 (Figures 5.4, 5.5). The head and left arm are the only recognizable features remaining on what was apparently a heavy boulder. The surface of the figure is now marked by erosion and the plow, and it was impossible to ascertain whether the facial features were originally better defined, or simply crudely fashioned. The face is inclined toward the back at a 28-degree angle. The lips and eyes are in relief, although the mouth opening is not evident. The hair is depicted in a roll over the top of the head with a somewhat elongated hair knot, suggesting a female.

Burgess Cove Statuary—The Rock Woman and the Little People

About 15 miles east of the confluence of the Falling Water and Caney Fork rivers, at least one and possibly as many as four statues were found in and around the Cherry Creek community in picturesque Burgess Cove (also known as Terry Cove). Although modern archaeological information about this area is limited, a probable Mississippian chiefdom center was located only a few miles from the find spot. The Reverend Monroe Seals described the Cherry Creek Mound site (40WH65) as follows: "Besides the fortified . . . town on Cherry Creek in the center of which was a mound used for council located between the Morris and Wilhite places. . . . The mound at Cherry

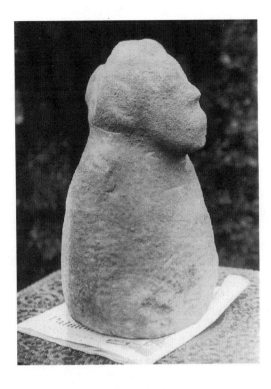

Figure 5.4. CSS-021. Photograph presumably by William E. Myer. Courtesy Samuel D. Smith.

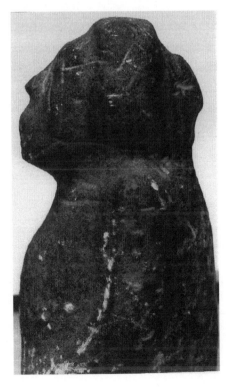

Figure 5.5. CSS-021, profile.

Creek was opened a few years ago and beads and pottery were found" (Seals 1935). John Haywood describes the site as having "several mounds from 12 to 14 ft. in height and higher, say 20 ft. above the ground before it was cultivated" (Haywood 1823:153).

The only well-documented statue from this area is CSS-023, which was plowed up on a farm in 1903 by James W. Terry (Smithsonian Catalog Card, Number 334006, Accession Number 94776). The Rock Woman quickly became a local legend that was thoroughly researched for a dissertation by Edwina Doran (1969). Frances Terry Lee, Terry's daughter, recounted her childhood memories of the statue:

> Daddy plowed it up. A lot of people thought it was a dead person that had petrified and they didn't want to be around it. But I played school with it. I'd line it up on the stairsteps with my dolls and dogs to be my pupils, and it was the most dependable—the only one that stayed with me.
>
> Mother always thought it might have been from the Mound Builders. Its eyes were closed, but I want to stress its features were small but not childlike. The tiny twist of hair in the back suggested a grownup. Its hands were folded.
>
> Daddy loaned it to some boys who showed it at the Cookeville Fair. They took pictures of it and advertised it as the "Rock Woman," and they charged people to see it. Finally, Daddy sold it to the Smithsonian Institution [Doran 1984:137].

The statue was actually first purchased from Mr. Terry by William Myer on July 11, 1923. Later, it was part of the 1927 Smithsonian purchase from Myer's widow.

James Terry provided a description of where he found the statue in a letter to the Smithsonian Institution, reporting that there were no ashes or graves with the statue. He did mention, however, that there were graves 150 yards to the east, and that a rock shelter about half a mile to the northwest had evidence of habitation.

The Terry statue also became intimately intertwined with one of the longest lasting folklore traditions in this part of Tennessee—the "race" of "Little People" or "Pygmies" that supposedly once lived in White County. In 1820, an extensive area of small stone box graves was discovered and reported by Turner Lane, a local resident (*Nashville Whig,* June 1820). His report, along with that of other locals, formed the basis of John Haywood's extensive account of a race of Tennessee pygmies.

A number of small skeletons were discovered a few miles from Sparta, Tennessee, in White County, an account of which was given by a Mr. Lane. The graves were about two feet in length, fourteen inches broad, and sixteen inches deep. These extend promiscuously throughout the farm of Mr. Lane, and in a large and closely connected burying-ground in the vicinity; there were others of the same description four miles south of Sparta, and it is said that hundreds of them might be found throughout the locality... From the great number of small graves found here, says Mr. Lane, all of the same description and, among them all, but one being of a large size, it seems to indicate that there was, in ancient times, a race of people whose height was from two feet ten to three feet [Haywood 1823:200–209].

George William Featherstonhaugh (1780–1866), the first U.S. government geologist, conducted a geological survey in 1834 of what was then the western country (Berkeley and Berkeley 1988). The story of the pygmies had reached the nation's capital, and Featherstonhaugh wrote that "I had heard of Indian graves of a peculiar kind that were found here, and was desirous of inspecting them" (1844:48).

Featherstonhaugh visited several of the local sites producing the small graves, including the one that had caused the initial excitement. "Mr. Lane and his friends were now convinced—as they still are—that they had discovered an ancient race of pigmies that had been buried in this valley before the existing forest had grown up ... they pronounced the skulls and bones to have belonged, not to children of the ordinary Indian race, but to adults of a pigmy race. A book was next written about it, and it became one of the wonders of the western country" (Featherstonhaugh 1844:48). After opening one of the graves and examining other remains, Featherstonhaugh satisfied himself that they were not the remains of pygmies. As a scientist, he could not resist trying to make the case for an alternative interpretation—with little success:

Before we parted with Mr. Doyle, I essayed to undeceive him about the pigmy race, and told him it was the custom with a great many tribes of Western Indians to expose their adult dead upon scaffolds, and when all the soft parts had wasted away, the bones of the skeleton were put into very short graves; that if he would consider the size of the oldest skulls he had found, he would see that they had belonged to individuals with as larges heads as our own, which would have been both inconvenient and unnecessary to a pigmy race. But Mr. Doyle was not at all pleased to have his wonder taken to pieces in this way, and fought for his pig-

mies with all the pertinacity of an inventor of genera and species for shells. . . . I regretted my indiscretion, and was determined henceforth to be as careful about interfering betwixt a man and his pigmies as I would be betwixt a man and his wife [Featherstonhaugh 1844:49].

Joseph Jones also expended considerable effort attempting to dispel the story, noting that "[Haywood's] account of the pigmies of Tennessee is an example of how a wild hypothesis may, from the love of the marvelous, be founded upon a few hasty and imperfect observations. . . . I carefully examined the bones from the small graves near Sparta . . . and found them to be the remains of infants and children during the period of dentition" (Jones 1876:11–13).

Nonetheless, Edwina Doran's research during the 1960s demonstrates the persistence of the legends of the little people or pygmies and how they became intertwined with The Rock Woman. In local tradition, the statue was not sculpted from stone, but was rather the petrified remains of an ancient person:

I saw it. I am sure it was not a rock. The hair was done up on the back of the head. It if had been a child, it would not have been that way. It had the breasts of a woman—with one of the knocked off. It was bound to have been of the little race [Doran 1984:136].

It looked like a twenty-four-pound sack of flour—with a face and head. The hair was kinda rolling on the sides. She was probably one of the Mound Builders or one of the Little People [Doran 1984:136].

Despite efforts of researchers throughout the nineteenth and early twentieth centuries to dispel the story of the pygmies of Tennessee, they were resurrected most recently by Barry Fell, a Harvard emeritus professor of marine biology, in his book *Bronze Age America* (1982:85–97). As Stephen Williams (1986) has noted: "pigmies in Tennessee have a long shelf life!"

Statue CSS-023 (Figure 5.6). CSS-023 is crudely sculpted with indistinct features. The hair seems to be in a roll over the top of the head, with a hair knot on the back similar to CSS-021. The eyes, nose, and lips are in relief with an incised opening. Hands meet on the abdomen, and there is an indication of knees or legs at the front of the base. The features that most impressed the early viewers were the breasts. The left had been broken off the figure (Doran 1969:65). One of Doran's informants provided the following description: "Old Uncle . . . thought this thing warshed down from the graveyard during a big flood. The graves have since disappeared. It was sortie the

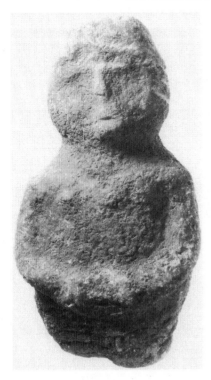

Figure 5.6. CSS-023. Smithsonian Institution, Museum of Natural History, Washington, D.C., MNH-1953.

color of a light-colored limestone rock, and it looked grainy, just similar to a rock. It showed to be a womern's body and face, but it was off about the waist, and one of the breasts had been broke off. It showed the shape of the eyes and all but didn't show the color. It seemed like there'd been hair there, but that didn't show too well" (Doran 1984:136).

Other Possible Statues. Virtually no information is currently available about the other three images from the vicinity. Haywood provides only a brief description of a possible additional statue (CSS-022) from Cherry Creek, indicating that it was depicted "from the waist upwards." However, reexamination of the context of Haywood's statement suggests that this image was probably a ceramic figurine rather than a stone statue. Doran (1984:138) indicates that this image had been found "at the same site [as CSS-023] in 1820." The current whereabouts of this image are unknown.

Doran also provided a brief mention of two other stone images "of human heads" that were plowed up about 4 miles from Sparta by Arthur Brown in the 1950s. Brown attached the larger image to a storage building. His farm became known as "Stonehead farm" and he was sometimes called by the nickname "Stonehead Brown" (Doran 1984:140). Whether these represent two more examples of Tennessee-Cumberland style statuary is un-

certain since we were not able to examine these during the statuary survey (CSS-072, CSS-073).

While the pygmies of Tennessee are only peripherally related to the stone statue from the vicinity, the beliefs and legends that came to link them with the Rock Woman are an excellent example of the pervasive influence of the statuary on the social and cultural heritage of some regions.

Cardwell Mound Statues—CSS-065 (Figure 5.7) and CSS-066

Two statues are reported to have been found at the Cardwell Mound site (40WR15) in Warren County, Tennessee (CSS-065, CSS-066). This unusual site contains a single mound on an elevated plateau forming the northern spur of Cardwell Mountain. The site has long been recognized as a significant ceremonial area: "The mound ... on the first step of the larger mountain was, without question, the center of activities, with the three large level fields now used as the Cardwell orchards, the gathering places of hords [*sic*] as they came to worship or sit in council" (Womack 1960:9–10). The summit and core of the platform mound were destroyed for placement of a large apple storage cellar in the nineteenth century, and the mound has been subject to digging (authorized and unauthorized) for many decades. The records of Major Henry Cardwell's finds in the mound are limited, but he reportedly "found many artifacts left by these ancients. He also found conch shells" (Womack 1960:10). Limited archaeological testing of the mound and surrounding level fields in 1991 indicates that the periphery of the mound stages remain intact (Smith 1993b). The artifacts recovered during these investigations are diagnostic of Middle-Late Woodland and Early-Middle Mississippian occupations. A wood charcoal sample from a test unit 30 m northwest of the mound yielded an uncorrected date of about A.D. 1200 (750 ± 70, TX 7416).

Only a few details are available concerning the two statues from the site. Sometime before 1970 or 1971, a local artifact collector showed a "female idol" (CSS-066) found on Cardwell Mountain to Shelby Griffin Smartt, a resident of McMinnville. Armed with the knowledge that these "idols" were often buried in male-female pairs, Mr. Smartt and two friends "found" a second statue (CSS-065) in the remains of the mound. The statue was donated to the Tennessee State Museum in 2003 by the heirs of Shelby Griffin Smartt and his wife Tennie Tim Smartt and is on display in the museum's *First Tennesseans* exhibit as a "male statue." No additional information is available on the "female idol."

Although not among the best sculpted or preserved examples of statuary in the survey, CSS-065 retains several features of the upturned face, including the nose, mouth, and a faint depiction of the eyes. The only observable details on the torso are the absence of nipples and an apparently unique depiction

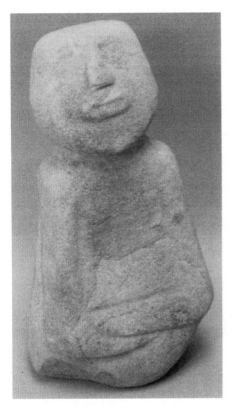

Figure 5.7. CSS-065. Courtesy Tennessee
State Museum.

of the arms—crossed left over right on the "lap" of the statue. The seating
position is not clearly sculpted.

The Western Periphery of the Nashville Basin

After meandering through a series of near horseshoe bends west of Nashville,
the Cumberland River begins a more direct course after entering the High-
land Rim. West of the modern town of Ashland City, two significant tribu-
taries enter the Cumberland within about a mile of each other—the Harpeth
River on the south and Sycamore Creek on the north. In contrast to the dense
cluster of mound centers and associated settlements in the Nashville Basin,
a series of single mound centers and potentially associated small villages are
relatively evenly spaced (10–15 km) along this portion of the Cumberland
River. These sites are primarily known from antiquarian records and very
limited (if any) modern excavations. Four statues, including a statuary pair,
are reported from sites in this vicinity.

Sycamore Creek Statue (40CH74)

According to Goodspeed's *History of Tennessee,* a statue (CSS-032) was plowed up in about 1890 "within a few miles of Ashland City . . . at the mouth of Marrowbone Creek . . . where the most noted" of the Indian burial grounds in Cheatham County was located (Goodspeed et al. 1887:950). While impossible to determine for certain, the Marrowbone Creek attribution appears to be an inaccuracy in Goodspeed. No other period documents record a "burial ground" at the mouth of Marrowbone Creek, but the burial ground at the mouth of Sycamore Creek is frequently mentioned. In addition, the mouth of Marrowbone Creek was located at the edge of Ashland City, while Sycamore Creek, located 3 miles from the city, better fits the description as "within a few miles of Ashland City." Archaeological surveys of the area have not confirmed the location of a major burial ground at the mouth of Marrowbone Creek, but site 40CH74 is recorded as a Mississippian "burial ground" at the mouth of Sycamore Creek. While the specific provenance of CSS-032 cannot be confirmed, the records do suggest an origin in Cheatham County on the western edge of the Nashville Basin.

Dr. I. B. Walton, a dentist and Confederate Veteran who lived at the village of Cheap Hill, 2 miles northwest of the Sycamore Creek site, purchased CSS-032. His wife inherited the figure upon her husband's death and thereafter sold it to William Myer (Smithsonian Catalog Card, Number 334010, Accession Number 94776).

Statue CSS-032 (Figures 5.8, 5.9, 5.10). Although the sex cannot be definitely determined, CSS-032 is probably male based primarily on the horizontal hair knot and the absence of breasts and nipples. The statue suffered considerable plow damage in both the front and back of the lower torso, and what appears to have been a prominent nose is missing. In addition to the hair knot, it has a straight hairline and a short part in the front. Ears protrude and have semicircular parallel incised detailing. The eyes are close together and are both incised and in relief, as is the mouth. The head is turned slightly to the left and not inclined backward. While extremely stocky, the arms are the only features indicated below the neck. The right arm is bent, while the left is straight. The most unique feature is an overlapping groove carved at the juncture of the neck and body on the front.

Murphy Farm (40MT48) Statuary

Dr. Morgan Brown laid out the town of Palmyra in Montgomery County on the south bank of the Cumberland River, 9 miles southwest of the mouth of the Red River. The town was incorporated in 1796. On October 1, 1799, Dr. Brown wrote to Thomas Jefferson, then vice president of the newly created United States, in Philadelphia. In his letter, he described the discovery of

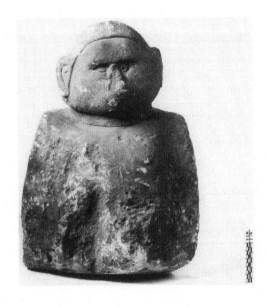

Figure 5.8. CSS-032, front view. Smithsonian Institution, Department of Anthropology, Washington, D.C., 83-13486.

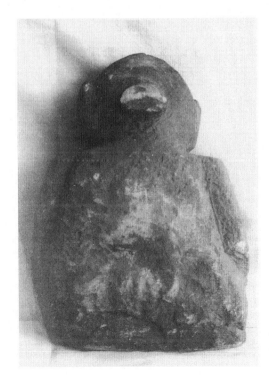

Figure 5.9. CSS-032, rear view. Photograph presumably by William E. Myer. Courtesy Samuel D. Smith

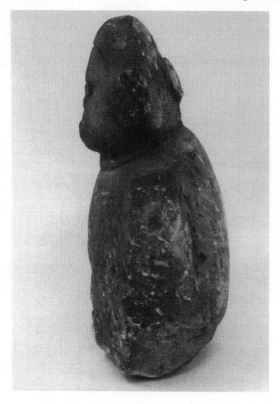

Figure 5.10. CSS-032, profile.

two "stone or Marble statues . . . taken out of the ground within a few miles of [Palmyra]." The figures were plowed up by a farmer on a "high bluff" on the north side of the river with "two large mounds a little to the west" and a "quantity of human bones under and near them." This description can only refer to the Murphy Farm site (Brown 1799).

Five 1/2 miles southwest of the mouth of the Red River on a bluff between the Cumberland and Sally Willis Branch is a large but poorly documented mound site known at different times as the Allen, Kimbrough-Sory, and Murphy Farm [40MT48]. Based primarily on anecdotal information, the site appears to have originally included a single platform mound, one burial mound, a substantial habitation area, and a stone box grave cemetery.

Brown reported that they were damaged by the plow and also by "the rustic inhabitants who first came to see them." He assured Jefferson that they were "still sufficiently entire to shew the degree of knowledge in sculpture the Aborigine had attained to." Brown offered to send them to Jefferson by way of Natchez or New Orleans if he were interested (Brown 1799).

Jefferson received the letter on December 30, and on January 16, 1800, informed Brown that he would gladly accept his offer, since "such monuments

of the state of the arts among the Indians are too singular not to be highly esteemed . . . they will furnish new and strong proof how far the patience and perseverance of the Indian artist supplied with very limited means which he possessed" (Jefferson 1800).

The "Indian busts" were shipped to Jefferson's agent, Daniel Clark Jr., in New Orleans, who then shipped them along with some pecan and orange trees via Philadelphia in July 1801 (Clark 1801). As mentioned in the introduction, Jefferson placed them in his museum, the entry of Monticello, which was also called the Indian Hall. Here they remained until after his death. Dr. James Barclay, who purchased Monticello, gave "a number of heathen idols" to Dr. Plummer of the Missionary Society of Boston, where they were displayed in the missionary rooms as late as 1831. Their current whereabouts are unknown.

Statuary Pair CSS-033 and CSS-034. While no illustrations of these two figures are known, several sources describe them well. The pair was apparently shown without clear indications of legs but "sitting in an Indian position" (*Niles' Weekly Register,* January 4, 1817). They also appear to have been leaning slightly forward (perhaps similar to CSS-001). Their source material was debated: "some people think they are formed of a solid stone cut with a chisel, while others think it is a moulded composition and fired like porcelain. It is uncommonly hard" (*Richmond Enquirer,* July 4, 1808). Dr. Brown's original description of them as "stone or marble" is probably the more accurate, since a low-grade marble is found in the area. Statue CSS-035, also from Montgomery County, is sculpted from this material.

One of them is noted as "representing an old Savage, in which the wrinkles in his face, and his whole countenance [are] peculiarly expressive" (Kennedy 1994:321, note 8). The "wrinkles" on the old man's face are a typical feature on other statues from the area. The female was also referred to as being "old," perhaps indicating she also exhibited these features. While virtually all observers pointed out that they were indeed heavily damaged, their features or "lineaments" were deeply cut and could be recognized.

Joseph Jones provides an additional description that is apparently of the two statues: "Dr. Brown had two stone images which were exhumed during the ploughing of the ground, near a very large mound below Charlottesville [Clarksville?]. One represented an old man, with his body bent forward and his head inclined downwards, exceedingly well executed. The other represented an old woman" (Jones 1876:133).

Wallace Farm Statue

Statue CSS-035 is said to have been recovered from "a mound on the Wallace Farm, near Clarksville" by H. L. Johnson in 1887 (Thruston 1890:105). At that time, Thomas H. Wallace and his father both owned farms approxi-

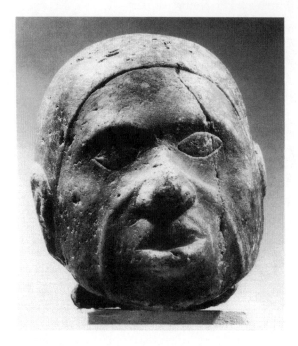

Figure 5.11. CSS-035, front view. Courtesy The Metropolitan Museum of Art, The Michael C. Rockefeller Memorial Collection, Bequest of Nelson A. Rockefeller, 1979 (1979.206.1139).

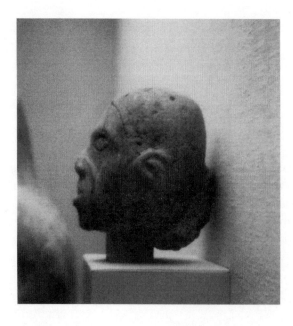

Figure 5.12. CSS-035, profile.

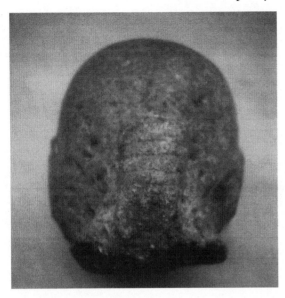

Figure 5.13. CSS-035, back.

mately 11 miles northwest of Clarksville in Christian County, Kentucky. After the published mention of the find spot in Thruston's *Antiquities of Tennessee,* Wallace married Ellen Dabney. Wallace then became owner of a farm 8 miles to the northwest along Little West Fork, which some have mistakenly argued was the find spot. Both of these sites are now on the Fort Campbell Military Reservation, and of the two, the Kentucky farm is the most likely find spot.

H. L. Johnson, who discovered the head, was a relic collector from nearby Clarksville, Tennessee. After his death in 1916, Johnson's enormous collection (representing over 40 years of dedicated "hunting") was sold in Boston. The head, accompanied by Thruston's description, was pictured in the auction catalog. Stephen Williams of the Peabody Museum recounts that the piece was brought to him in the 1940s or 1950s in a knitting bag and appeared to be a bowling ball until pulled from the bag. The head eventually became part of the Nelson A. Rockefeller collection and was exhibited at the U.S. Embassy residence in Paris in 1968 and the Princeton University Art Museum in conjunction with a symposium on Red Power in 1970. It was incorporated into the Metropolitan Museum of Art collection in 1979, where it now resides.

Statue CSS-035 (Figures 5.11, 5.12, 5.13). CSS-035 has a straight hairline, the upper part of an elongated hair knot on the neck with incised horizontal lines across it, incised almond-shaped eyes, and realistically detailed ears in relief. Wrinkles, described at times as tattoos, are depicted running from the nostrils to the jaw, similar to the description of the Murphy Farm pair. The

round face, 7 1/2 inches high, could have fitted onto a body "down to the waist" with the same dimensions of the Jefferson pair, 18 inches. The occipital region is compressed. The head exhibits an open mouth and broad nose.

Trigg County, Kentucky, Statuary

West of Clarksville, Tennessee, the Cumberland River turns northward and flows into Kentucky toward a confluence with the Ohio River. Two stone statues are reported from Trigg County, Kentucky, along the Lower Cumberland.

As probably the first explorer to discover a Tennessee-Cumberland style stone statue, Harry Innes deserves some special mention. Discovered 5 or 6 inches beneath the surface in July 1790, near the Cumberland River some 70 miles south and west of Lexington, Kentucky, Innes sent the statue to President Thomas Jefferson. As noted earlier, the gift "found by a farmer as he was plowing his corn field" became the first piece in Jefferson's collection of Native American sculpture. Based on the description, the statue was probably found in the vicinity of the Little River and Canton Mound sites.

In August 1791, Jefferson, still believing it to be a woman in labor, gave it to the American Philosophical Society. Their artifacts and antiquities were given in the late 1800s to the Academy of Natural Sciences of Philadelphia, and later the statue entered the Fitzhugh Collection of the Heye Foundation (Boyd 1965), eventually to become part of the National Museum of the American Indian collections.

Statue CSS-049

Innes correctly described the female, CSS-049, as "roughly executed." The statue is exhibited in a kneeling position with the legs indicated on the sides. The hands with incised lines to indicate fingers are on the knees. Nipples are in relief as are the eyes, nose, and small oval mouth with an incised center. A crescent-shaped raised area above the eyes could indicate either her brows or hairline. On the back of the head is a typical hair knot. Her round face is inclined backward and is slightly tilted to the right.

Statue CSS-050 (Figure 5.14)

Little information is available about the provenance of the second statue from Trigg County, Kentucky. CSS-050 was illustrated and discussed by Bennett Young, who gives the find spot as "a mound on the Cumberland River in Trigg County" (Young 1910:268). Perhaps made from the same type of stone as CSS-049, it was badly eroded by the elements on its front side, while the back retained "clear cut lines" and better definition. The faced inclined back-

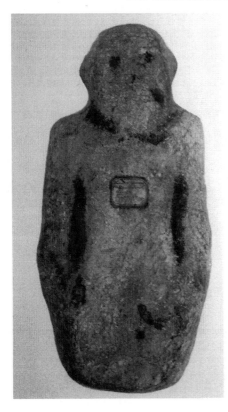

Figure 5.14. CSS-050 (Young 1910:264).

ward and had a massive jaw and protruding ears. Its arms to the side, prominent head, and similar dimensions bear a resemblance to CSS-049.

Tennessee River Valley Statuary

Outside the Cumberland River drainage, 10 possible Mississippian statues have been reported from a scattered series of sites along the length of the Tennessee River. The river runs southwestward from its origins in the Appalachian Mountains in eastern Tennessee, turns west through north Alabama, and then flows northward through Tennessee and Kentucky to a confluence with the Ohio River. Along this vast length of river, three eccentric statues have been recovered as outliers. An additional three of the 10 seem to fit more clearly into the Tennessee-Cumberland style. The last four of the set are documented only incidentally.

Strawberry Plains Statue (CSS-044; Figure 5.15)

In far northeastern Tennessee, the Holston and French Broad rivers converge to form the Tennessee River near the city of Knoxville. Somewhere in this

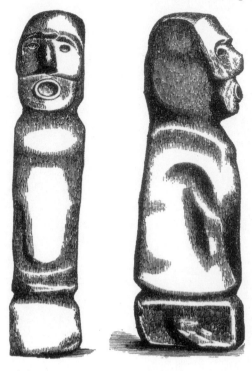

Figure 5.15. CSS-044 (Jones 1876:Figure 66).

vicinity, the eccentric statue CSS-044 was reported discovered in a cave "near Strawberry Plains, 16 miles east of Knoxville, Tennessee" (Wilson 1898:470). Pinpointing the find spot of the statue is difficult, since the cliffs along the Holston River near Strawberry Plains are peppered with caves and rockshelters. The nearest significant Mississippian site is the Loy site (40JE10), a mound center located east of Strawberry Plains in Jefferson County.

CSS-044 is one of the most eccentric statues examined in our survey. Exercising considerable imagination, one can envision anatomical features. The face exhibits the only detailed sculpted features, including incised eyes framed by prominent brows, a prominent nose, and a mouth depicted by an incised oval opening with lips in relief. Above the mouth and crossing the eyes and nose is a feature in relief that could be interpreted as a mask. The sculpting of the torso is relatively abstract and difficult to interpret. The "arms" are only vaguely indicated. The right profile seems to show a base or stool, while the left profile may indicate a kneeling leg and foot. The front of the torso seems to have a simplified chest or breasts and the abdomen is represented in relief.

The rear of the statue shows some evidence of having been separated or broken from a larger piece of stone, leading Joseph Jones to suggest that it was

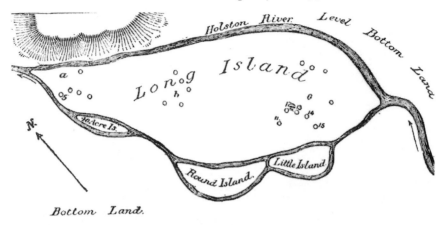

Figure 5.16. Long Island of the Holston (Thomas 1894:Figure 238).

fashioned in place from a stalactite and later broken from the cave wall. The statue was collected by Captain Edward M. Grant of Nashville and presented to the Smithsonian in 1868. The 1886 *Handbook of the National Museum* provides the following description: "One of the most valuable objects in the Museum is a stone image, 20 inches long, weighing 37 pounds 4 ounces, discovered in a cave near Strawberry Plains, 16 miles east of Knoxville, Tennessee. This relic consists of crystalline limestone, the fracture of which can be seen at the back of the head where the figure seems to have been detached from the rock out of which it was sculptured. This is undoubtedly among the best sculptures thus far discovered in the United States, and compares favorably with kindred sculptures of Mexico or Central America."

While too eccentric to readily classify as part of the Tennessee-Cumberland style statuary, CSS-044 remains historically significant as one of the earliest statues acquired by the Smithsonian Institution.

Long Island of the Holston Statue (40RE17)

Prior to construction of the Watts Bar Reservoir, Long Island was the largest of a series of islands in the Holston River of eastern Tennessee. According to Cyrus Thomas (1894:358), Long Island was 3 to 5 miles long and 1 mile wide at its maximum extent. After the impoundment of the reservoir, the find spot of CSS-043 on Long Island in the Tennessee River was flooded, and today only the higher elevations of the big island are visible.

At the time of the Bureau of Ethnology's mound exploration survey, Thomas recorded 19 mounds in three clusters or "groups" on Long Island (Figure 5.16). Group A, on the westernmost (downstream) end and Group B in the middle of the island were both recorded as containing five mounds.

Group C, the easternmost cluster, was recorded as containing nine mounds and an associated habitation area. The Long Island statue was discovered in Mound 3 of Thomas's Group A on the downstream or western end of the island.

In 1889, Mound 3 was recorded as extending 93 ft north-south and 105 ft east-west. At that point, it was only five ft in height, having been reduced to an unknown extent by 60 years of cultivation and digging by a "previous explorer." Since this is one of the only statues recovered with any semblance of contextual data, we have included Thomas's description verbatim:

> The body of the mound was composed of dark, sandy soil similar to that of the surrounding surface of the island, with numerous small patches of yellow clay scattered through it without any apparent order or arrangement. In it were five skeletons near the original surface of the ground . . . In the center, at *a,* was a large, boat-shaped vessel of clay, 9 feet long, 4 feet wide in the middle, but tapering to each end, and about 15 inches deep. This vessel, which was probably only sun-dried, was watersoaked to such an extent that it crumbled into minute fragments when an attempt was made to remove it. It lay northwest and southeast and contained an adult skeleton lying at full length with the head northwest. In the vessel, near the head of the skeleton, was the stone image . . . [Figure 5.17] This, which represents a squatting figure, is 14 1/2 inches high and is carved out of stone. At each of the points marked *h, h, h, h,* corresponding with the cardinal points, was a sitting skeleton facing toward the center. With the one at the north was a clay pipe and two discoidal stones, lying by the feet of the one at the east was a large shell, and with the one at the south were two polished celts, one of which was broken [Thomas 1894:359–360].

During the Watts Bar Reservoir excavations in 1941, Rowe interpreted the mound (WPA number 28Re17) as a domiciliary mound (at least in the uppermost stages), but four large oval pits from the earlier excavations had destroyed any definitive house patterns. In addition, Rowe concluded that two of the "mounds" in Group A were actually natural rises.

Statue CSS-043 (Figure 5.18). Statue CSS-043 exhibits several features typical of Tennessee-Cumberland style statuary, but the treatment of the base is unique. The head appears to exhibit a compressed occipital region and a long hair knot. The eyes and mouth are in low relief. The face is inclined backward at a 22-degree angle. A very pronounced treatment of the rib cage above a depressed abdomen is framed by the arms on either side. The arms end above the knees and no definite representation of the hands is visible. The treatment of the legs and base is unique. The knees are sculpted as pro-

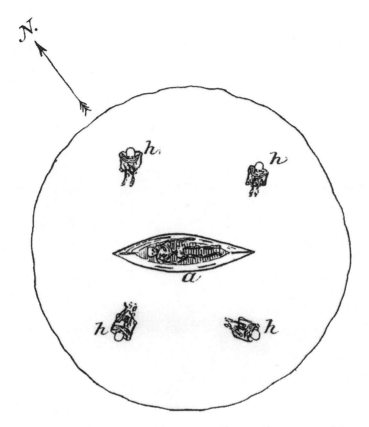

Figure 5.17. Plan view of excavations (Thomas 1894:Figure 239).

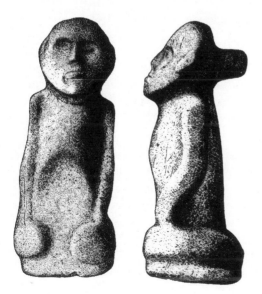

Figure 5.18. CSS-043 (Thomas 1894:Figure 240).

nounced circles on the front under the "hands" while the legs extend down the sides with no visible feet. The buttocks are sculpted. Below the buttocks is a shallow base, circular on the bottom, which is distinctly separate from the physical features of the statue.

Citico Statues? (CSS 079-082)

William Myer briefly mentions four statues from the Chattanooga area that may have been found at the Citico site (40HA65). Virtually no reliable information is available since the statues were destroyed by fire without any known surviving drawings, photographs, or detailed descriptions. The brief description implies that they probably fit within the Tennessee-Cumberland style, but cannot be considered definitive.

Myer corresponded with William J. Seever concerning the four statues in 1919. On February 8, 1919, Mr. Seever wrote: "I purchased four large stone idols, which were almost replicas of the Humphreys County find [Link Farm pair, CSS-036 and CSS-037], from parties who had taken them from a mound on the Tennessee River, just above Chattanooga. These were utterly destroyed by fire shortly afterwards. I always had the thought that the same party made them. The distance between the two finds is not so very great, and easily reached by water" (Myer 1923a:681). In a second letter dated February 22, 1919, Mr. Seever continued: "The images I wrote you about in a former letter were found just above Chattanooga. In those days one was not as careful abut details, but from what I was told me I was inclined to think that these were found on the Citico Mound. I did not personally find them [but] bought them of the finder. He told me they struck them when ploughing. Whether it was on or near the mound I cannot now say. Mound was mentioned" (Myer 1923a:681). Seever's intimate familiarity with the Link Farm statues (CSS-036, CSS-037; Seever 1897) lends significant credibility to his statement that they were "almost replicas."

The Citico site, although largely destroyed in the nineteenth and early twentieth centuries, was clearly the center of a significant polity involved in the exchange of Southeastern Ceremonial Complex items. Citico is believed to have been first occupied not long after A.D. 1200 with occupations extending into the early historic period (Hatch 1976). Competition between the polities centered at Citico and Etowah has been suggested as a possible explanation for the brief abandonment of Etowah in the early thirteenth century (King 2003:124–125). While the loss of the four statues limits current interpretations, the geographical location of Citico between the two primary production areas for Tennessee-Cumberland style statuary lends some additional credence to the notion that the shrines atop the Citico Mound may have contained stone statuary pairs in addition to the multitude of other sacra discovered at the site.

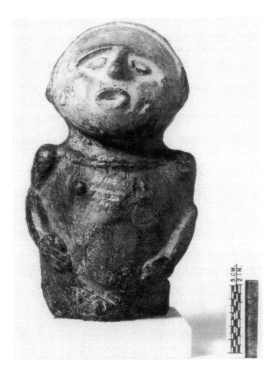

Figure 5.19. CSS-028, front view. Smithsonian Institution, Department of Anthropology, Washington, D.C., 83-9337.

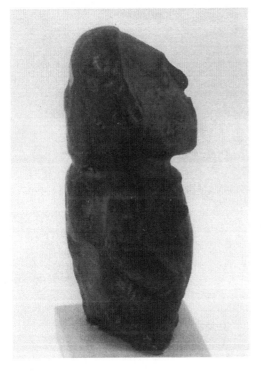

Figure 5.20. CSS-028, profile.

Sequatchie Valley Statue (CSS-028; Figures 5.19, 5.20)

Downriver from Chattanooga and the Citico site, the Sequatchie River converges with the Tennessee. As some point prior to 1845, a small stone statue was discovered somewhere in the Sequatchie Valley: "I have another image made of stone similar to that of the two mentioned above, but it is only nine inches high; it much resembles the first. It was found in the Sequatchy valley" (Troost 1845:363; illustrated p. 364).

At only nine inches in height, CSS-028 is among the smallest of the stone statues included in our survey. Shown without legs, the face is inclined backward at an angle of 28 degrees. The face is well carved with almond-shaped eyes in relief, nose, oval mouth with a depressed center, and small ears. A straight hairline in relief seems to indicate a hair roll, while a small 3/4-inch hair knot is centered in the flattened occipital region. The torso exhibits prominent collarbones, nipples, and arms terminating in hands on the abdomen. The statue probably represents the character of the Old Woman rather than part of a statuary pair. The Smithsonian cast shows damage on the statue where a vulval motif could have been depicted, although Troost does not mention this feature.

Elk River Statue—Daniel Mound Statuary (40LN96)

Flowing southward out of Tennessee to a confluence with the Tennessee River in Alabama, the Elk River drainage has produced one known eccentric statue (CSS-042). Discovered at the "edge" of the Daniel Mound site (40LN96), the site and the statue present many questions. The feature known locally as the Daniel Mound is a stone mound situated on a hill in the forks of Mulberry Creek, which empties into the Elk River 2 1/2 miles to the south. While archaeological information is limited, the mound has generally been assumed to be of Woodland period construction. Farther down the Elk, there are numerous small Mississippian settlements.

Another artifact said to be from Lincoln County is in the collections of the Museum of the American Indian. The six inch sandstone head with eyes, eyebrows, nose, mouth, cleft chin, and ears, but no hair indicated, came from the collection of William M. Fitzhugh and has the catalog number 19/2192. It cannot be determined if it was originally part of a larger statue.

Statue CSS-042 (Figure 5.21). The statue appears to have been sculpted from a thin slab of sandstone, since its horizontal features are not in proportion to those of its depth. Apart from its arms, most of its other features are out of proportion or distorted. With abrasions in the areas of the eyes, the head has a straight incised mouth and a crudely sculpted nose. On either side of the head toward the rear of the crown are projections resembling horns, but which can be interpreted as hair buns. The legs, drawn up with the knees

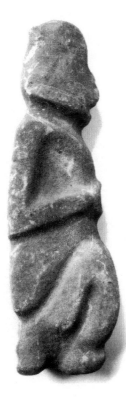

Figure 5.21. CSS-042. Smithsonian Institution, Department of Anthropology, Washington, D.C., 31105-D.

against the abdomen, along with the feet are pressed together in front. There is an indication of the spine. The two most uncharacteristic features are the low "stool" or platform on which the figure sits and a round object or disk held by both "hands" in front of the abdomen. The disk had a depression in the center, potentially suggestive of a chunkey stone.

McKelvey Mound Statue (40HR30)

The McKelvey Mound site included an earthen mound located less than a mile north of the Alabama state line on the east bank of the Tennessee River in Hardin County. Now inundated by Pickwick Lake, this multicomponent site was excavated by W. S. Webb and D. L. DeJarnette during the 1930s prior to the impoundment (1942:9–25). Before discovery by the Tennessee Valley Authority during timber clearing, the site was covered by a grove of cypress trees whose extensive root system had prevented cultivation, although the top of the mound had been used as the site for a tenant house.

Mound construction was initiated atop a shell midden apparently associated with a Late Woodland and/or Emergent Mississippian component, as reflected in the limestone- and mixed clay-grit-tempered sherds. However, the statue appears to have been associated with the fully developed Missis-

Figure 5.22. CSS-038, in situ (Webb and DeJarnette 1942).

sippian component. Other artifacts, including sandstone palettes, recovered from presumably related portions of the mound, suggest connections with the Moundville region. Since this is one of the only statues recovered during professional excavations, Webb and DeJarnette's observations and interpretations are included verbatim:

> Feature No. 11.—This was a sandstone human effigy found lying on its side at a depth of 3.5 feet below stake 45R3 . . . Nearby were sherds of a crushed pot and a charcoal area with some scattered animal bones and animal jaws. It is not certain that this material was an intentional association with the sandstone effigy. There was no burial and no burial pit in association [Webb and DeJarnette 1942:11].

> The most interesting stone artifact from this site is the sandstone human effigy. . . . Beyond being clearly a human effigy, it is not possible to see in it any special form delineated. It has a maximum height of 16 inches and a maximum breadth of 9 inches. While the head is fairly well expressed, the trunk is not so clearly executed. Below the neck and shoulders the effigy is rough and unfinished. The back of the head is decorated by seven parallel deeply incised lines about 1/2 of an inch apart. The effigy has a smooth but rounded base, and it was evidently designed to set erect, perhaps on a clay floor. The eyes are made by incised ellipses but the other features were worked in low relief. The nose portion was slightly damaged and the head was broken from the body just

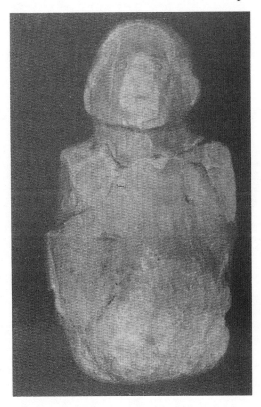

Figure 5.23. CSS-038 (Webb and DeJarnette 1942).

below the neck. One shoulder was broken off, and a portion was missing. It was found lying on its side . . . but breakage had been done before discovery, perhaps at the time of deposition. The nature of the fracture, when one considers the size of the object, would suggest "ceremonial breakage" [Webb and DeJarnette 1942: 18].

Interpretation of the excavation records suggest that the sand layer in which CSS-038 was buried may have been associated with a nearby 25-by-28-ft structure. When uncovered, CSS-038 was lying on its left side (Figure 5.22). The paint palette loosely associated with the statue has been dated to the Moundville I through Moundville III phases in regions to the south. Unfortunately, the wide chronological span of this artifact prevents any tight temporal placement, with uncorrected dates ranging from A.D. 1030 through 1550.

Statue CSS-038 (Figure 5.23). Seven parallel deeply incised lines half an inch apart on the back of the head may have been intended to represent an elongated hair knot. This feature along with the pointed hairline at the temples tends to indicate the gender depicted was female. Since there are no

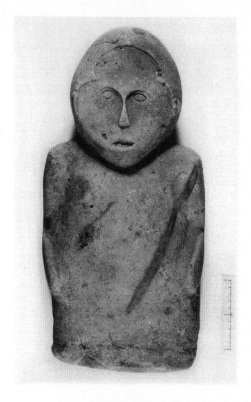

Figure 5.24. CSS-064, front. Frank H. McClung Museum, University of Tennessee, Knoxville.

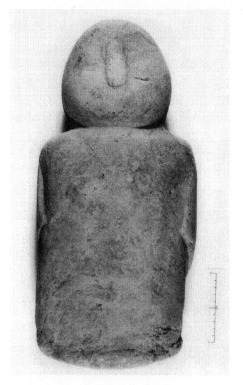

Figure 5.25. CSS-064, back. Frank H. McClung Museum, University of Tennessee, Knoxville.

visible features below the neck, except a hint of arms to the side, these are the only elements indicative of gender.

The eyes are incised ellipses; the nose has been damaged; the mouth and ears are in low relief; and the base is rounded, indicating this sandstone statue had to sit in a depression in the earth in order to stand upright.

Another Hardin County Statue (CSS-064; Figures 5.24, 5.25)

Among the handful of stone statues discovered in the past two decades is another from Hardin County, Tennessee. The statue was discovered by Larry Shannon while surface collecting "near the Tennessee River" on March 19, 1992 (a more specific locale is not available). The statue was found along with a broken eccentric polished stone mace or ax with serpentine incised lines and an unusual four-legged stone "stool" (Central States Archaeological Societies 1993).

CSS-064 is another eccentric statue that does not precisely fit the core description of the Tennessee-Cumberland style statuary from the Nashville Basin. The elements of face and torso most closely resemble the female statues CSS-039 and CSS-045 that we have postulated are representations of the Old Woman, although the female genitals depicted on both those statues are not present on the Shannon statue.

6

Ohio and Mississippi Valley Statuary

An idol, of which this is a correct miniature, was, a few years since, dug up in Natchez, Mississippi, on a piece of ground, where, according to tradition, long before Europeans visited this country, stood an Indian Temple.

—Caleb Atwater 1820

Eight statues included in our survey were recovered at widely scattered locations outside the Cumberland and Tennessee river drainages. Although we discuss these together as originating in the Ohio River and Central/Lower Mississippi River valleys, this is for organizational purposes rather than describing a coherent subset of statues.

One feature that does link several of these statues is the material from which they are sculpted—calcium fluoride. Commonly known as fluorite or fluorspar, this relatively soft mineral comes in a variety of colors, including light green, yellow, bluish green, purple, white, brown, and many shades of blue. Deposits of calcium fluoride are widely accessible in an area referred to as the Illinois-Kentucky fluorspar region. The deposits are divided by the Ohio River into two districts in southern Illinois and western Kentucky. This type of stone was commonly used to create small effigies, pendants, and ear ornaments, some of the latter being found at sites very distant from the geological source area.

Statues created from this colorful mineral have been documented only from sites within or near the fluorspar region, including examples from southern Illinois, southern Indiana, western Kentucky, and northern Tennessee. This commonality of material type does not necessarily imply a common production site for the fluorite statues. We suggest that it simply underlines the assertion that statues in the Tennessee-Cumberland style were generally produced using suitable stones available at or not far distant from the sites where they were discovered.

Obion Site (40HY14)

Of the many recorded Mississippian sites in west Tennessee, only the Obion site (40HY14) is known to have produced a stone statue. Located on the

north fork of the Obion River in Henry County, the Obion site "consists of a rectangular plaza, 900 ft long by 200 ft wide, surrounded by seven mounds" (Garland 1992:1). Dominated by a ramped mound 500 ft long and 30 ft in height, the site includes at least six other mounds and two depressions arranged around a central plaza. Although spatially not that distant from Middle Tennessee, the Obion River flows westward into the Mississippi River. By A.D. 1100 and perhaps a century earlier, the Obion site appears to have been the only large Mississippian town in the west Tennessee interior (Mainfort 1992:206).

In the spring of 1845, Solomon Hartsfield, one of the site owners, dug up the fluorite statue (CSS-041) as he was "cleaning out what he thought to be a sink" (Jones 1876:130). While the precise provenance within the site cannot be established, the "sink" may have been one of the "depressions" on the southwestern edge of the site. These features may represent borrow pits used as the source of mound construction fill, although additional investigations would be necessary to confirm such a function. In an issue of the *Franklin Weekly Review* (October 18, 1868) S. H. McWhirter reported that the statue was damaged in an 1857 house fire with only part of the head and some of the body (now lost) remaining (Jones 1876:131).

The vicinity of the Obion site is not rich in stone resources of any kind, including fluorite. The nearest potential source is approximately 35 miles to the northeast in what is now Crittenden County, Kentucky. Fluorite would likely have been the nearest colorful soft mineral available to the occupants of the Obion site. However, the available evidence does not permit interpretation of whether the raw material was brought to the Obion site for sculpting or the statue was imported after its creation.

Statue CSS-041 (Figure 6.1). Before the fire, the complete statue was described as "in a sitting position, the left knee and foreleg resting on the ground, the left arm against the body, and resting on the knee. The body stooped forward slightly; the right knee was elevated to the shoulder; the arm resting against the body, with the hand on the knee" (Jones 1876:131). With the exception of the position of the left leg, this description fits fairly precisely the description of that of the two better-documented fluorite statues from Illinois (CSS-052) and Indiana (IN-17-A). The description of the "foreleg resting on the ground" could be interpreted as similar to the position of the leg on one of the Sellars statuary (CSS-003) with the leg beneath the body instead of in front. Since this portion of the statue is now gone, the precise configuration of the body remains subject to various interpretations.

The hairstyle is straight with a hair roll with incised lines on the crown, possibly indicating plaiting, while segments on either side come down from underneath in front of the ears. The head is broken near the rear of the hair roll, so the complete form cannot be determined. The incised eyes are diamond shaped. The face is rounded with closed sculpted lips.

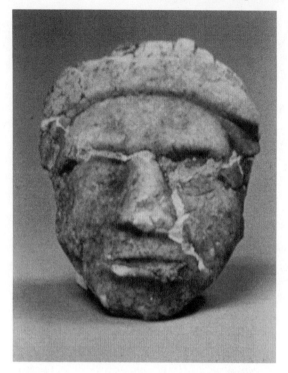

Figure 6.1. CSS-041. Smith-
sonian Institution, National
Museum of the American
Indian, Washington, D.C.,
Slide #2612.

The surviving front portion of the head, though damaged, displays fea-
tures that are so similar to IN-17-A from the Angel site in Indiana that we
are tempted to suggest that they might have been created in the same work-
shop. While the Angel nose is more prominent, the profiles are almost iden-
tical. The only significant difference is the larger size of the Obion sculpture.

Tolu, Kentucky

One of the most intricately carved and realistically detailed statues (CSS-051)
was discovered near Tolu, Kentucky, by Willard Johnson, while plowing on
the Mildred Orange farm in May 1954 (Figure 6.2). Sculpted from gray-
white fluorite, the surface of the statue exhibits small frost fractures suggest-
ing that it was not very deeply buried. The find spot is located on the edge
of the floodplain on the south bank of the Ohio River a few miles west
of Tolu.

The statue is one of the most detailed of the Tennessee–Cumberland style
statuary and is the only known statue to exhibit a beaded forelock (Waring
and Holder 1968:23). Beginning at the center of a hair roll, the hair lock and
two beads extend in relief to the right across the forehead. The hairstyle also
includes a longer than usual hair knot on the back of the flattened occipi-

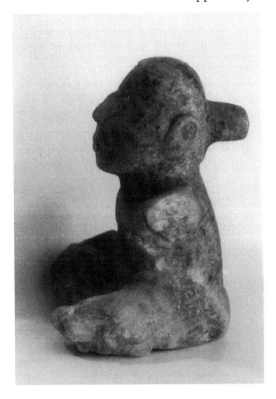

Figure 6.2. CSS-051.

tal region. The incised eyes are almond shaped. The ears are in relief and the mouth is realistically sculpted but closed with no tongue and teeth visible.

The torso is shown in natural proportion to the head and shows the lower rib cage in relief above a depressed abdomen. The arms, originally completely sculpted, were broken below the shoulders by the plow. With more damage, the left was retrieved in three pieces with the left hand and a portion of the left knee still attached to the lower section. The right section could not be found, but the right hand is still resting on the right knee. The hands have fingers indicated and an incised line across the knuckles. The lower torso is more detailed than in most statues with the right leg shown clearly crossed over the left. On the bottom of the statue, the unique feature of an erect penis and testicles are shown in relief, along with an anus surrounded by an incised concentric circle.

The nearest major Mississippian site is the mound complex at the Tolu site (15CN1) to the east of the find spot. The site originally contained at least three mounds, including one known platform mound and one burial mound (Kreisa 1995). Most of the available information on this site comes from excavations in 1930 under the direction of W. S. Webb and W. D. Funkhouser (1931), who documented a series of superimposed structures in the "ceremo-

nial mound." Although no radiocarbon dates are available, the ceramic assemblage suggests a temporal placement between A.D. 1200 and 1450, with the likelihood that the primary occupation lies within the first century of that time range.

Running Lake Mounds/Ware Site (11U31)

In 1873, Thomas M. Perrine unearthed a fluorite statue, CSS-052, at a site on the banks of Running Lake about 7 miles southwest of the towns of Anna and Jonesboro (Figures 6.3, 6.4). During the nineteenth century, this Mississippian mound complex was known as the Running Lake Mounds because of its location on the east side of a slough of the same name. Now known as the Ware site after a nearby community, the site apparently originally included at least four mounds (Milner 1993; Perrine 1873) with associated habitation areas.

The largest mound (Mound 3) was probably a rectangular platform mound. Mound 4 to the north may also have been a platform mound. The remaining two mounds were situated west of Mound 3. Although Mound 2 was disturbed by a historic graveyard, the northern side of this mound yielded a burned layer and "Indian graves" along with numerous large chert spades (Milner 1993).

Mound 1, the northernmost mound, had already been partially removed by the time Thomas Perrine investigated the site in 1873. About 1858, a significant part of Mound 1 was removed to provide earth for the causeway of the Mobile and Ohio Railroad crossing Running Lake slough. The original size of the mound was estimated to have been at least 9 ft in height and 60 ft in diameter (Thomas 1894:159). Despite the extensive damage to Mound 1, Perrine discovered human bones and "pottery, representing in their formation turtles, fish, etc." In addition, he recovered a "white porphyry stone, of forty pounds weight, which had been carved from the rough into an idol" (Perrine 1874:410). Dubbed the Anna Statue, the fluorite figure was undamaged, suggesting that it was deposited rather early in the stages of the construction of Mound 1. Excavations of the same mound remnant by archaeologists from the Bureau of Ethnology in the 1880s documented scattered human bones and other artifacts, including a "rude clay pipe, pottery, shell, and bone implements" (Milner 1993).

CSS-052 shows many similarities to the fluorite statues from the Obion site in Tennessee (CSS-041) and the Angel site in Indiana (CSS-054). The round face shows thick closed lips, a large nose, and eyes in relief. The occipital region is flattened. The hair roll is almost identical to that on the Angel statue. The torso shows few details outside of the arms and legs. Similar to the Angel statue, the right hand is shown on the raised right knee and the other hand rests on the knee of the left leg, which is crossed in front of the body.

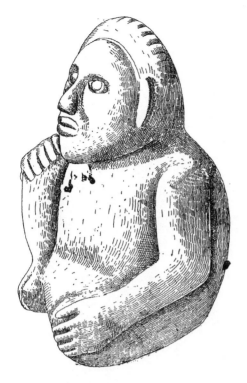

Figure 6.3. CSS-052 (Wilson 1898).

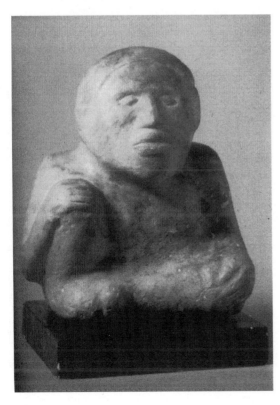

Figure 6.4. CSS-052.

Figure 6.5. CSS-053 (Emerson 1982). Courtesy Thomas E. Emerson and the Illinois Archaeological Survey.

The statue was loaned to the Smithsonian for casting and display at the Centennial Exhibition in 1876 and returned in October 1877. Eventually, the original ended up in the Field Museum in Chicago. We should also note that published illustrations of this statue have occasionally been interpreted as two different statues. Most of this confusion appears to derive from an illustration and brief reference to this statue with the incorrect provenance of "east of Cahokia on the bluffs" (Moorehead et al. 1929:99).

Another Southern Illinois Statue (CSS-053)

A fragmentary fluorite statue from an unknown location in southern Illinois is in the collections of the University of Illinois Museum of Natural History in Urbana (Emerson 1982:24). Although only the head and shoulders survive, the fragment appears to have been broken from a Tennessee-Cumberland style statue.

The face exhibits a broad nose, diamond-shaped eyes, and slightly protruded closed lips inclined backward at an angle of about 25 degrees (Figure 6.5). The ears are only roughly depicted. The depiction of hairstyle or head ornamentation is very detailed, including the typical straight hairline across the forehead. On the top of the head, two "buns" are sculpted on each side similar to the Sellars and Link Farm statues (CSS-003 and CSS-036) with

Figure 6.6. Angel site (Hilgeman 2000:Figure 1.2). Courtesy Sherri Hilgeman and the University of Alabama Press.

the additional feature of "streamers" or braids below the buns. On the back, sculpted details seem to suggest hair reaching to the top of the shoulders and then pulled into a broad flat band down the back similar to the Link Farm male (CSS-036).

Angel, Indiana

Along with Tolu, Kincaid, and Wickliffe, the prehistoric town of Angel (12VG1) was one of the four major mound centers in the lower Ohio Valley. Located on the north bank of the Ohio River in Indiana, the 100-acre Angel site consists of 11 mounds enclosed on three sides by a semicircular bastioned palisade (Hilgeman 2000; Figure 6.6). On the basis of the available information, initial occupation and construction of the mound center began in the Angel 2 phase (A.D. 1200–1325) with the most extensive occupation during the Angel 3 phase (A.D. 1325–1450).

During excavations of the second largest platform mound (Mound F) in 1940, a fluorite statue (CSS-054) was discovered in situ within the subprimary mound (Figure 6.7). The Mound F excavations documented three

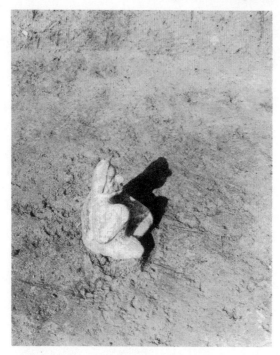

Figure 6.7. CSS-054 in situ (Black 1967). Courtesy of the Glenn A. Black Laboratory of Archaeology and the Trustees of Indiana University.

or possibly four episodes of mound-and-structure construction (Hilgeman 2000). As recorded by Glenn Black, the statue "probably had been placed, facing east, in an intrusive pit dug into the southeast corner of the truncate top of the secondary mound" (1967:249). Radiocarbon dates from Mound F suggest that the statue was probably buried sometime after A.D. 1250 (initial construction of Mound F) and prior to A.D. 1400 (Hilgeman 2000; Hilgeman and Schurr 1990).

CSS-054 (Figure 6.8) is sculpted from yellow fluorite, the nearest sources of which are located in Rosiclare, Illinois, or Marion, Kentucky (Black 1967: 248–251). Although smaller than the Obion (CSS-041) and Anna statues (CSS-052), the Angel statue shows numerous stylistic similarities. Each exhibits similar facial features, hair rolls, arm-leg position, occipital flattening, and incised lines indicating the toes. A feature unique to the Angel statue is a depiction of three vertebra in relief on the back.

Schugtown Mounds, Arkansas (CSS-070)

Far to the west of the fluorspar region, a sandstone statue is reported to have been found on or near a large truncated mound at the Schugtown site (3GE2) near the St. Francis River in Arkansas. When initially described by Smithsonian archaeologists in 1883, the 12-acre site included four mounds (Thomas 1894:199). More recently, Dan Morse and Phyllis Morse (1983:250) indicate

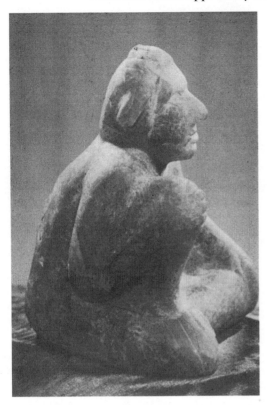

Figure 6.8. CSS-054 (Black 1967).
Courtesy of the Glenn A. Black
Laboratory of Archaeology and
the Trustees of Indiana University.

that "today, only one potted mound and the remnant of a second one exist. A plaza area is apparent, and residential areas exist around it. The site is shallow, and the remains are sparse." The statue was found about 1933 by Charlie Miller, whose house was located on the site.

The 12-in-high male, now in the University of Arkansas Museum collection, displays several features that are foreign to most Tennessee-Cumberland style statues. The hairstyle is a combination hair roll and small occipital knot. The face is unusually flat with pupils indicated on the eyes. The arms are asymmetrically depicted, with a greater bend in the left arm. Very rounded shoulder blades are sculpted on either side of a distinct double incised spinal column. The chest exhibits nipples along with an unusually well defined pectoral area. Unlike the vast majority of the well-documented statues shown in the Type A seating position, the left leg is shown crossed over the right.

The Natchez Statues (CSS-063, CSS-078)

The two statues from the vicinity of Natchez, Mississippi, are the southernmost outliers of the stone statuary tradition and present some potential ties with the protohistoric and early historic native peoples of the southeast.

Sometime before 1820, a statue (CSS-063) was found or acquired by James Thomas, a local Natchez planter. At the request of the owner, Winthrop Sargent presented the statue to the American Antiquarian Society. Subsequently, the image was illustrated in the society's first archaeological publication authored by Caleb Atwater (1820). Although the details of its discovery and precise provenance are not recorded, Atwater records that the "idol . . . was a few years since, dug up in Natchez, Mississippi, on a piece of ground, where, according to tradition, long before Europeans visited this country, stood an Indian temple" (Atwater 1820:215).

Although the provenance is uncertain, CSS-063 is of particular interest for two reasons: (1) historic documents suggest the use of stone statues by the Natchez during the early eighteenth century and, (2) the more reliably documented recovery of a statue fragment (CSS-078) from the Grand Village of the Natchez on the Fatherland plantation.

Sculpted from limestone, CSS-063 appears to represent a female based on the seating position and depressions presumably representing nipples and possibly the vulva (Figure 6.9). The face and head show the eyes as oval depressions, a prominent nose, a depressed oval mouth, and pierced ears. The hairstyle is not detailed. The statue is now in the collections of the Peabody Museum of Archaeology and Ethnology at Harvard University.

The head of a second statue (CSS-078) was recovered during excavations by Moreau Chambers at the Fatherland site in 1930 (Figure 6.10). The Fatherland site (22AD1) is located on the west side of St. Catherine Creek, about 3 miles south of Natchez. James A. Ford described the excavations that yielded substantial evidence that the Fatherland site was occupied during the early historic period:

> Mound C, the southernmost of the Fatherland group, was entirely excavated by Chambers. It proved to be a burial mound. Fifty-nine skeletons were found lying on the mound base. They were orientated in various directions and were extended, flexed, or bundled after removal of the flesh. Two children were buried in wooden chests, outlined by iron nails, hinges, and hasps with locks. Although the skeletal material was in very poor condition, a few skull fragments showed that some of the heads had been flatted . . .
>
> Large quantities of European material accompanied these bodies: glass and porcelain beads which were white blue or striped, glass bottles, crockery, pocket knives, C-shaped iron bracelets, brass turkey bells, metal buttons, a flintlock pistol, and short sections of coil spring about one inch in diameter [Ford 1936:61].

Although the size of the specimen is not indicated, Ford further records the following contextual information: "With one of the burials was found the re-

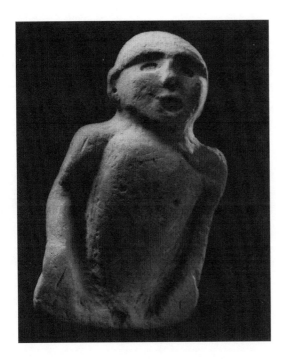

Figure 6.9. CSS-063. Peabody Museum of Archaeology and Ethnology, Harvard University, 10-47-10/79934.

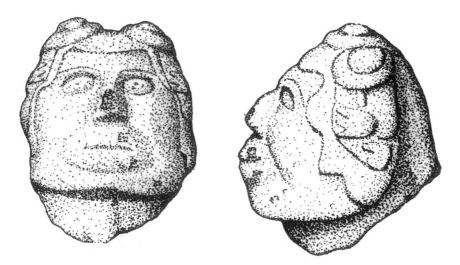

Figure 6.10. CSS-078 (Ford 1936). Courtesy Michael J. O'Brien, R. Lee Lyman, and The University of Alabama Press.

markable human effigy head . . . on the hair will be noticed one of the curious three-pronged ornaments that so often appear on effigy pieces from the sites of Moundville, Alabama and Etowah, Georgia" (Ford 1936:64). Historical and archaeological evidence connect the Fatherland site to the Grand Village of the Natchez, which was probably occupied between A.D. 1682 and 1729, when the Natchez lost a war with the French and were forced to abandon the site. While the Natchez statues are widely separated in space from the Middle Cumberland region, we would be remiss not to mention the Natchez Trace, the ancient overland trail that led from southern Mississippi to Nashville.

Although most of these statues share a number of features with those from Middle Tennessee and north Georgia, some apparent differences in distribution and treatment can be noted. Stone statues have been identified much less frequently in the lower Ohio and Mississippi valleys. While alternative explanations are certainly plausible, the simplest may be that stone statues are most common in areas where relatively soft stones were readily available to local sculptors. In the major sites in the Mississippi valley, counterparts carved in wood may have been more frequent (as evidenced in the several examples from the great mortuary at Spiro). In addition, the available evidence does not readily support the creation of stone statuary pairs outside of Tennessee and north Georgia. If the Angel statue had a mate, it was removed before the total excavation of Mound F in 1940, which seems unlikely given the apparently undisturbed nature of the surrounding matrix. Although probably still serving as shrine sacra, these statues appear to have carried a slightly different meaning (see Wolforth and Wolforth 2000).

7
The Statuary Complex
and Ancestor Veneration

"It's a poor sort of memory that only works backwards," the Queen remarked.

—Lewis Carroll, *Through the Looking Glass*

Interpreting the functions and meanings of symbolically charged objects within a prehistoric society has always proven a difficult task for the archaeologist. Although material objects may serve as focal symbols during rituals, those beliefs exist largely in the minds of the participants. In the case of the Tennessee-Cumberland style stone statuary, many of their mouths are open as if to speak, yet they remain mute because we cannot quite "speak their lingo." Although we cannot yet communicate as directly with the statues as their creators did, careful examination of the contexts of these objects and historical documentation of southeastern tribal groups permits the construction of some hypotheses about their possible meanings and functions.

At a broad conceptual level, all Mississippian stone statuary probably can be viewed as part of a much larger body of paraphernalia subsumed under the terms *temple statuary* or *shrine sacra*. Recent examinations of Mississippian iconography and symbolism use the anthropological concept of *cult institutions* as "a useful means for integrating the variety of themes and multiplicity of images and image combinations characteristic of Mississippian art" (Brown 1985:102). Anthony Wallace (1966:75) defines *cult institution* as "a set of rituals all having the same general goal, all explicitly rationalized by a set of similar or related beliefs, and all supported by the same social group." James Brown (1985:102) defines the concept of *cult* as "a formalized set of rites dedicated to the veneration or propitiation or specific individuals, spirits or forces."

Different analysts have proposed three broadly similar cults or complexes within the realm of Mississippian beliefs systems (Brown 1985; Knight 1986). James Brown (1985:102–129) describes these as an ancestor shrine complex, a chiefly elite complex including a warrior cult, and a communal earth or fertility cult. Knight's perspective is comparable and includes a temple statuary

complex, a warfare/cosmogony complex, and a communal earth or fertility cult symbolized by platform mound construction (1986:680–681). Both of these models include a formally constituted cult centering on an ancestor shrine or house where the bodies of the elite were preserved in honored status along with objects of wealth, sumptuary devices, weapons, statuary, fetishes and sacred relics (Anderson 1994:79). Among the objects housed in these temples were different types of sculptures depicting human or human-like figures. Both the Cahokia style and the Tennessee-Cumberland style statues can be interpreted as temple statuary, but each appears to symbolize slightly different interpretations of widely shared belief systems. Before offering some closing interpretations of and speculations about the nature and function of Tennessee-Cumberland style statues, we offer a summary of the available archaeological information and ethnographic accounts concerning statues.

Archaeological Evidence

Generally speaking, the types of archaeological "information" available for the Tennessee-Cumberland style stone statues can be organized into four categories with differing levels of reliability:

(1) Direct evidence in the form of statues recovered during archaeological excavations;
(2) anecdotal records of the recovery of statues (general or site-specific geographic location and/or limited intrasite information);
(3) indirectly associated evidence including artifacts, excavation data, radiocarbon dates from sites where statues were reportedly found; and
(4) features of the statues themselves.

Excavated Statues

The first category of evidence provides the most reliable information since archaeological investigations document in a systematic fashion not only the statues themselves but also their contexts and associations. Unfortunately, this type of evidence is available for only a tiny subset of the Tennessee-Cumberland style statues. Detailed contextual information is available for about half of the statues from Etowah, Georgia, and the single example from Angel, Indiana. Somewhat less detailed archaeological observations are available for the statues from the McKelvey Mound and Long Island of the Holston in Tennessee.

Although the excavations and contexts are described in detail in the preceding chapters, these four sets of data provide some critical information. At Etowah, four of the best-documented statues (CSS-057, CSS-058, CSS-059,

CSS-060) were buried as pairs in discrete features in Mound C. The pair that Warren Moorehead discovered somewhere in Mound C was buried in a small stone box apparently created solely for the purpose of entombing the statues. Both were apparently intentionally broken and/or defaced prior to burial. The second pair from Mound C is significantly better documented. The male-female pair was interred along with other objects and human remains in a log tomb near the end of the use of Mound C. Both of these statues were either intentionally or accidentally broken before or during their burial (King 2004). Although the published descriptions suggest that the statue fragment recovered by J. P. Rogan during earlier excavations at Etowah was not from Mound C, records from that excavation are scanty and of mixed reliability. Although detailed information is not available for all of the statues reported from Etowah, it is possible to argue that all of the statues were recovered from contexts associated with Mound C.

At the Angel site in Indiana, the single statue was recovered during excavations of Mound F, the second largest platform mound. As Glenn Black recorded, "it probably had been placed, facing east, in an intrusive pit dug into the southeast corner of the truncate top of the secondary mound" (1967:249). Unlike those from Etowah, the Angel statue was not buried as part of a pair, nor was it broken prior to interment. In addition, Mound F did not yield comparable evidence of bundled human remains, sumptuary items, or other shrine paraphernalia. Radiocarbon dates from Mound F along with ceramic data suggest that the statue was probably buried sometime after the initial construction of Mound F around A.D. 1250 and prior to A.D. 1350 (Hilgeman 2000; Hilgeman and Schurr 1990).

The remaining two examples of excavated statues similarly provide both comparisons and contrasts. Contextual data for the Long Island statue from east Tennessee indicates interment in a tomb containing the remains of five articulated skeletons accompanied by other sumptuary items. In this instance, the statue and other items are more interpretable as "grave goods" accompanying an individual than the examples from Etowah and Angel would suggest. Again, however, this statue was not interred as part of a pair, nor was it broken prior to interment.

The final excavated statue is from the McKelvey site in Tennessee. Found in a mound context in loose association with a structure pattern, the statue was not clearly associated with human skeletal remains or other sumptuary items but may have been associated with nearby features suggestive of ceremonial activities. The statue was not buried as part of a pair, but it was apparently broken prior to burial.

What do these four examples tell us about the statues? The most consistent point of comparison is that all of the *excavated* statues were discovered in earthen mound constructions that were still visible and prominent

features of the four sites at the time of their investigation. Beyond that singular comparison, the archaeological contexts are not unanimous and provide both comparisons and contrasts. At Etowah, the statues were buried as pairs (possibly male-female pairs) while at the other three sites they were buried as single statues. At Etowah and Long Island, they were in close association with human skeletal remains, while at Angel and McKelvey they were not. At Etowah and McKelvey, the statues appear to have been broken before burial, while at Long Island and Angel they were not. At the most basic level, two significant observations can be offered: (1) the statues were very important objects that ended up in sacred places in all of these sites; and (2) their contexts at each site suggests that the trajectory ending with their deposition in the archaeological record was different in each case.

Anecdotal Information

Since over 90 percent of the statues recorded during our survey were not from any kind of documented archaeological investigations, and these four sites are an even smaller percentage of the "places" where statues were found, it should be no surprise that they do not appear to be fully representative of the range of contexts. Leaving interpretations aside for now, the second category of information—less systematic observations of geographic distribution and intrasite provenance—provides both support for the previous observations and some contrasts as well. Stone statues have been found at sites over an enormous geographic area stretching from Illinois to Mississippi and from Arkansas perhaps as far east as West Virginia. Despite the breadth of their distribution, the overwhelming majority of known Tennessee-Cumberland style statues were recovered from sites in a much smaller area encompassing portions of Middle Tennessee and north Georgia. At least at the macroscopic level, the materials from which the statues were sculpted are available within a few miles of the sites where they were found. These observations contrast with interpretations of the Cahokia style statuary, which were probably all sculpted in a small geographic area and later entered the archaeological record at sites scattered throughout the trans-Mississippi south.

At this level of observation, Tennessee-Cumberland style statues may have been buried at a broader range of site types than the excavated examples would suggest. Most reportedly came from sites exhibiting monumental public architecture in the form of platform mounds. However, a few reportedly were discovered in smaller settlements, caves, or small settlements without such obvious features. Although the reported locales are often very near mound sites, the anecdotal information suggests the possibility that statues did not always enter the archaeological record at sites with public architecture in the form of mounds. The statuary pair discovered at the Martin Farm site (CSS-018, CSS-019) and those recovered from Dr. Frost's farm (CSS-030 and possibly

CSS-031) provide what we believe to be reliable examples of statues buried at smaller sites without any evidence of mounds. Although they are often the most archaeologically visible, mounds were certainly not the only forms of ceremonial architecture created by Mississippian peoples.

Again relying on the broader level of anecdotal information, the statues recovered from sites with platform and burial mounds are not unambiguously associated with those features. In several instances, observers identified the find spot as "near the mound" or even emphatically state that statue X did *not* come "from the mound." The discovery location of the Duck River cache and loosely associated Link Farm statues (CSS-036, CSS-037) is a reliably documented example of a significant cache of probable shrine paraphernalia secreted in an elite residential area at some distance from the central mound complex. Many other seemingly reliable accounts place the statue discovery areas outside of visible mound contexts, including the six statues at Beasley Mounds, and at least two of those from Sellars (see Table 2, Appendix A). Although some of these statements can be attributed to untrained observers, eradication of mounds through plowing, or even deliberate misdirection on the part of some recorders, the consistency of these reports merits strong consideration. Another consistent point in the anecdotal records of statue discovery relates to sites yielding more than one statue. In virtually all cases, when two or more statues were found at a single site, they came from a relatively restricted area within the larger site. Although we acknowledge that the discovery of one statue often prompted additional digging and poking around in the same vicinity, most of the sites were extensively plowed, and we suspect that statues were usually buried in specific areas within sites.

The fact that the small number of archaeologically excavated statues came from mound contexts is not surprising given the inclination of excavators to focus on these highly visible features. The archaeological discovery of several of the Cahokia style statues, including the Birger and Kellar figures, at "rural" settlements distant from apparent earthen constructions underlines the likelihood that significant less-visible ceremonial structures were part of the architectural landscape associated with the use and deposition of statues. Larger-scale sampling of nonmound contexts at sites producing statues will be necessary to examine the validity of these hypotheses in the Tennessee-Cumberland region.

Indirectly Associated Archaeological Evidence

The third category of information available is in the form of indirectly associated evidence including other types of diagnostic artifacts, excavation data, and radiocarbon dates from sites where statues were reportedly found. For the most part, this category provides some general clues to the chronological span of production, use, and deposition for Tennessee-Cumberland style statues.

Although few radiocarbon dates are available from contexts clearly associated with statues (e.g., Etowah Mound C and Angel Mound F), several other statue-producing sites have seen other excavations in recent years.

Excavations at the Sellars site (40WI1) in the 1970s and 1980s yielded a series of radiocarbon dates (Table 3, Appendix A). While the error range on a number of these dates is unfortunately large, both they and the artifact assemblage from the site suggest it was first occupied as early as A.D. 1000 and was probably abandoned as the center of a small chiefdom sometime around A.D. 1350. Although the mortuary mound at Sellars is not quite as elaborate a facility as Mound 1 at the nearby Castalian Springs site or Mound C at Etowah, Frederic Putnam's well-documented excavations (1878) did yield a particularly diagnostic human effigy pipe. The steatite pipe from the mortuary mound at Sellars portrays a male figure with sculpted penis holding a four-handled pottery jar that forms the pipe bowl. Labeled the Lebanon style by Jeffrey Brain and Philip Phillips, this pipe "is important because it is clearly one of a series (same workshop, probably same hand), other examples of which are known from the Etowah and Hollywood sites. . . . A fourth pipe in the same style, but slightly different configuration, is known from the Dallas phase Bell site in Roane County, Tennessee" (Brain and Phillips 1996:255, 384). The nearly identical pipe from Etowah is attributed to Mound C and provides some additional linkages between the two sites and their ancestral pair statues. The pipe from the Hollywood site (9RI1) in Georgia was discovered in a burial along with a tripodal bottle with human heads for feet, a bottle painted with a cross and sunburst motif, and five clay elbow pipes attributed to early in the Hollywood phase from circa 1250 to 1350 (Anderson 1994:189–191). A nearly identical tripodal vessel with human faces for feet was discovered prior to 1820 at or near the Piper's Ford site that yielded statue CSS-020 (Atwater 1820). Finally, although not bearing human faces, a similar tripodal vessel was also recovered by Putnam at the Sellars site. With the current information, the Sellars statues were most likely created and deposited sometime between A.D. 1000 and 1350 and probably in the latter half of that range.

While radiocarbon dates are not yet available from the Castalian Springs site, with at least two stone statues, diagnostic artifacts from the elite mortuary facility in Mound 1 included Nashville Negative painted bottles and bowls, over two dozen marine gorgets, two ceramic figurines, a copper-coated wooded coiled serpent and "milkweed pod," and a Dover "sword" form. In concert with the results of recent excavations, the assemblage suggests a significant component of the site occupation took place between A.D. 1200 and 1325. Discovered during the same excavations that yielded the two Moorehead statues, Burial 17 in Etowah's Mound C included a Moore-

head style crib gorget at the neck. As noted by Brain and Phillips (1996:139), "the only other known example of the Moorehead style is from Castalian Springs."

The Castalian Springs site is also one of three Mississippian towns in Middle Tennessee that has produced sherds from Angel Negative painted plates (Smith and Beahm 2006). Among the particularly diagnostic ceramics recovered at type site in Angel Mound F were Angel Negative painted plates. Sherri Hilgeman notes that, "The primary mound surface of Mound F does have a higher percentage of negative painted sherds (0.57 percent) when compared with the typical range (0.10 to 0.25 percent) elsewhere in the site. A large rectangular pit in the primary mound surface (F12/Mound F) contained the single example of a negative painted vessel, a black-on-red plate decorated with owl heads and striped or spotted poles, which was recovered from a specific 'ceremonial' context" (Hilgeman 2000:166). Hilgeman (1985; 1991; 2000) has argued convincingly that these types of ceramic plates were used in "world renewal" ceremonies similar to the "new fire" or annual community renewal ceremonies known better during the historic period as the "busk" or Green Corn ceremony.

Another relatively tight association comes from the Link site, where the statuary pair was apparently buried with (or at least beneath) the famed Duck River cache. While archaeological information is limited for the Duck River cache, this feature may well represent a collection of sacra from a well-equipped shrine. The presence of the Dover sword forms again suggests a ritual event centering on the late thirteenth or early fourteenth century. The early twentieth century excavations at the Link Farm site also yielded evidence of the manufacture of Dover sword forms (including one burial containing unfinished sword blanks). The cache and (presumably) associated statuary could be interpreted as an event somewhat similar to that proposed for Mound C at Etowah, although the details available do not necessarily suggest the haste proposed for that event.

Radiocarbon dates and associated artifacts are also available from the Obion Mounds, one of the sites producing a fluorite statue. Elizabeth Garland (1992:118) indicates that "mound construction began at Obion by A.D. 1050. If there was an initial premound Mississippian occupation of the site, as I believe is likely, this may have commenced by about A.D. 1000." Although the terminus of occupation of the site is uncertain, the main period of site occupation falls between about A.D. 1050 and 1300.

Finally, the single radiocarbon date from the Cardwell Mound site in Warren County indicates occupation around A.D. 1200, although the small artifact assemblage tends to suggest an occupation beginning a century or more earlier.

Evidence from the Statues

The final category of information—that derived from the statues alone—
is the most accessible in terms of the majority of the statues examined in
our survey and is presented as the central focus of this volume. As discussed
previously, interpretations based solely on this type of information are lim-
ited because of the absence of other contextual information and reliance
on historical accounts widely separated in both space and time from the ar-
chaeologically documented examples. The probable presence of some fakes
and forgeries in the sample introduces another level of uncertainty. Those
caveats aside, we can reiterate some general observations concerning the
Tennessee-Cumberland style statues:

(1) Unlike the Cahokia style statues, Tennessee-Cumberland style statues
are sculpted from a wide variety of relatively soft stones. At least based
on macroscopic observations, these stones are distributed in a broad geo-
graphic area of the interior southeastern United States.
(2) Tennessee-Cumberland style stone statues include representations of both
male and female genders (although rarely depicting biological indicators
of sex).
(3) Unlike the Cahokia style statuary, Tennessee-Cumberland style statues
conform to a relatively restricted pattern of seated or kneeling humans
at rest (e.g., not depicting a wide array of actions or events).
(4) While ranging from 20 to 70 cm (8 to 27 in) in height, over 70 percent
of the statues fall within a 30–50 cm (12–20 in) range.
(5) The face is one of the most significant and consistently depicted features
of the statues.
(6) Although diverse as a corpus, some pairs of statues exhibit clusters of
characteristics that suggest they were created by the same sculptor or
workshop.

While these characteristics provide the general means by which to clas-
sify the Tennessee-Cumberland style stone statues, a few observations con-
cerning their relationships with the ceramic and stone figurines that tend to
fall within the 2- to 3-in range in height is warranted.

Relationship with Ceramic Figurines

To date, ceramic figurines have not been reported in direct or even close as-
sociation with statues. While several sites producing statues have also pro-
duced figurines, none of the available data suggests that figurines have yet
been found in the same intrasite contexts as statues. Figurines appear at sites
without recorded statues and vice versa. In general, the corpus of figurines

seems to include greater diversity in both distribution and subject matter than their larger counterparts. Figurines have been found frequently at farmsteads, hamlets, small villages, and large towns. They are frequently included as mortuary offerings accompanying individual human burials, unlike the statues, which are more often treated as if they *were* humans rather than simply accompanying them. Whether these distinctions are simply an artifact of the greater frequency of ceramic figurines in the archaeological record or reflect some real chronological or functional differences remains to be firmly established. However, as will be discussed further following, stone statue production (at least in Middle Tennessee and north Georgia) appears to be more restricted in time than production of the figurines. Figurines have been recovered in archaeologically well-documented contexts ranging from the 1200s through the late 1400s.

Untangling the complex interrelationship of the statues and figurines will undoubtedly greatly expand our understanding of both. At this point, we suggest that the ceramic figurines express a greater diversity of "characters" than is reflected in the stone statuary. While some of the known figurines are apparently simply smaller ceramic versions of ancestral pairs and the Old Woman, others seem to be communicating a somewhat different and broader story or set of stories, perhaps more comparable to the Cahokia style statuary. Hence, while we recognize some overlap between the statuary and figurines, we also believe that future research on the figurines will demonstrate some differences as well.

Before turning to the implications of these archaeological observations, a review of the available ethnohistoric accounts provides a separate source of information on ancestor shrines and human figural sculptures.

Ethnographic Observations and Interpretations of Southeastern Statues

As described in the introduction, although the manufacture of *stone* statuary may not have been as widespread in the sixteenth and seventeenth centuries as it was during the late prehistoric period, several early European explorers documented vestiges of apparently similar objects. Most of the early historic documentation concerning figurines and statuary clearly associate them with "guardianship" of temples or ossuaries that served as shrines for honored ancestors.

Numerous scholars have discussed the appropriate (and inappropriate) uses of ethnographic analogy and the direct historical approach for the interpretation of prehistoric objects and features (cf. Brown 1990; 1997). While the lack of solid contextual information for many of the stone statues described herein forces us to lean a bit more heavily on analogy than we would pre-

fer, our examination is not intended as the final word on the meanings of the Tennessee-Cumberland style statuary. Out of context, the statues as artifacts alone do not provide enough information. Substantial additional information from controlled archaeological investigations will be necessary to test the various hypotheses offered herein.

As Jon Muller has pointed out, "we need to emphasize objective human *behaviors* described in the accounts rather than the observer's *understanding* of their meaning. We need to know what was seen and done, before we can even begin to discuss what it meant" (1997:57). In the following examination of historic accounts, we have followed this approach by attempting to separate description from understanding.

The earliest known document recording information on stone statuary comes from the account of Francisco de Chicora, as recorded firsthand by the Italian-born Spanish historian Pietro Martire d'Anghiera. In 1521, Francisco was among 70 natives captured in what is now South Carolina by a Spanish expedition under the command of Francisco Gordillo and Pedro de Quexo. Francisco was captured somewhere inland from Winyah Bay, where the Pee Dee River and several lesser drainages enter the Atlantic, or possibly near the Santee River (Hudson 1990:6). Eventually, Francisco was attached to the household of Lucas Vasquez de Ayllon, one of the auditors of Santa Domingo, where he met Anghiera, who was a chronicler for the Royal Council of the Indies (Anderson 1994:56). Anghiera summarized the stories he heard from Francisco in *De Orbe Novo* (Anghiera 1912, 2:259–269). Speaking of the palace of a chief called Datha who ruled in a province known as Duhare, Francisco reported that,

> In the courtyard of this palace, the Spaniards found two idols as large as a three-year-old, one male and one female. These idols are both called Inamahari, and had their residence in the palace. Twice each year they are exhibited, the first time at the sowing season, when they are invoked to obtain successful results for their labors. We will speak later of the harvest. Thanksgivings are offered to them if the crops are good; in the contrary case they are implored to show themselves more favorable in the following year.
>
> The idols are carried in procession amidst much pomp, accompanied by the entire people. It will not be useless to describe this ceremony. On the eve of the festival the king has his bed made in the room where the idols stand, and sleeps in their presence. At daybreak the people assemble, and the king himself carries these idols, hugging them to his breast, to the top of his palace, where he exhibits them to the people. He and they are saluted with respect and fear by the people, who fall upon their knees or throw themselves on the ground with loud shouts. The

king then descends and hangs the idols, draped in artistically worked cotton stuffs, upon the breasts of two venerable men of authority. They are, moreover, adorned with feather mantles of various colors, and are thus carried escorted with hymns and songs into the country, while the girls and young men dance and leap. . . . The men escort the idols during the day, while during the night the women watch over them, lavishing upon them demonstrations of joy and respect. The next day they are carried back to the palace with the same ceremonies with which they were taken out. If the sacrifice is accomplished with devotion and in conformity with the ritual, the Indians believe they will obtain rich crops, bodily health, peace, or if they are about to fight, victory, from these idols. Thick cakes, similar to those the ancients made from flour, are offered to them. The natives are convinced that their prayers for harvests will be heard, especially if the cakes are mixed with tears [Anghiera 1912:262–267].

Separating the observations from the interpretations, Anghiera reports several items of specific interest: (1) the idols were created in a male–female pair; (2) they were housed in an important building (palace) with restricted access; (3) they were brought out only a few times a year for public display; and (4) they were adorned with feather cloaks and clothing. In interpreting their meaning, Anghiera places them within the context of planting and harvest. If this interpretation of their meaning is accurate, it illustrates a connection between the idols and the agricultural cycle.

Although perhaps prone to exaggeration, the chroniclers of the Hernando de Soto expedition in 1539–1543 also provide relevant records of human images within temple precincts in southeastern chiefdoms. The most important description of such a "temple-shrine" was recorded in Garcilaso de la Vega's account (Shelby 1993:298–306; see also Varner and Varner 1951:315–325). The temple of Talimeco, where the sacred wealth and chiefly elite of Cofita-Chequi were placed, may well be located at the Adamson mound group near Camden, South Carolina (Anderson 1994; DePratter et al. 1983).

To go inside [the temple of Talimeco], the Spaniards opened some large doors. . . . Near the door were twelve giant figures carved from wood, such faithful imitations of life and with such a fierce and bold posture that the Castilians stayed to look at them for a long time without passing on, marveling to find in such a barbarous country works that, if they had been in the most famous temples of Rome in the most flourishing period of its power and empire, would have been esteemed and valued for their grandeur and perfection. The giants were placed as if to guard the door and oppose the entrance of those who might enter.

There were six on one side of the door and six on the other, one after the other, descending gradually in size from the largest to the smallest. . . .

They had various weapons in their hands made in proportion to the size of their bodies. . . .

Lowering their eyes from the roof, our captains and soldiers saw that among the highest part of the four walls of the temple were two rows, one above the other, of statues or figures of men and women corresponding in size to the ordinary stature of the people of that country, who are as large as Philistines. Each was set on its own base or pedestal, near one another, and they served no other purpose except to ornament the walls, so that the upper part of them would not be bare and uncovered. The figures of the men had various weapons in their hands. . . . The statues of the women had nothing in their hands [Shelby 1993:299, 301–302].

This account describes a very different type of human statuary. In this passage, statues in human form are clearly associated with the "temple." While the interpretations are heavily flavored with notions of Rome, Philistines, and militarism, an additional section of the account provides additional details.

On the floor against the walls, on very well-made wooden benches, as was everything in the temple, were the chests that served as sepulchers, in which were the bodies of the curacas who had been lords of that province of Cofachiqui, and of their sons and brothers and nephews, the sons of their brothers. No others were buried in that temple.

The chests were well covered with their lids. Exactly one vara [approximately a yard or meter] above each chest was a statue carved from wood, against the wall on its pedestal. This was a portrait taken while living of the deceased man or woman who was in the chest, at the age at which they died. The portraits served as a record and memorial of their ancestors. The statues of the men had weapons in their hands, but those of the children and women had nothing [Shelby 1993:302].

This section indicates that this temple also contained the (bundled?) remains of related elites accompanied by a wooden "portrait" statue. In addition, the writer suggests that the portraits reflected the age of the person at the time they died.

Thomas Hariot (1560–1621) was sent to Virginia in 1585 by Sir Walter Raleigh as surveyor and historian to the first English colony. Based on his

notes, he published *A Brief and True Report of the New Found Land of Virginia* in 1588. The town of Secota, as discussed below, is probably in the present Beaufort County, North Carolina (Black 1967:501). Among his observations, he recorded information on the images of gods in the form of men.

> They believe that all the gods have human shapes; therefore they represent them by images in the form of men and call the images *Kewasowok*. A single god is called *Kewas*. These images are set up in temples which they call *Machicomuck*. Here the natives worship, pray, sing and make frequent offerings to the gods. In some of these temples we saw only one *Kewas*, but others had two or three. Most of the natives think that the images themselves are gods. . . .
>
> Their idol, *Kewas*, is four feet high and carved of wood. Its head is like those of the people of Florida; the face is flesh-colored, the breast white, and the rest all black except the thighs, which are spotted with white. Around the idol's neck is a chain of white beads interspersed with round copper beads, which they value more than gold or silver.
>
> Kewas is placed in the temple of Secota to guard their dead kings. Sometimes there are two of these idols in their temples—sometimes three, but never more—set in a dark corner, where they have a terrifying appearance. . . .
>
> Under the tombs of their Weroans, or chief lords, they build a scaffold nine or ten feet high. . . . They cover this with mats and upon them they lay the dead bodies of their chiefs. First the intestines are taken out; then the skin is removed and all the flesh cut from the bones and dried in the sun. When it is well dried, they wrap it in mats, which they place at the feet. Then the bones, still held together by the ligaments, are covered with the skin and made to look as if the flesh had not been taken away. They wrap each corpse in its own skin after it has been thus treated and lay it in its rightful order beside the bodies of the other chiefs. Near the bodies they place their idol, for they are convinced that it keeps the bodies of their chiefs from all harm [Lorant 1965:266–268].

This account provides several details of interest: (1) the "temple" is again associated with the bundled remains of the chiefly linage; (2) the wooden "idols" were limited in number to not more than three; and (3) the statues were painted and adorned. The chronicler interprets the statues as representations of gods created to guard the bones of the ancestors.

William Strachey, writing of travels in 1612, described two "holy houses" of the Powhatan paramount chiefdom located on the York River in Virginia (Rountree and Turner 1994). While apparently different from the paired

statuary described by Francisco, this narrative continues to underline the association of chiefly effigies with the resting place of their skeletal remains:

> In every territory of a weroance is a temple and a priest . . . at the west end a spence or chuncell from the body of the temple, with hollow wyndings and pillers, wheron stand divers black imagies, fashioned to the shoulders, with their faces looking downe the church, and where within their weroances, upon a kind of beere of reedes, lye buryed; and under them, apart, in a vault low in the gruond (as a more secrett thing), vailed with a matt, sitts their Okeus, an image ill-favouredly carved, all black dressed, with chaynes of perle, the presentment and figure of that god . . . which doth them all the harme they suffer, be yt in their bodies or goods, within doores or abroad [Strachey 1849:83].
>
> Their principall temple, or place of superstition, is at Vtamussack, at Pamunky. Neere unto the towne, with in the woods, is a chief holie howse, proper to Powhatan, upon the top of certaine red sandy hills, and it is accompanied with two other sixty feet in length, filled with images of their kings and devills, and tombes of the predicessors. This place they count so holy as that none but the priests and kings dare come therein [Strachey 1849:90].

Strachey's observations are interwoven thoroughly with interpretation. However, multiple shrines were apparently present in the Powhatan chiefdom, with a principal temple dedicated to the paramountcy. He records a single statue at the smaller temples, adorned and dressed with perishable items. At the principal temple, multiple statues are mentioned accompanying the bodies of "kings."

Writing in 1682, Henri de Tonti describes the temple of the Taensa:

> There is a temple opposite the house of the chief, and similar to it, except that three eagles are placed on this temple, who look toward the rising sun. The temple is surrounded with strong mud walls, in which are fixed spikes, on which they place the heads of their enemies whom they sacrifice to the sun. At the door of the temple is a block of wood, on which is a great shell, and plaited round with the hair of their enemies in a plait as thick as the arm and about 20 fathoms long. The inside of the temple is naked; there is an altar in the middle, and at the foot of the altar three logs of wood are placed on end, and a fire is kept up day and night by two old priests, who are the directors of their worship. These old men showed me a small cabinet within the wall, made of mats of cane. Desiring to see what was inside, the old men pre-

vented me, giving me to understand that their god was there [Swanton 1911:260–261].

While no temple statuary are specifically mentioned by Tonti, the reference to a "god" apparently housed in the small cabinet may be a reference to such an object. Father Le Petit also described a Taensa temple:

> They have a temple filled with idols, which are different figures of men and of animals, and for which they have the most profound veneration. . . .
>
> In the interior of the temple are some shelves arranged at a certain distance from each other, on which are placed cane baskets of an oval shape, and in these are inclosed [sic] the bones of their ancient chiefs. . . . Another separate shelf supports many flat baskets very gorgeously painted, in which they preserve their idols. These are figures of men and women made of stone or baked clay [Le Petit 1900].

Similarly, this passage associates the temple with idols and the bones of chiefs. In this instance, statues made of stone (and ceramics) are described as representing both males and females.

French explorers also recorded a human figure in use as temple statuary among the Natchez. The Natchez related the story that the first leaders were a man and woman from the Upper World—the man being a younger brother of the Sun. As related by St. Cosme: "The chiefs were regarded as spirits descended from a kind of idol which they have in their temple and for which they have a great respect. It is a stone statue enclosed in a wooden box. They say that this is not properly the great spirit, but one of his relatives which he formerly sent into this place to be the master of the earth; that this chief became so terrible that he made men die merely by his look; that in order to prevent it he had a cabin made for himself into which he entered and had himself changed into a stone statue for fear that his flesh would be corrupted in the earth" (Swanton 1911:172). This passage is particularly telling in terms of identifying the Natchez idol as the direct ancestor of the chiefs. In his 1705 history of Virginia, Robert Beverley included a lengthy account of his clandestine examination of one of these buildings, which provides additional details concerning the use of human images:

> [Within the temple] we found large Shelves, and upon these Shelves three Mats, each of which was roll'd up, and sow'd fast. These we handed down to the light, and to save time in unlacing the Seams, we made use of a Knife, and ripp'd them, without doing any damage to the Mats.

In one of these we found some vast Bones, which we judged to be the Bones of Men, particularly we measured one Thigh-bone, and found it two foot nine inches long: In another Mat, we found some Indian tomahawks finely grav'd and painted. . . . They were made of a rough heavy wood. . . . In the third mat there was something, which we took to be their Idol, tho of an underling sort, and wanted putting together. The pieces were these, first a Board three foot and a half long, with one indenture at the upper end, like a Fork, to fasten the Head upon, from thence half way down, were Half hoops nail'd to the Edges of the Board, at about four Inches distance, which was bow'd out, to represent the Breast and Belly; on the lower half was another Board of half the length of the other, fasten'd to it by Joynts or pieces of Wood, which being set on each side, stood out about 14 inches from the Body, and half as high; we suppos'd the use of these to be for the bowing out of the Knees, when the Image was set up. There were packt up with these things, red and blue pieces of Cotton Cloath, and Rolls made up for Arms, Thighs and Legs, bent to at the Knees. . . . It wou'd be difficult to see one of these Images at this day, because the Indians are extreme shy of exposing them. We put the Cloaths upon the Hoops for the Body, and fasten'd on the Arms and Legs, to have a view of the representation: But the Head and rich Bracelets, which it is usually adorn'd with, were not there, or at least we did not find them . . . [Beverley 1705, bk. 3, pp. 28–30].

From a much later source, the use of human statues at the Creek town of Tu-kabahchee is described:

There is a carved human statue of wood, to which, however, they pay no religious homage: it belongs to the head war-town of the upper Muskohge country, and seems to have been originally designed to perpetuate the memory of some distinguished hero, who deserved well of his country; for, when their cusseena, or bitter, black drink is about to be drank in the synhedrion [Adair's term for the square ground], they frequently, on common occasions, will bring it there, and honour it with the first conch-shell-full, by the hand of the chief religious attendant: and then they return it to its former place. It is observable, that the same beloved waiter, or holy attendant, and his co-adjutant, equally observe the same ceremony to every person of reputed merit, in that quadrangular place. When I past this way, circumstances did not allow me to view this singular figure; but I am assured by several of the traders, who have frequently seen it, that the carving is modest, and very neatly finished, not unworthy of a modern civilized artist" [Adair 1775:22–23].

In sum, early historic documentation from throughout a very broad portion of the southeastern United States suggests a strong and consistent correlation between "human" statues, sacred buildings, and the actual bones of the elders. While most of these statues were apparently made of wood, several accounts mention stone and at least one mentions ceramic images. Although the use of human statues links these accounts, the diversity of types and apparent uses in the context of shrines is striking.

Tennessee-Cumberland Style Statues and Ancestor Shrine Complexes

Human figures sculpted of stone, wood, and pottery were in widespread use during both the late prehistoric and early historic periods in the southeastern United States. As the epigraph for this chapter suggests, however, simply "upstreaming" the details provided by the ethnographic record is insufficient to expand our understanding of the complex and changing sociopolitical landscape of the Mississippian Southeast. Recent examination and interpretations of the corpus of Cahokia style statuary offers new and important insights into the dynamics of this landscape over the course of several centuries. The corpus of Tennessee-Cumberland style statues provides some different but equally intriguing hypotheses about the nature of the late prehistoric landscape.

Both the ethnohistoric and archaeological data converge on the notion that Mississippian stone statues were initially created as sacra for use in shrines associated with the veneration of ancestors. Given the diversity represented in the handful of historic records of ancestor shrines, it should be no surprise that the archaeological record suggests an equal if not greater diversity in how these beliefs were enacted both within regions and across the broader Mississippian world. The corpus of Tennessee-Cumberland style statues includes statues exhibiting several themes, not all of which are explicable with the current information. At this point, the two most definable themes relate to male-female statuary pairs and the Old Woman.

Given the available information, the sculpting of male-female statuary pairs in stone seems to be restricted geographically to a relatively small region centering on a few major towns in Middle Tennessee and northern Georgia. The simplest explanation for these statuary pairs is that they are physical representations of ancestral chiefly couples, the progenitors of the chiefdom. While stone statues were certainly being manufactured, used, and buried outside this small region, the current evidence does not suggest they were parts of statuary pairs. At sites outside this "heartland" region, the presence of single statues frequently depicting males may represent a different conceptualization of community and leadership. Alternatively, the consis-

tency of representation of seating style, hairstyle/headgear and other features found particularly in the fluorite statues suggests the possibility that they represent a specific as yet unidentifiable supernatural character of significance in the oral traditions of those regions. Among the multiple possibilities are the male progenitors mentioned in many oral traditions (cf. First Man, Venerable Man, First Creator, Old Man Immortal). The St. Cosme description of the statue in the Natchez temple certainly suggests such an association during the seventeenth century. Some of the paired statues may also have carried meanings broader than simply ancestral pairs. The statues may be multivocalic symbols where real venerated ancestors become merged in part with supernatural characters and their oral traditions upon death.

The statues we identify as representing the Old Woman appear to be distributed more broadly and in a greater range of contexts in Tennessee than the statuary pairs. Given the centrality of the "earth mother" in native oral traditions from across North America, it is not surprising that images of the Old Woman would be components of Mississippian shrines. Although no definitive patterns emerge from the available evidence, the Old Woman statues may not have been as tightly linked to the chiefly shrines as their ancestral pair counterparts. As noted in the Cahokia style statuary, the female images identified as the Old Woman seem more closely associated with rural shrines. Ceramic bottles, rattles, and figurines interpreted as the Old Woman are found at a much greater diversity of sites in the Nashville Basin than the statues, including hamlets and villages. While varying stylistically, they range chronologically from A.D. 1200 to 1450 in the Nashville Basin. More often than not, they are found buried with individuals in graves. After A.D. 1500, clay vessels in the form of an old woman are found throughout much of the Mississippian world. From this perspective, the discovery of statues representing the Old Woman in locations apparently remote from chiefly mortuary shrines may reflect a distinct cult institution. At least among the Siouan groups, sacred bundles and ceremonies associated with the Old Woman were the responsibility of women (Duncan and Diaz-Granados 2004:196–197). The very widespread occurrence of a variety of Old Woman motifs in Middle Tennessee supports the likely presence of such a cult institution and could explain the broader distribution of the statues as well.

Entering the Archaeological Record

With the current data, we cannot offer firm conclusions about the events that precipitated the entrance of individual statues into the archaeological record. However, some viable alternative hypotheses can be suggested. These hypotheses are not necessarily mutually exclusive; in other words, the burial of an individual statue or set of statues was probably set in motion for different reasons at different places and times. Ethnographic evidence would tend

to suggest that the interment of *sacra* from shrines would be precipitated by two (sometimes interrelated) types of events: (a) chiefly succession, and/or (b) interpolity competition.

Probably the best archaeologically documented reason that the statuary as shrine sacra would enter the archaeological record is the threatened or real destruction of a shrine by external forces. The shrine and its sacra comprised the foundation of chiefly power and the ideological underpinnings of the chiefdom itself. As such, destruction or desecration of the structure and its contents may have been the most significant goal of military attacks on ceremonial centers. Even if physical control of a town or territory could not be established or maintained, destruction of the ancestral mortuary shrine might serve to destabilize the often-fragile foundations of chiefly authority. As noted by Brown, the ethnographic accounts suggest that "the mortuary that housed the bones of the honored ancestors was considered the ideological heart of the town or community. Military defeat was truly complete once the mortuary was breached, the structure burned, and the bones defiled and scattered" (Brown 1975:17). This centrality is clearly reflected in the following account:

> ...the Casquins moved on to the temple in the large public plaza, which was the burial place of all who had ever ruled that land—the fathers, grandfathers and other ancestors of Capaha.... Summoning all of their forces so that everyone might enjoy the triumph, the Casquins went to this temple and sepulcher, and since they realized how much Capaha... would resent their daring to enter and desecrate this place, they not only proceeded within but committed every infamy and affront they could. Sacking it of all ornaments and riches, they took the spoils and trophies which had been made from the losses of their own ancestors. Then they threw to the floor each of the wooden chests which served as sepulchers, and for their own satisfaction and vengeance as well as for an affront to their enemies, strewed upon the ground the very bones and bodies the chests enclosed. Afterward not content with having cast these remains to the ground, they trod upon them and kicked them with utter contempt and scorn [Varner and Varner 1951:438].

A convincing case has been presented that the disposal of one of the Etowah ancestral pairs resulted from such an unplanned and hasty sequence of events. In this instance, the destruction may even have resulted in the abandonment of the Etowah center.

Other plausible explanations relate to internal factors such as chiefly succession events. Most models of chiefly succession in the Mississippian Southeast include some element of the destruction of structures, facilities, and tal-

ismans of power associated with the recently deceased chief. Addition of a new construction stage to a mound along with new facilities to sit atop it is a frequently mentioned aspect of chiefly succession. David Hally (1996:95) has argued that there is "only one event having sufficient community interest and occurring with sufficient frequency and regularity to have served as the stimulus for most rebuilding, namely, succession to the office of chief. Succession probably occurred most commonly as a result of the incumbent's death, but chiefs may have been overthrown on occasion." Based on his analysis of well-documented mound construction episodes in north Georgia, Hally further argues that "duration of construction stages is seen to range about fifteen to twenty-five years. This range does not seem unreasonable as an estimate for the average duration of a chief's tenure in office and supports the position that mantles of fill were added to platform mounds at the time of chiefly succession" (Hally 1996:110). In his interpretation of the evidence for Mound C, Adam King (2003) identified seven construction stages with three dating to the early Wilbanks phase (A.D. 1250–1325) and four dating to the late Wilbanks phase (A.D. 1325–1375). If Hally's assertion is valid, this sequence would represent the installation of seven chiefly couples during the early and late Wilbanks phase. Three and possibly as many as five statuary pairs are documented to varying degrees from Etowah, most probably from Mound C. We offer the possibility that during at least part of the Wilbanks phase, the transfer of authority from one generation to the next involved the creation of statuary pairs venerating the immediate ancestors of the new chief.

However, this begs the questions of the statue pairs recovered from sites without evidence of monumental architecture. One potential means of explaining this discrepancy is simply to dismiss this largely anecdotal evidence as inaccurate or misrepresentative. However, assuming that these reports contain at least a grain of truth, such events are explicable in the context of successional events. On occasion, succession probably did not always proceed in an orderly fashion within the same lineage. If a successional event involved the transfer of political authority from one lineage to another, disposal of ancestral figures outside of the context of mound construction could have been preferable. Where links between the "new lineage" and the "old lineage" were undesirable because of specific historical circumstances, a statuary pair representing the ancestors of the "old lineage" could have been perceived as symbols of a past best buried elsewhere. The apparent secretion of the Martin Farm statuary pair at a small village near the Beasley Mounds site can be accommodated within this model. If the transfer of political control occasionally involved residential relocation, as some scholars have suggested, the lineage "out of power" might have relocated their ancestral statues for burial in settlements remaining under the political authority of that lineage. For ex-

ample, where chiefly lineages adhered to a pattern of matrilocal postmarital residence, brothers and other male relatives of a deposed chief might well have been geographically dispersed in other settlements (Anderson 1994:89).

In other cases, entry into the archaeological record may have been linked with other as yet unidentified types of events—particularly in the case of statues in the Old Woman theme. These statues and even some of the statuary pairs may have been (or become) disassociated from centralized political authority. Given that the complex histories of individual chiefdom centers are not thoroughly understood, it remains possible (and even likely given the ethnographic record) that some shrine sacra may have remained significant even where political authority was vested in councils rather than chiefs. If some individual statues or statuary pairs were perceived as sacred to a *community* (as holy tribal mysteries) rather than solely as ancestors of a *lineage,* then their retention in a council house or other public dwelling in a settlement without temple mounds or other physical evidence of chiefly organizational structure is plausible.

None of the above arguments can be adequately tested using the current evidence for the Tennessee-Cumberland style statues. They should be accepted for what they are—a wide variety of hypotheses based on the limitations of the available information. At heart, our argument is that the deposition of stone statues in the archaeological record was undoubtedly the end result of many different possible trajectories. Rather than attempting to provide a single monolithic explanation that would encompass every statue while dismissing conflicting anecdotal evidence, we instead argue that the diversity is probably more real than apparent. We should expect no less diversity in the archaeological record than we see in the ethnohistoric accounts. Indeed, past practices may be even more dynamic and diverse than those represented in the ethnographic present.

Chronological Range of Production

While the evidence for ancestral shrines and associated figural sculptures spans many centuries, the creation of specific styles of *stone* figural sculptures appears to have been most common during the period between A.D. 1100 and 1350. While noting that the Natchez statues provide an exception, the majority of the available evidence supports two phases of stone sculpture production. If Thomas Emerson's assertions are correct, the first phase of statuary production by Mississippian artisans is represented in the Cahokia style statuary and is restricted to the Stirling phase (A.D. 1100–1200) (Emerson et al. 2003). Some of these statues (particularly nonfemale statues) were later acquired by elites outside the American Bottoms and entered the archaeological record at sites distributed throughout the trans-Mississippi south in the century or two following A.D. 1200.

While not unequivocal, the available radiocarbon dates and diagnostics associated with Tennessee-Cumberland style statuary suggest that most of them were probably created during a second more widespread phase of statuary production in the interior Southeast ranging from around A.D. 1200 to 1400. We also offer for consideration that the Tennessee-Cumberland style statues in the Ancestral Pair theme may have all been created in a more restricted timeframe between A.D. 1250 and 1350. The known statuary pairs come from a very small number of town centers in Middle Tennessee and north Georgia exhibiting multiple lines of evidence for intensive interaction in what has generally been called the Southeastern Ceremonial Complex. While subject to further refinement, the available evidence suggests that elites at only a few towns were creating and using stone ancestral pairs as symbols of chiefly authority—and probably as tools of factional competition within and between these polities. The chert used to make the flint "swords" from early Wilbanks Mound C burials came from Tennessee (Larson 1971) and quite possibly from the Link Farm site. The copper used to make the plates and other headdress elements also probably came from southeast Tennessee (Goad 1980). While future archaeological research at sites such as Link Farm, Sellars, Castalian Springs, and Beasley Mounds will be required to expand on these relationships, we suspect that the Tennessee-Cumberland style ancestral pairs will ultimately prove to be yet another geographically centered artifact style produced during the thirteenth and early fourteenth centuries.

Between A.D. 1300 and 1450, the sociopolitical landscape of the Nashville Basin appears to have slowly fragmented into a relatively decentralized network of dispersed fortified villages. Although a few of the former chiefdom centers continued to be occupied, most of the later phase occupations are functionally indistinguishable from contemporary fortified villages without mounds. While some of these towns may have briefly controlled larger territories, the general picture is one of a steady and sure degradation of a formerly much more centralized political landscape. By A.D. 1450 or shortly thereafter, evidence of nucleated settlements in the Nashville Basin that could be called villages or towns disappears from the archaeological record (Smith 1992; 2006).

Conclusions

While the presence of ancestral shrines and associated human sculptures clearly spans many centuries in the prehistoric and early historic southeastern United States, we perceive the production of the stone statues at the core of the Tennessee-Cumberland style as a chronologically brief and geographically restricted expression of this persistent and widespread complex. While artisans from centers scattered across the Mississippian world produced a statue or two reflecting local beliefs and traditions, in Middle Tennessee and north Georgia this practice became commonplace for a few generations.

In the "heartland" of Tennessee-Cumberland style statuary production between about A.D. 1250 and 1350, a basic and required accoutrement of ancestral mortuary shrines were pairs of male and female statues representing the ancestors of the chiefly lineage. Sometimes, these ancestral pairs were probably accompanied by other stone statues representing Old Woman, the more distant grandmother of all native peoples. Outside of the chiefdom centers, stone sculptures of the Old Woman may have been created and housed in different types of shrines at smaller settlements or in isolated locations such as caves or rockshelters perceived to lead to her lodge in the watery Underworld.

Clearly the archaeological evidence associated with the Tennessee-Cumberland style statues alone does not provide a viable database against which to test all of these hypotheses and outright speculations. However, we hope that by adding what details we could muster for statuary production, distribution, and entry into the archaeological record to the mix, future researchers will be able to test and refine our understanding of the statues, ancestor shrines, and southeastern belief systems. We fully expect that there was great variation in the treatment of shrine sacra throughout the geographic and temporal span of the Mississippian world. We also anticipate that no simple or single explanation will emerge for why and how statuary came to enter the archaeological record—their placement is not singularly influenced by *cultural process,* but also by the effects of *agency* as reflected in the historical circumstances of individual leaders, lineages, and polities.

Sadly, one of the conclusions to be drawn from of our survey of Tennessee-Cumberland style statuary is that although many tidbits of information can be teased from the documentary record, the context for many of the known statues has already been lost beyond recovery. Tennessee-Cumberland style statues are rare because they were exceptionally significant objects to their creators. They are unique and irreplaceable not only because of their monetary value and simple beauty but also because of their potential to tell us remarkable stories about the past. If, as we postulate, the ancestral pairs are indeed portraits of real chiefly couples who lived from about A.D. 1250 to 1350, they are also a rare and unique chance to look into the faces of individual men and women from the ancient Mississippian world in the same fashion that we can appreciate the sculptures and paintings of George and Martha Washington. In closing, we hope that our survey—despite its limitations—will provide food for thought for both archaeologists and the interested public. In particular, we hope that anyone who discovers a Tennessee-Cumberland style statue in the future will treat it with greater respect and appreciation than were most of those recovered in the past.

Appendix A
Tabular Summaries of
Statue Characteristics

Table A.1. Summary of Statuary Characteristics.

CSS#	Figure	Style	Theme		Interpreted Gender (Genitals if present)	Seating Type (Figure 2.7)	Height (nearest cm)	Width (nearest cm)	Thickness (nearest cm)	Hair Type (Figure 2.4)	Raw Material
001	3.4	Tennessee-Cumberland		Core	Male	A?	65	33	23	B	Siltstone
002	3.5, 3.6, 3.7	Tennessee-Cumberland	Ancestral Pair	Core	Female	C	38	28	25	C	Siltstone
003	3.8, 3.9, 3.10, 3.11, 3.12, 3.13	Tennessee-Cumberland	Ancestral Pair	Core	Male	B	47	<	<	E, F	Siltstone
004	3.14	Tennessee-Cumberland	Old Woman	Core	Female	C?	48	25	17	C	Siltstone
005		Tennessee-Cumberland			Female	C?	38			C?	"Hard stone"
006	3.15	Tennessee-Cumberland		Core	Male	?	14 (head only) 60?	17	10	B★	Hard sandstone
007		Tennessee-Cumberland			Female?	C	22 (head only)			-	"sandstone"
008	3.36	Tennessee-Cumberland		Core	Female?		28 (body only)	25		C	"sandstone"
009	3.37	Tennessee-Cumberland		Core	Male (Penis?)	B	28 (body only)	25	28	-	Sandstone
010	3.17, 3.18	Tennessee-Cumberland	Ancestral Pair	Core	Male	A?	36	22	17	B	Siltstone

011	3.19, 3.20	Tennessee-Cumberland	Ancestral Pair	Core	Female	C?	33	22	17	C	Siltstone
012	3.21	Tennessee-Cumberland		Core	Male?	A	31 (body only)	28	19	–	Siltstone
013	3.22	Tennessee-Cumberland	Old Woman	Core	Female (Vulva)	C	22 (body only)	15	13	–	Siltstone
014	3.23	Tennessee-Cumberland		Core	?	A?	26 (body only)	29	11	–	Siltstone
015	3.24, 3.25	Tennessee-Cumberland	Ancestral Pair?	Core	Male (Penis?)	C?	41	24	13	B, D	"a kind of sandstone"
016	3.26, 3.27	Tennessee-Cumberland	Ancestral Pair?	Core	Female	C	39	23	14	C★	"a kind of sandstone"
017	3.28, 3.29	Tennessee-Cumberland		Core	Female	C	32	17	10	D	"sandstone"
018	3.30, 3.31	Tennessee-Cumberland	Ancestral Pair	Core	Male	A	38	24	18	B	Sandstone
019	3.32, 3.33, 3.34	Tennessee-Cumberland	Ancestral Pair	Core	Female	C?	33	22	13	C	Sandstone
020	5.3	Tennessee-Cumberland	Old Woman	Core	Female	C?	38			C	Probably sandstone?
021	5.4, 5.5	Tennessee-Cumberland		Core	Female?	?	48	36		C, D	"hard limestone"
022		Unassigned								–	"grayish exterior white interior, glittering with specks"
023	5.6	Tennessee-Cumberland	Old Woman	Core	Female	C	42	23	18	C, D	Quartzite sandstone?

Continued on the next page

CSS#	Figure	Style	Theme		Interpreted Gender (Genitals if present)	Seating Type (Figure 2.7)	Height (nearest cm)	Width (nearest cm)	Thickness (nearest cm)	Hair Type (Figure 2.4)	Raw Material
024	B.7	Tennessee-Cumberland	Old Woman	Core	Female	C?	35			C	Probably sandstone
025		Tennessee-Cumberland	Old Woman?		Female?	C?	35–40?			-	Probably sandstone
026		Cumberland "Old Woman"?			F?	C?	35–40?			-	
027		Cumberland "Old Woman"?			F?	A?/C?	35–40?			-	
028	5.19, 5.20	Tennessee-Cumberland	Old Woman	Core	F	C	23	13	9	B	Sandstone
029		Unassigned			Female	?	?			-	"sculptured stone"
030	3.39	Tennessee-Cumberland	Ancestral Pair?	Core	Male (Penis?)	B	34			F	Sandstone
031	3.40	Tennessee-Cumberland	Ancestral Pair?	Core	Female?	B	31	16	20	C	Sandstone
032	5.8, 5.9, 5.10	Tennessee-Cumberland	Ancestral Pair?	Core	Male?	?	33	23	13	B	Sandstone
033		Tennessee-Cumberland	Ancestral Pair?		Male?		46?			-	"stone or marble" "hard stone"
034		Tennessee-Cumberland	Ancestral Pair?		Female?		46?			-	"stone or marble" "hard stone"

035	5.11, 5.12, 5.13	Tennessee-Cumberland		Core		?	19 (head only)	14	15	C	"marble or crystalline limestone"; large grained marble consisting of the mineral calcite
036	3.43, 3.44	Tennessee-Cumberland	Ancestral Pair	Core	Male	B	67	36	27	E	Quartzite sandstone (X-ray defraction by Metropolitan Museum of Art Objects Conservation Lab, 1990)
037	3.45	Tennessee-Cumberland	Ancestral Pair	Core	Female	C	61			C	Quartize sandstone
038	5.23	Tennessee-Cumberland			Female?	?	41	23		C?	Sandstone
039	3.46, 3.47, 3.48, 3.49	Tennessee-Cumberland	Old Woman	Core	Female (Vulva)	C	36	19		A★	Sandstone
040		Unassigned					42			–	
041	6.1	Tennessee-Cumberland		Core	Male?	B	25–30? (head only)			D	Fluorite
042	5.21	Unassigned					45	8	13	E?	Sandstone

Continued on the next page

CSS#	Figure	Style	Theme		Interpreted Gender (Genitals if present)	Seating Type (Figure 2.7)	Height (nearest cm)	Width (nearest cm)	Thickness (nearest cm)	Hair Type (Figure 2.4)	Raw Material
043	5.18	Tennessee-Cumberland		Core	M	C	37			B	"compact limestone"
044	5.15	Unassigned				C?	52	11	17	-	"crystalline limestone"
045	B.1	Tennessee-Cumberland	Old Woman	Core	Female (Vulva)	C	29			C★	Sandstone
046	B.2, B.3	Tennessee-Cumberland	Old Woman	Core	Female	C	40	17	20	C	Sandstone
047	B.4, B.5	Tennessee-Cumberland	Old Woman		Female	C?	24	14	6	-	Sandstone
048	B.6	Tennessee-Cumberland	Old Woman?		Female (Vulva?)	C	20	10	8	A★	Sandstone
049	1.2	Tennessee-Cumberland	Old Woman	Core	Female	C	25	13	15	C	Limestone or a type of sandstone
050	5.14	Tennessee-Cumberland			?	A	30			-	"limestone"
051	6.2	Tennessee-Cumberland		Core	Male (Penis and Testicles)	A?	25	13	16	B, D	Fluorite
052	6.3, 6.4	Tennessee-Cumberland		Core	Male	B	30	25	18	D	Fluorite
053	6.5	Tennessee-Cumberland			Male?	?	10 (head only)			E	Fluorite

ID	Nos.	Region	Type		Sex	Class				Grade	Material
054	6.7, 6.8	Tennessee-Cumberland		Core	Male	B	21	14	15	D	Fluorite
055		Tennessee-Cumberland?			Male?	A?	30			B	"Coarse dark sandstone"
056	4.2	Tennessee-Cumberland		Core	Female	C	40	25	18	C	"soft talcose rock"
057	4.5	Tennessee-Cumberland		Core	Male	A	45			B	Sandstone
058		Tennessee-Cumberland		Core	Female?	?	43	17	9	C	Sandstone
059	4.6, 4.7, 4.8	Tennessee-Cumberland	Ancestral Pair	Core	Male	A	61			B	Marble
060	4.9, 4.10, 4.11	Tennessee-Cumberland	Ancestral Pair	Core	Female	C	57			–	Marble
061	4.19	Tennessee-Cumberland		Core	Male	A	55			B	"fine grained sandstone"
062	5.1, 5.2	Tennessee-Cumberland			Female?	C?	43	20		B	
063	6.9	Tennessee-Cumberland?			Female? (Vulva?)	C?					
064	5.24, 5.25	Tennessee-Cumberland			Female?	C?	47	22.5	9	★	"metasandstone"
065	5.7	Tennessee-Cumberland?			Male	A					
066		Unassigned			Female?						
067	B.8, B.9	Fake									
068	B.10, B.11	Fake									

Continued on the next page

CSS#	Figure	Style	Theme	Interpreted Gender (Genitals if present)	Seating Type (Figure 2.7)	Height (nearest cm)	Width (nearest cm)	Thickness (nearest cm)	Hair Type (Figure 2.4)	Raw Material
069	3.38	Unassigned (possible fake)								
070		Unassigned		Male?	A?	30			B, D	Sandstone
071		Unassigned								
072		No information								
073		No information								
074	4.15, 4.16	Unassigned	Ancestral Pair?	Male	A	43				Hard stone
075	4.17, 4.18	Unassigned	Ancestral Pair?	Female	C	28				Hard stone
076	4.20, 4.21	Unassigned		Male	A?	40	22			
077		No information available								
078	6.10	Tennessee-Cumberland?								
079		Tennessee-Cumberland?	Ancestral Pair?							
080		Tennessee-Cumberland?	Ancestral Pair?							
081		Tennessee-Cumberland?	Ancestral Pair?							

082		Tennessee-Cumberland?	Ancestral Pair?	
083		No information		
084		No information		
085		No information		
086		No information		
087	4.3, 4.4	Tennessee-Cumberland?		
088		No information	Male?	41

*Pointed hairline at temples

Table A.2. Statuary Provenance, Curation Location, and Conditions of Recovery.

CSS#	Site Name (Number)	Intra-Site Provenance	Conditions of Recovery	Date of Find	Curation Location	Location of Casts
001	Sellars (40WI1), Wilson County, TN	Habitation area	Plowed up	June 8, 1922	Private collection	
002	Sellars (40WI1), Wilson County, TN	Habitation area	Plowed up	Late 1938 or early 1939	Private collection	
003	Sellars (40WI1)?, Wilson County, TN	Habitation area?	Dug up	December 1939	Frank H. McClung Museum, University of Tennessee Knoxville	
004	Sellars (40WI1)?, Wilson County, TN	Habitation area?	Dug up	December 1939	Frank H. McClung Museum, University of Tennessee Knoxville	
005	"Gilliam farm," Wilson County, TN		Dug up	March 1823		
006	Dodson Farm, Wilson County, TN	"in a field south of Cedar Creek"	Plowed up	1954 or 1955	Private collection	
007	Castalian Springs (40SU14), Sumner County, TN	Anecdotal "plowed up in the neighboring field" "top of the mound"	Plowed up	"Some years" before 1823		
008	Castalian Springs (40SU14), Sumner County, TN	"in a mound" Wilson; "near the earthworks and graves of Castalian Springs," Thruston	Plowed up	Summer 1888	NMAI/Heye, 3/5337	
009	Castalian Springs (40SU14), Sumner County, TN	"in The Bottom across the creek" (Wynne 1973)	Plowed up	After 1923?	Wynnewood State Historic Site, Castalian Springs, Tennessee	

010	Beasley Mounds (40SM43), Smith County, TN	Approximately 30–40 ft west of "main mound"	Plowed up	1898	USNHM, Smithsonian, 334008
011	Beasley Mounds (40SM43), Smith County, TN	Approximately 30–40 ft west of "main mound"	Plowed up	1898	USNHM, Smithsonian, 334007
012	Beasley Mounds (40SM43), Smith County, TN	Approximately 30–40 ft west of "main mound"	Plowed up	1898	USNHM, Smithsonian, 334012
013	Beasley Mounds (40SM43), Smith County, TN	Approximately 30–40 ft west of "main mound"	Plowed up	1898	USNHM, Smithsonian, 334013
014	Beasley Mounds (40SM43), Smith County, TN	"in the field at Dixon Creek"		Before 1923	USNHM, Smithsonian, 334011
015	Possibly Beasley Mounds, Smith County, TN		Plowed up	Before 1845	USNHM, Smithsonian, 30252
016	Possibly Beasley Mounds, Smith County, TN		Plowed up	Before 1845	USNHM, Smithsonian, 30251
017	Possibly Beasley Mounds, Smith County, TN			Before 1883	USNHM, Smithsonian, 61259
018	Martin Farm, Smith County, TN		Plowed up	Spring 1905	Private Collection
019	Martin Farm, Smith County, TN		Plowed up	Spring 1905	USNHM, Smithsonian, 334009
020	Near Piper's Ford, Smith County, TN		Plowed up	Before 1880	Destroyed in Myer house fire ca. 1880
021	Dekalb County, TN	"village site and near cemetery on Caney Fork at the mouth of Falling Water"	Plowed up	Before 1898	USNHM, Smithsonian, 334005

Continued on the next page

CSS#	Site Name (Number)	Intra-Site Provenance	Conditions of Recovery	Date of Find	Curation Location	Location of Casts
022	Cherry Creek Site (40WH65), White County, TN	"field"		Before 1823		
023	Terry farm, Burgess Cove, White County, TN	"bench of the hill"	Plowed up	1903	USNHM, Smithsonian, 334006	
024	Base of Cumberland Mountains near McMinnville, Warren County, TN	"one burial place"	Dug up	About 1870	NMAI/Heye, Smithsonian, 21/965	
025	Base of Cumberland Mountains near McMinnville, Warren County, TN	"one burial place"	Dug up	About 1870		
026	Base of Cumberland Mountains near McMinnville, Warren County, TN	"one burial place"	Dug up	About 1870		
027	Base of Cumberland Mountains near McMinnville, Warren County, TN	"one burial place"	Dug up	About 1870		
028	Sequatchie Valley, probably Bledsoe County, TN	"in a hollowed out conch shell"	Plowed up	Before 1845		USNHM, Smithsonian, 30155
029	Mayfield's Station east of Brentwood (40WM30)?, Williamson County, TN	"near the base of a mound"		About 1803		
030	Valley of the Cumberland	"in the neighborhood of large pyramidal mounds and numerous stone graves (J. Jones 1876:129)		Probably prior to 1868	NMAI/Heye, Smithsonian, 00/7277	

No.	Location	Description	Condition	Date	Repository
031	Near Jarman Farm site (40WM210), Williamson County, TN			1883	Tennessee State Museum, Nashville, 1091
032	"A few miles from Ashland City," Possibly Sycamore Creek site (40CH74), Cheatham County, TN		Plowed up	About 1890	USNHM, Smithsonian, 334010
033	Murphy Farm (40MT48), Montgomery County, TN	On a high bluff east of two mounds, quantity of human bones under and near them	Plowed up	Between 1796 and 1799	
034	Murphy Farm (40MT48), Montgomery County, TN	On a high bluff east of two mounds, quantity of human bones under and near them	Plowed up	Between 1796 and 1799	
035	Wallace Farm, probably Christian County, KY	"In a mound"		1887	Metropolitan Museum of Art, New York City, 1979.206.1139
036	Link Farm (40HS6), Humphreys County, TN	Habitation area east of main mound. Beneath the Duck River cache	Dug	March 23, 1895	Metropolitan Museum of Art, New York City, 1979.206.476
037	Link Farm (40HS6), Humphreys County, TN	Habitation area east of main mound. Beneath the Duck River cache	Dug	March 23, 1895	
038	McKelvey Mound (40HR30), Hardin County, TN	Possibly associated with structure	Excavated during Pickwick Lake reservoir project	1936	
039	Acuff farm on Big Bigby Creek, Maury County	Near a mound and a spring . . . site of a large prehistoric town	Shows plow damage	Before August 1931	Columbus Museum, Columbus, GA

Continued on the next page

CSS#	Site Name (Number)	Intra-Site Provenance	Conditions of Recovery	Date of Find	Curation Location	Location of Casts
040	Fortress at the Narrows of Piney (40HI36), Hickman County, TN	325 ft east of the main mound	Plowed up	Before 1923		
041	Obion Mounds (40HY14), Henry County, TN	Borrow pit?	Dug up while "cleaning out a sink"	Spring 1845	Head in NMAI/Heye, Smithsonian, 00/7260; Body destroyed in S. H. McWhirter house fire in 1857	
042	Daniel Mound (40LN96), Lincoln County, TN	At the end of the mound		Before 1933	USNHM, Smithsonian, 388049	
043	Long Island (40R E17), Roane County, TN	Mound 3 "domiciliary mound"	Excavated during BAE Thomas survey by John Emmert	1889	USNHM, Smithsonian, 131781	
044	Knox County, TN	Cave on banks of Holston River near Strawberry Plains	"Collected"	1866 or 1867	USNHM, Smithsonian, 6462	
045	Valley of the Cumberland	"in the neighborhood of large pyramidal mounds and numerous stone graves (J. Jones 1876:129)		Before 1868	NMAI/Heye, Smithsonian, 00/7276	
046	Possibly Williamson County, TN	"in a grave by the side of a skeleton, much taller than the present race" (W. M. Clark 1878:276)	"Procured," shows plow damage to head	Prior to 1875	USNHM, Smithsonian, 19932	

047	Possibly Williamson County, TN	"grave" (W. M. Clark 1878:276)	"Procured"	Prior to 1875	USNHM, Smithsonian, 19933
048	Perry County, TN	"from a mound surrounded by stone graves"	"Exhumed from mound"	Prior to 1868	USNHM, Smithsonian, 19934
049	Trigg County, KY	Near Cumberland River, 70 miles south and west of Lexington	Plowed up	Prior to July 1790	NMAI, Smithsonian, 19/2495
050	On Cumberland River, Trigg County, KY	Mound		Prior to 1910	
051	Mildred Orange farm several miles west of Tolu, Crittenden County, KY	At edge of bottomland on the south bank of Ohio River	Plowed up	May 1954	Private Collection
052	Bank of Running Lake, Union County, IL	Base of mound	Dug	1873	Field Museum, Chicago USNHM, Smithsonian, 30259
053	Southern Illinois				University of Illinois, Museum of Natural History, Urbana
054	Angel Site (12VG1), Vanderburgh County, IN	Southeastern corner of Mound F	Excavated by WPA Angel Site Project	November 26, 1940	Glenn A. Black Lab, University of Indiana, Bloomington
055	Etowah (9BR1), Bartow County, GA	Near the large mound on Etowah River; habitation area away from mounds?	Plowed up	Before 1859	Lost or destroyed during Sherman's march through Georgia in 1864
056	Etowah (9BR1), Bartow County, GA	Near the base of one of the mound	Plowed up	Before 1873	NMAI/Heye, Smithsonian, 14/1455

Continued on the next page

CSS#	Site Name (Number)	Intra-Site Provenance	Conditions of Recovery	Date of Find	Curation Location	Location of Casts
057	Etowah (9BR1), Bartow County, GA	"in a stone box" Mound C	Exposed by scraper while filling west trench during Moorehead expedition	1925	R. S. Peabody Foundation, Phillips Academy, Andover, MA	
058	Etowah (9BR1), Bartow County, GA	"in a stone box" Mound C	Exposed by scraper while filling west trench during Moorehead expedition	1925	R. S. Peabody Foundation, Phillips Academy, Andover, MA	
059	Etowah (9BR1), Bartow County, GA	Log tomb, burial 15 Mound C	Excavated by Lewis Larson Jr. and A. R. Kelly	1954–56	Etowah Mounds Archaeological Area Museum, Cartersville, GA	
060	Etowah (9BR1), Bartow County, GA	Log tomb, burial 15 Mound C	Excavated by Lewis Larson Jr. and A. R. Kelly	1954–56	Etowah Mounds Archaeological Area Museum, Cartersville, GA	
061	Probably Raccoon Creek site (9BR26), Bartow County, GA			1886	Last known to have been in the A. J. Powers Collection at Cornell College, Mt. Vernon IA	
062	Clay County, TN		Surface collected	February 1983	Private collection	
063	Natchez, MS	"where stood an Indian temple"	Dug	Bef. 1820	Peabody Museum of Archaeology and Ethnology, Cambridge, MA	

No.	Location	Feature	How obtained	Date	Repository
064	Hardin County, TN "near Tennessee River"		Surface collected	March 19, 1992	Private collection
065	Cardwell Mountain (40WR15), Warren County, TN		"Dug up"	1970 or 1971	Tennessee State Museum, Nashville, TN
066	Cardwell Mountain (40WR15), Warren County, TN		"Dug up"	1970 or 1971	Private collection
067	Forgery				Tennessee State Museum, Nashville, TN
068	Forgery				Tennessee State Museum, Nashville, TN
069	Trousdale County, TN		"in an Indian grave"	Before 1890	
070	Schugtown (3GE2), AR	On or near a platform mound		About 1933	University of Arkansas Museum
071	Grave Creek Flats, WV		Plowed up	Before 1845	
072	Four miles south of Sparta, White County, TN		Plowed up	1940s	
073	Four miles south of Sparta, White County, TN		Plowed up	1940s	
074	Etowah (9BR1), Bartow County, GA	Burial mound	Dug	Summer 1885	
075	Etowah (9BR1), Bartow County, GA	Burial mound	Dug	Summer 1885	Museum of the Cherokee Indian
076	Haralson County, GA	Low mound on Tallapoosa River	"Found"	1901	
077	Clay County, TN				

Continued on the next page

CSS#	Site Name (Number)	Intra-Site Provenance	Conditions of Recovery	Date of Find	Curation Location	Location of Casts
078	Fatherland Site (22AD1), MS		Excavated by Moreau Chambers	1930		
079	Citico Site (40HA65)?, Hamilton County, TN		Found when ploughing	Before 1919	Destroyed in fire	
080	Citico Site (40HA65)?, Hamilton County, TN		Found when ploughing	Before 1919	Destroyed in fire	
081	Citico Site (40HA65)?, Hamilton County, TN		Found when ploughing	Before 1919	Destroyed in fire	
082	Citico Site (40HA65)?, Hamilton County, TN		Found when ploughing	Before 1919	Destroyed in fire	
083	Beasley Mounds (40SM43), Smith County, TN		Plowed up	1898		
084	Beasley Mounds (40SM43), Smith County, TN		Plowed up	1898		
085	No information					
086	No information					
087	Etowah (9BR1), Bartow County, GA	In one of the low mounds now nearly obliterated, to the east of the Great Mound	Excavated by J. P. Rogan	March 1884		
088	Catoosa Springs, Catoosa County, GA			1860		

Table A.3. Radiocarbon Dates.

Site	Sample	Context	Sample Type	Calibrated Years A.D. 1 Standard Deviation*	¹⁴C age year BP	Source
Sellars (40WI1)	UGa-0944	Sq. 13–30SW, Feature 2. Associated with wall-trench house, Structure 1	Charcoal	1020 (1160) 1260	900 ± 110	Butler 1981
Sellars (40WI1)	UGa-0945	Sw. 18–78NW, Feature 4. Large refuse filled pit	Charcoal	1268 (1288) 1382	705 ± 65	Butler 1981
Sellars (40WI1)	UGa-0946	Trench1, Feature 22. Post trench of main village palisade	Charcoal	1189 (1256) 1282	800 ± 65	Butler 1981
Sellars (40WI1)	UGa-0947	Sq. i–36SE, Feature 6. Refuse filled pits associated with early palisade	Charcoal	781 (1026) 1280	975 ± 235	Butler 1981
Sellars (40WI1)	UGa-0948	Sq. 9–27SW, Feature 39. Early village palisade	Charcoal	414 (537) 637	1545 ± 100	Butler 1981
Sellars (40WI1)	UGa-4551		Charcoal	723 (890) 992	1160 ± 100	
Sellars (40WI1)	UGa-4552		Charcoal	1223 (1282) 1379	730 ± 80	
Sellars (40WI1)	UGa-4553		Charcoal	1018 (1031) 1158	965 ± 55	
Angel (12VG1)	DIC-2357	On R3.5 line between blocks 7R4 and 8R4, exposed in profile at elevation 378.47 ft, Mound F. Collected in 1962 and submitted in 1981	Wood charcoal	1282 (1296) 1385	680 ± 50	Hilgeman 2000
Angel (12VG1)	DIC-2358	Elevation 380.26 ft, Mound F. Collected in 1965 and submitted in 1981	Wood charcoal	1296 (1304, 1367, 1385) 1397	630 ± 45	Hilgeman 2000
Angel (12VG1)	Beta-39233	FS# Md. F/4499, Feature 12, Mound F, Primary mound surface, collected in 1941 and submitted 9/5/90	Wood charcoal	1300 (1329, 1343, 1395) 1413	590 ± 60	Hilgeman 2000

Continued on the next page

Site	Sample	Context	Sample Type	Calibrated Years A.D. 1 Standard Deviation*	^{14}C age year BP	Source
Angel (12VG1)	M-4	Feature 12, Mound F, primary mound surface, collected in 1941 and submitted in 1949	Charcoal	1302 (1409) 1443	540 ± 100	Hilgeman 2000
Etowah (9BR1)	Beta-145488	Structure 1	Soot	432 (538) 579	1540 ± 50	King 2003
Etowah (9BR1)	Beta-67492	F 64A	Charred corn	1405 (1434) 1453	480 ± 70	King 2003
Etowah (9BR1)	Beta-67943	F 64A	Wood charcoal	1278 (1296) 1390	680 ± 70	King 2003
Etowah (9BR1)	Beta-67944	F 64B	Charred corn	1475 (1519, 1594, 1622) 1640	340 ± 5 0	King 2003
Etowah (9BR1)	M-402	Md C—Burial 38	Wood	1044 (1283) 1414	725 ± 200	King 2003
Etowah (9BR1)	M-542	Md C—Burial 57	Wood	902 (1071, 1079, 1128, 1136, 1158) 1287	910 ± 200	King 2003
Etowah (9BR1)	M-543	Md C—Burial 57	Shell beads	1278 (1426) 1652	500 ± 250	King 2003
Etowah (9BR1)	M-1060	Md C—Mantle 2	Charred vegetal	1483 (1661) 1951	225 ± 150	King 2003
Etowah (9BR1)	M-1061	Md C—Burial 155	Charcoal	1165 (1297) 1437	670 ± 200	King 2003
Etowah (9BR1)	M-1062	Md C—Burial 164	Charred wood	1301 (1441) 1652	450 ± 200	King 2003
Etowah (9BR1)	M-1064	Sub Md C—Feature 19	Charcoal	1021 (1212) 1290	850 ± 150	King 2003

Site (number)	Lab no.	Provenience	Material	Calibrated date*	Radiocarbon age	Reference
Cardwell Mound (40WR15)	TX-7416	Test Unit 6, Charcoal lens 30 cm below surface, 30 meters from mound	Charcoal	1221 (1278) 1296	750 ± 70	Smith 1993b
Obion (40HY14)	M-1953	Midden under Phase E, Mound 6	Wood charcoal	1018 (1071, 1079, 1128, 1136, 1158) 1256	910 ± 110	Garland 1992
Obion (40HY14)	M-1954	Midden under phase E, Mound 6	Wood charcoal	779 (1029) 1284	970 ± 250	Garland 1992
Obion (40HY14)	M-1955	Summit C, Mound 6	Wood charcoal	902 (1034) 1240	960 ± 150	Garland 1992
Obion (40HY14)	M-1956	Summit C, Mound 6	Wood charcoal	779 (1029) 1284	970 ± 250	Garland 1992

*University of Washington Quaternary Isotope lab Radiocarbon Calibration Program Rev. 4.2 using Intca198.14c dataset. Stuiver, M. and Reimer, P.J. 1993, Radiocarbon 35, pp. 215–230.

Appendix B
Two Fakes and Some
Odds and Ends

While removing and cleaning the two figures which were to be placed in another case, it was found that the seven beautiful flint-like objects were made of plaster of Paris and had been painted to look like flint. The two figures presented another surprise. On the back of the female were marks like those made by a file or rasp and others which looked suspiciously like they had been made by a chisel.

—H. C. "Buddy" Brehm

During the course of our survey, we encountered nine statues where the available information did not fit neatly into a geographically oriented organizational structure. Among these are several apparently authentic statues where the available documentation is unclear on their origin or where the sources provide contradictions that we were unable to reconcile. In an effort to be comprehensive and in the hopes that papers may surface in the future that clarify some of these issues, we have included these in this appendix on "odds and ends." Rather than discuss the thoroughly documented "Benton County fakes" alongside the other potentially legitimate statues from the Tennessee River valley, we have included them here as well.

Joseph Jones Statue (CSS-045; Figure B.1)

For CSS-030 and CSS-045, Joseph Jones provides only the very general provenance of the "valley of the Cumberland." We suspect that Jones purchased both of these statues since he is typically explicit in citing the provenance of artifacts when that information was available. Based on numerous similarities to CSS-031, we have argued that CSS-030 probably also came from Dr. Frost's farm near Brentwood in Williamson County. Unfortunately, CSS-045 does not provide the same opportunity to postulate a more specific provenance.

CSS-045 exhibits several unique characteristics, but also shares several general characteristics with the statues we interpret as representing the Old Woman. Among the distinctive details is the long cylindrical neck above a squarish torso, absence of hands visible from the front, cone-shaped breasts

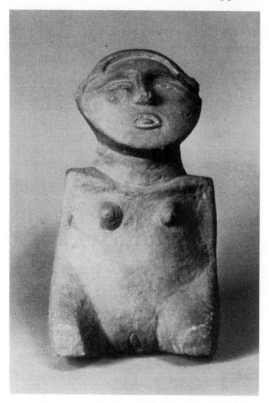

Figure B.1. CSS-045. Courtesy Smithsonian Institution, National Museum of the American Indian, Washington, D.C., Slide #2573.

with incised nipples, and deeply incised "half moon" shaped eyes. The statue is also among of the few showing the vulvar motif in relief on the front between the widely separated knees.

More traditional features include the oval mouth with protruding tongue in relief (showing traces of pigment) and the pointed hairline in relief terminating in an elongated hair knot on the flattened occipital region. The statue shows evidence of plow damage on the face (especially on the nose, right cheek, and ears) and the right knee.

William M. Clark Statues (CSS-046, CSS-047, CSS-048)

Dr. William M. Clark of Franklin, Tennessee, was another avocational archaeologist and artifact collector of local prominence in the mid- to late 1800s who acquired some stone "idols" (Clark 1878). In the 1870s, he sent a handwritten manuscript to the Smithsonian Institution describing his excavations around Franklin and a description of three stone statues in his collection. Excerpts from the manuscript were published as "Antiquities of Tennessee" (omitting some speculations in the original manuscript on con-

nections between Middle Tennessee artifacts and the South Seas). The provenance of these statues is not entirely clear, but given the general nature of Clark's collection, all three are likely to have been discovered in Middle Tennessee.

After acquisition of these statues by the Smithsonian Institution in 1876, their provenance has sometimes been assumed to be "Old Town" (40WM2; Smith 1993a), a Mississippian period mound site located 7 miles northwest of Franklin where Clark spent at least some small amount of time digging. Apparently based on notations in the Smithsonian records, Thomas Wilson identified their provenance as Williamson County (Wilson 1898:470). Careful reading of the original manuscript and published version does not support an interpretation that they were found at the Old Town site nor even for certain that they were found in Williamson County. Clark indicates that he had "procured" the statues but does not discuss them in the context of his personal excavations. Our interpretation is that he probably acquired the three statues by purchase, possibly from Williamson County but almost certainly from somewhere in Middle Tennessee.

CSS-046, a female, is depicted kneeling with a short skirt above the knees (Figures B.2, B-3). Details of the face include eyes, nose, ears, and small oval mouth in relief. The back of the head shows a pierced elongated hair knot. The upper torso shows stooped shoulders and shoulder blades, collarbones, breasts, and the lower rib cage. The hands meet on the abdomen, with the fingers indicated by incised lines. A hole on the left site behind the ear seems to derive from plow damage. Clark stated that it was found "lying in a grave by the side of a huge skeleton, much taller than the present race of men" (Clark 1878:276).

The second statue in Clark's collection (CSS-047) may be from the same site since he notes "another idol of sandstone of much ruder workmanship than the former *was found here*" (Clark 1878:276; emphasis added). Unfortunately, it is unclear whether he is referring to the same site or simply to where he was writing (Williamson County). CSS-047 has very few sculpted details but appears to represent a female (Figures B.4, B.5). The eyes and nose are shown in relief, but no ears are depicted. The mouth is an incised oval with hints of lips. The hairstyle is illustrated only by an incised line over the brow. On the torso, arms are indicated only by the forearms crossed left over right on the abdomen. Small breasts or nipples are in relief. Legs are not represented. The left shoulder is higher than the right and the head is tilted and slightly turned to the left. Clark indicates that it "was also taken from a grave" (1878:276).

At 8 inches in height, the final "idol" in Clark's collection, CSS-048, just barely meets our minimum size criterion for a statue and is eccentric in many of its details (Figure B.6). The face shows an oval mouth in relief, a broad

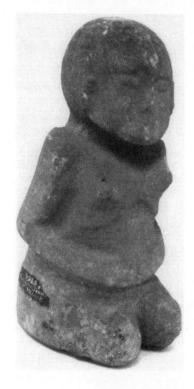

Figure B.2. CSS–046, right front.

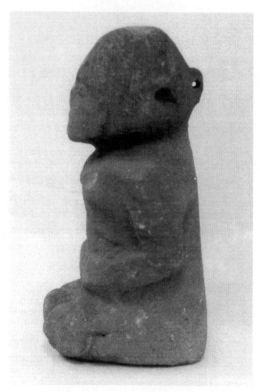

Figure B.3. CSS–046, left profile.

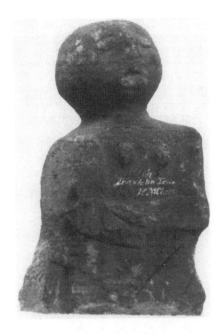

Figure B.4. CSS-047, front.

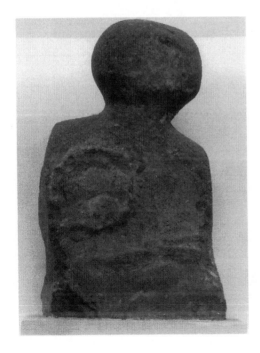

Figure B.5. CSS-047, back.

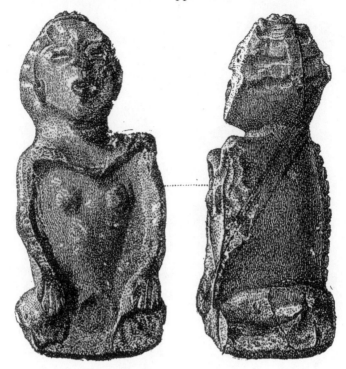

Figure B.6. CSS-048 (Wilson 1898:Figure 123).

flat nose, and eyes in relief with an incised slit across the middle. The hairstyle is a variant of the beehive style with a pointed hairline and is divided into sections by what appear to be three fillets hanging vertically from the point of the crown. At the back of the head in the middle of the rear fillet is a small hair knot. On the torso, breasts or nipples are shown in relief. Below the stooped shoulders, arms descend from the collarbone to terminate with hands showing incised fingers on the knees. The legs are tucked underneath the body in the typical female seating positions with feet at the rear. The most unique feature of the statue is the apparent representation of sculpted vertebra running the entire length of the back. While not unusual on ceramic effigy bottles in the Nashville Basin, this is an unusual feature on the statuary.

In most respects, CSS-048 appears to be same statue illustrated and described by Joseph Jones (1876:Figure 71). Jones (1876:131–132) indicates that it was "exhumed from a mound surrounded with stone graves, in Perry County, four miles south of the Tennessee River near Clifton." To confuse matters further, Jones describes the statue as a small male image and that "the male organ of generation, which was large and prominent in the sandstone idol A, was broken off accidentally." If this discussion does indeed refer to CSS-048, it seems likely that Jones was relying in this instance on secondhand

information rather than personal observation. Dr. Clark reports that CSS-048 "unquestionably represents a woman" (1878:276). The statue shows evidence that a feature in relief was filed smooth on the lower torso. Given the other characteristics of CSS-048, we suspect that the damage derives from filing smooth the vulvar motif. Given the contradictions, however, it remains possible that Jones is referring to a different, but nearly identical, statue.

The Cumberland Mountain Cache (?)

Along the headwaters of the Caney Fork River, a cache of four (or possibly five) statues were reportedly dug up "in one grave" near McMinnville in Warren County "at the base of the Cumberland Mountains" in 1870 (Myer 1923a:978–979). Although sometimes referred to locally as part of the Cumberland Mountains, this geographic feature in the vicinity of McMinnville is more properly referred to as the Cumberland Plateau. As the southernmost extension of the Appalachian Plateau, the Cumberland Plateau is a dissected elevated tableland ranging 500 to 1,000 ft higher than the valley-and-ridge to the east and the highland rim to the west. The specific provenance of the Cumberland Mountain cache remains uncertain, but two poorly understood Mississippian mound sites are recorded in a location that could be called "at the base of the Cumberland Mountains." The Irving College Mound (40WR17) lies on the western escarpment of the plateau and includes a 15-ft-high platform mound. Also on the western escarpment, the Myer Mound site (40WR5) includes a single 9-ft-high probable platform mound and has yielded considerable "sandstone debris" in its habitation area (Tennessee Division of Archaeology, Site Survey Files).

The eventual disposition of the statue cache is even more ambiguous than its find spot. The cache statues appear to have ended up for sale by Pogue, Hoffheimer, and Pogue, a legal firm in Cincinnati that authorized their exhibition at the Cincinnati Art Museum sometime prior to 1900. Warren K. Moorehead (1900:175–176) provided a very rough sketch of two of the five statues (CSS-025, CSS-027) with the caption of "Two stone idols from Tennessee. Pogue & Pogue collection, Cincinnati. Five idols of different form were found in one burial place." He described them as 20 to 28 inches in height and weighing 25 to 40 lbs. William Myer corresponded at length with the firm of Pogue, Hoffheimer, and Pogue in 1919, but failed to obtain further information about the disposition of the cache.

By 1949, the statues had apparently changed hands several times—and seemingly their provenance as well. Donald O. Boudeman, the prominent collector from Kalamazoo, Michigan, published a brief note and photograph of three "stone idols" in his collection (Boudeman 1949). Boudeman purchased the three statues from the collection of Edward W. Payne of Springfield, Illinois. The central statue depicted by Boudeman is identical to one of the two depicted by Moorehead (CSS-025), but CSS-027 is not illus-

trated. According to Boudeman (1949), "the idols, pictured above . . . were found near Dayton, Rhea County, Tennessee." How and why the provenance of at least one statue shifted about 60 miles from "near McMinnville" to "near Dayton" remains an unsolved mystery. Boudeman described the three statues as "4 to 16 inches" in height, but it appears more likely that this is a typographic error and should have read "14 to 16 inches." CSS-024 is 13 3/4 inches in height. He further indicates that they weigh from "12 to 18 pounds."

The other two statues illustrated by Boudeman (CSS-024, CSS-026) are not figured by Moorehead, lending additional confusion. We can only postulate that Boudeman's other statue (CSS-024) might be the fourth statue from the Cumberland Mountain cache "near McMinnville." CSS-024 is now in the Museum of the American Indian and is identified as originating in Rhea County. The current location of the remaining three statues is unknown. Unfortunately, we are unable to resolve the multiple ambiguities and outright contradictions in these references.

Statues CSS-024 (Figure B.7), CSS-025, CSS-026, CSS-027

If it actually came from the Cumberland Mountain cache, CSS-024 is the only known example to survive. The eyes, nose, and oval mouth with an incised opening are in relief, and the face has a sharp backward inclination. This statue has a long neck and more pronounced breasts than is typical. The hands with incised fingers rest near the abdomen and the knees are thrust forward. On the back of the head is an elongated female hair knot. Unfortunately, the other statues are illustrated only in very rough sketches. The treatment of the legs and base was apparently different on each of the statues. All appear to represent females.

West Virginia Statue (CSS-071)

Henry R. Schoolcraft also refers briefly to a stone statue from the far eastern periphery of the Mississippian world (Schoolcraft 1845:407). Plowed up 8 miles south of the Grave Creek Flats in modern Moundville, West Virginia, the 13-in-high "sandstone" statue is poorly illustrated but appears to represent another eccentric statue.

Benton County Fakes (Figures B.8, B.9, B.10, B.11)

While it might seem inappropriate to close our survey of stone statuary with a detailed discussion of two forgeries, the circumstances of their discovery, acceptance as genuine statues, and eventual unmasking as a hoax merits some consideration.

Figure B.7. CSS-024. Courtesy Smithsonian Institution, National Museum of the American Indian, Washington, D.C., Specimen #21/965.

The so-called Benton County pair was purportedly found in 1896 not long after the discovery of Adam and Eve at the Link Farm site. The pair was donated to the Tennessee Historical Society and accepted as genuine for many decades. They were prominently displayed at the Tennessee Centennial Exposition in 1897 and subsequently in the Tennessee State Museum. William Myer examined them in detail and provided the following discussion:

In the Tennessee Historical Society at Nashville, are two fine images which were found about ten miles west of the Link Mounds on Duck River. One of these fine images is a male and the other a female. Dr. J. I. D. Hines, the chemist for the Tennessee Geological Survey, analyzed the material of these images. The analysis shows them to be made of a fine siliceous ball clay, such as is found about eight miles west of where the images were unearthed. This ball clay is likewise found at several points in Henry, Carroll, and Madison counties, in West Tennessee.

These images are of a creamy white color. They had been modeled out of the soft ball clay, and then burned as well as possible. . . . The images are still relatively soft, and can be scratched with the thumb nail. . . .

Figure B.8. CSS-067. Photograph presumably by William E. Myer. Courtesy Samuel D. Smith.

Figure B.9. CSS-067. Photograph presumably by William E. Myer. Courtesy Samuel D. Smith.

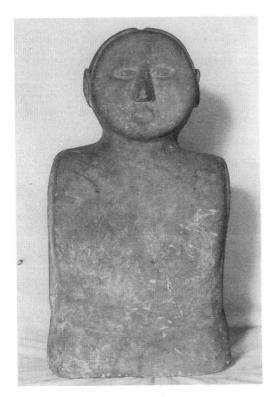

Figure B.10. CSS-068. Photograph presumably by William E. Myer. Courtesy Samuel D. Smith.

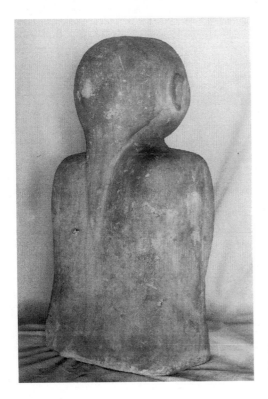

Figure B.11. CSS-068. Photograph presumably by William E. Myer. Courtesy Samuel D. Smith.

They were given the Tennessee Historical Society by H. L. Crowell, Gleason, Tenn., June 27, 1897. They were dug up in the first district of Benton County, Tennessee 1 1/2 miles west of the junction of the Tennessee and Duck Rivers. They were unearthed by William Hensley on the 29th of April, 1896. These images were found in a mound placed side by side, and were three feet under the surface of the mound. A careful inquiry in Benton County, as well as in the Tennessee Historical Society, yields no further information" [Myer 1923a:644–645].

Without putting words in Myer's mouth, his phrasing of the above in comparison to other writings suggests that he may have had some suspicions about the authenticity of the pair as early as the 1920s. In subsequent decades, the two figures were on display at the Tennessee State Museum with the following information: "Sculptured Stone Images. Found buried beneath flint pieces, three feet underground, 1 1/2 miles from the mouth of Duck River, where it runs into the Tennessee River, in the 1st district, Humphreys County near Camden, Tenn. Found by Billy Hensley on 29 April, 1896. Presented to T. H. S. by H. L. Crowell, Gleason, Weakley Co. 25 June 1897." The case containing the two "statues" also displayed seven large artifacts apparently chipped from chert or flint. Eventually, these objects were examined more closely, as reported by H. C. Brehm (1987):

> While removing and cleaning the two figures which were to be placed in another case, it was found that the seven beautiful flint-like objects were made of plaster of Paris and had been painted to look like flint. The two figures presented another surprise. On the back of the female were marks like those made by a file or rasp and others which looked suspiciously like they had been made by a chisel. Several were also found on the body of the male figure. On inspecting the marks outlining the breasts of the female figure, it became apparent that they were made by a pair of metal dividers, a tool found in most early workshops. This was reported to the director of the museum and the president of the Tennessee Historical Society and after they inspected the items, all were removed from display and placed in storage.

While the circumstances cannot be established in greater detail, the appearance of this "cache" of "flint objects" and statue pair soon upon the heels of the discovery of the Duck River cache suggests the inspiration for the creation of what we can now describe as Tennessee folk art. Ironically, they are once again on display in the Tennessee State Museum, but are now included in a case of objects exhibited during the Tennessee Centennial Celebration.

References Cited

Adair, James
1775 *The History of the American Indians.* E. and C. Dilly, London.
Albright, Edward
1909 *Early History of Middle Tennessee.* Brandon Printing, Nashville.
Anderson, David G.
1994 *The Savannah River Chiefdoms: Political Change in the Late Prehistoric Southeast.* University of Alabama Press, Tuscaloosa.
Anghiera, Pietro Martire d'
1912 *De Orbe Novo: The Eight Decades of Peter Martyr D'Anghera.* 2 vols. Translated by Francis Augustus MacNutt. G. P. Putnam's Sons, New York.
Arkansas State University Museum
2006 The Great King Crowley Hoax. Electronic document, http://Museum.astate.edu/vewebsite/exhibit2/vexmain2.htm, accessed January 14, 2006.
Atwater, Caleb
1820 Description of the Antiquities Discovered in the State of Ohio and Other Western States. *American Antiquarian Society Transactions (Archaeologia Americana)* 1:105–267, Worchester, Massachusetts. Reprinted with a new introduction 1973, AMS Press, Inc. for Peabody Museum of Archaeology and Ethnology, Harvard University, Cambridge.
Bartram, William
1792 *Travels through North and South Carolina, Georgia, East and West Florida, the Cherokee Country, the Extensive Territories of the Muscogulges or Creek Confederacy, and the Country of the Chactaws.* London. Other editions are Philadelphia, 1791; and New York 1940.
Bass, Quentin R., II
1985 Sociopolitical and Economic Aspects of the Mississippian Occupation in the Lower Tennessee River Valley. Manuscript on file, Middle Cumberland Mississippian Survey Project, Department of Sociology and Anthropology, Middle Tennessee State University, Murfreesboro.
Berkeley, Edmund, and Dorothy Berkeley
1988 *George William Featherstonhaugh: The First U.S. Government Geologist.* University of Alabama Press, Tuscaloosa.
Berryman, H. E., and D. W. Owsley
1984 Effects of Occipital Cranial Deformation Asymmetry and Severity on the Appearance of Wormian Bones. In Averbuch: A Mississippian Manifestation in the

Nashville Basin, Vol. 1, Observations, edited by W. E. Klippel and W. M. Bass. Report submitted to the National Park Service in accordance with the Provisions of Contract CX 5000-9-5943 between the University of Tennessee and the National Park Service.

Beverley, Robert

1705 *The History and Present State of Virginia, in Four Parts. . . . By a Native and Inhabitant of That Place.* Printed for R. Parker, London.

Black, Glenn A.

1967 *Angel Site: An Archaeological, Historical, and Ethnological Study.* 2 vols. Indiana Historical Society, Indianapolis.

Boudeman, Donald O.

1949 Stone Idols from the Stone Grave Race of Tennessee: From the Collection of Donald O. Boudeman, Sr., Kalamazoo, Michigan. *Journal of the Illinois State Archaeological Society* 6:12.

Boyd, Julian P. (editor)

1965 *The Papers of Thomas Jefferson,* Vol. 17. Princeton University Press, Princeton.

Brain, Jeffrey P., and Philip Phillips

1996 *Shell Gorgets: Styles of the Late Prehistoric and Protohistoric Southeast.* Peabody Museum Press, Cambridge.

Brehm, H. C.

1981 The History of the Duck River Cache. Tennessee Anthropological Association Miscellaneous Paper No. 6, Knoxville.

1984 *Duck River Cache: Tennessee's Greatest Archaeological Find.* Mini-Histories Press, Nashville.

1987 *The History of the Duck River Cache.* Mini-Histories Press, Nashville.

Brose, David S., James A. Brown, and David W. Penney

1985 *Ancient Art of the American Woodland Indians.* Harry N. Abrams in association with the Detroit Institute of Arts, New York.

Brown, James A.

1975 Spiro Art and Its Mortuary Contexts. In *Death and the Afterlife in Pre-Columbian America: A Conference at Dumbarton Oaks, October 27, 1973,* edited by Elizabeth P. Benson, pp. 1–32. Dumbarton Oaks Research Library, Washington, D.C.

1985 The Mississippian Period. In *Ancient Art of the American Woodland Indians,* pp. 92–145. Harry N. Abrams in association with the Detroit Institute of Arts, New York.

1990 Archaeology Confronts History at the Natchez Temple. *Southeastern Archaeology* 9(1):1–10.

1996 *The Spiro Ceremonial Center: The Archaeology of Arkansas Valley Caddoan Culture in Eastern Oklahoma.* Memoir No. 29, 2 vols. Museum of Anthropology, University of Michigan, Ann Arbor.

1997 The Archaeology of Ancient Religion in the Eastern Woodlands. *Annual Review of Anthropology* 26:465–485.

2001 Human Figures and the Southeastern Ancestor Shrine. In *Fleeting Identities: Perishable Material Culture in Archaeological Research,* edited by Penelope Ballard Drooker, pp. 76–93. Center for Archaeological Investigations, Occasional Paper No. 28. Board of Trustees, Southern Illinois University, Carbondale.

Brown, Morgan

1799 Brown to Thomas Jefferson, October 1, 1799. Library of Congress, Washington, D.C.

Bushnell, David I.
 1920 Native Cemeteries and Forms of Burial East of the Mississippi. Bulletin No. 71,
 Bureau of American Ethnology, Smithsonian Institution, Washington, D.C.
Butler, Brian
 1981 Sellars: A Small Mound Center in the Hinterlands. *Tennessee Anthropologist* 6(1):
 37–60.
Carrier, J. M., and L. G. Moffatt (translators and editors)
 1944 A Frenchman Visits Monticello, 1816. *Papers of the Albemarle County Historical So-
 ciety,* Vol. 4 (1943–1944), pp. 45–52. Charlottesville, Virginia.
Central States Archaeological Societies
 1993 Both Sides of a Stone Idol, Close up of the Face of the Stone Idol. *Central States
 Archaeological Journal* 40(1):44–45.
Claassen, Cheryl
 1992 Questioning Gender: An Introduction. In *Exploring Gender through Archaeology:
 Selected Papers from the 1991 Boone Conference,* edited by Cheryl Claassen, pp. 1–9.
 Monographs in World Archaeology No. 11. Prehistory Press, Madison.
Clark, Daniel, Jr.
 1801 Clark to Thomas Jefferson, Letter of July 20. The Thomas Jefferson Papers, Li-
 brary of Congress, Manuscripts Division, Washington, D.C.
Clark, W. M.
 1878 Antiquities of Tennessee. *Smithsonian Institution Annual Report for 1877,* pp. 269–
 276. Washington, D.C.
Clayton, W. W.
 1880 *History of Davidson County, Tennessee.* J. W. Lewis, Philadelphia.
Clifford, John
 1820 Indian Antiquities. Letter V. *Western Review* 1:346–353.
Cole, Fay-Cooper, Robert Bell, John Bennett, Joseph Caldwell, Norman Emerson, Richard
 MacNeish, Kenneth Orr, and Roger Willis
 1951 *Kincaid: A Prehistoric Illinois Metropolis.* University of Chicago Press, Chicago.
Cox, P. E.
 1925 Cox to J. W. Fewkes. March 23, 1925. P. E. Cox Papers, Box 2, Folder 3. Tennes-
 see State Library and Archives, Nashville.
 1931 Cox to A. Wetmore. P. E. Cox Papers, Box 2, Folder 15; Box 3, Folder 14; Box 4,
 Folder 8. Tennessee State Library and Archives, Nashville.
DePratter Chester B.
 1991 *Late Prehistoric and Early Historic Chiefdoms in the Southeastern United States.* Gar-
 land, New York.
DePratter, Chester B., Charles M. Hudson, and Marvin T. Smith
 1983 The Route of Juan Pardo's Explorations in the Interior Southeast, 1566–1568.
 Florida Historical Quarterly 62:125–158.
Doran, Edwina B.
 1969 Folklore in White County, Tennessee. Ph.D. dissertation and Peabody Contribu-
 tions to Education Number 747, George Peabody College, Nashville.
 1984 The Rock Woman and the Little People—White County Legends. *Tennessee
 Folklore Society Bulletin* 50:136–140.
Dowd, John T.
 1972 *The West Site: A Stone Box Cemetery in Middle Tennessee.* Tennessee Archaeological
 Society Miscellaneous Paper No. 10.

1974 History of the Brick Church Pike Mound (40DV39). *Tennessee Archaeologist* 30(2): 85–106.

1985 History of the Brick Church Pike Mound (40DV39). Reprinted from *Tennessee Archaeologist* 30(2), 1974, with the addition of "The Brick Church Pike Mound, 1983." Mini-Histories Press, Nashville.

Duncan, James R., and Carol Diaz-Granados

2004 Empowering the SECC: The "Old Woman" and Oral Tradition. In *The Rock-Art of Eastern North America: Capturing Images and Insight,* edited by Carol Diaz-Granados and James R. Duncan, pp. 190–215. University of Alabama Press, Tuscaloosa.

Emerson, Thomas E.

1982 *Mississippian Stone Images in Illinois.* Circular No. 6. Illinois Archaeological Survey, Urbana.

1983 The Bostrom Figure Pipe and the Cahokian Effigy Style in the American Bottom. *Midcontinental Journal of Archaeology* 8:257–267.

1989 Water, Serpents, and the Underworld: An Exploration into Cahokian Symbolism. In *The Southeastern Ceremonial Complex: Artifacts and Analysis, the Cottonlandia Conference,* edited by Patricia Galloway, pp. 45–92. University of Nebraska Press, Lincoln.

1997 Cahokian Elite Ideology and the Mississippian Cosmos. In *Cahokia: Domination and Ideology in the Mississippian World,* edited by Timothy R. Pauketat and Thomas E. Emerson, pp. 190–228. University of Nebraska Press, Lincoln.

2003 Materializing Cahokia Shamanism. *Southeastern Archaeology* 22(2):135–154.

Emerson, Thomas E., and Randall E. Hughes

2000 Figurines, Flint Clay Sourcing, the Ozark Highlands, and Cahokian Acquisition. *American Antiquity* 65:79–101.

Emerson, Thomas E., Randall E. Hughes, Mary R. Hynes, and Sarah U. Wisseman

2003 The Sourcing and Interpretation of Cahokia-Style Figurines in the Trans-Mississippi South and Southeast. *American Antiquity* 68(2):287–313.

Emerson, Thomas E., and Douglas K. Jackson

1984 *The BBB Motor Site (II-Ms-595).* American Bottom Archaeology, FAI-270 Reports No. 6. University of Illinois Press, Urbana.

Engle, Nancy Lou

1957 Prehistoric Human Figurines of the Eastern United States and Their Significance. Unpublished M.A. thesis, Department of Anthropology, University of Illinois at Urbana-Champaign.

Farnsworth, K. B., and T. E. Emerson

1989 The Macoupin Creek Figure Pipe and Its Archaeological Context: Evidence for Late Woodland-Mississippian Interaction beyond the Northern Border of Cahokian Settlement. *Midcontinental Journal of Archaeology* 14:18–37.

Featherstonhaugh, George W.

1844 *Excursion through the Slave States.* Harper, New York.

Fell, Barry

1982 *Bronze Age America.* Little, Brown, Boston.

Ferguson, Robert (editor)

1972 *The Middle Cumberland Culture.* Vanderbilt University Publications in Anthropology No. 3. Vanderbilt University, Nashville.

Fiske, Moses

1820 Conjectures Respecting the Ancient Inhabitants of North America. *American Antiquarian Society, Transactions and Collections* 1:300–307.

Ford, James A.
1936 Analysis of Indian Village Site Collections from Louisiana and Mississippi. Louisiana Department of Conservation, Anthropological Study No. 2. Reprinted 1999 in *Measuring the Flow of Time: The Works of James A. Ford, 1935–1941,* edited by Michael J. O'Brien and R. Lee Lyman, pp. 131–410. University of Alabama Press, Tuscaloosa.

Fundaburk, E., and M. Foreman (editors)
1957 *Sun Circles and Human Hands.* Emma Lila Fundaburk, Publisher, Luverne, Alabama.

Galloway, Patricia (editor)
1989 *The Southeastern Ceremonial Complex: Artifacts and Analysis, the Cottonlandia Conference.* University of Nebraska Press, Lincoln.

Garland, Elizabeth Baldwin
1992 *The Obion Site: An Early Mississippian Center in Western Tennessee.* Report of Investigations No. 7. Cobb Institute of Archaeology, Mississippi State University, Mississippi State.

Gibson, Jon L.
2000 *The Ancient Mounds of Poverty Point: Place of Rings.* University Press of Florida, Gainesville.

Goad, S. I.
1980 Chemical Analyses of Native Copper Artifacts from the Southeastern United States. *Current Anthropology* 21:270–271.

Goodspeed, Weston A., et al. (editors)
1887 *History of Tennessee.* [by county]. Goodspeed Publishing Company, Chicago and Nashville.

Griffin, James B.
1985 Changing Concepts of the Prehistoric Mississippian Cultures in the Eastern United States. In *Alabama and the Borderlands,* ed. R. Badger and L. Clayton, pp. 40–63. University of Alabama Press, Tuscaloosa.
1990 Comments on the Late Prehistoric Societies in the Southeast. In *Towns and Temples along the Mississippi,* edited by David H. Dye and Cheryl Anne Cox, pp. 5–15. University of Alabama Press, Tuscaloosa.

Hally, David
1994 An Overview of Lamar Culture. In *Ocmulgee Archaeology, 1936–1986,* edited by David J. Hally, pp. 144–174. University of Georgia Press, Athens.
1996 Platform-Mound Construction and the Instability of Mississippian Chiefdoms. In *Political Structure and Change in the Prehistoric Southeastern United States,* edited by John F. Scarry, pp. 92–127. University Press of Florida, Gainesville.

Hariot, Thomas
1893 *Narrative of the First English Plantation of Virginia.* Reprint. London. Earlier editions 1588 and 1590.

Hatch, James W.
1976 The Citico Site (40HA65): A Synthesis. *Tennessee Anthropologist* 1(2):75–103.

Haywood, John
1823 *The Natural and Aboriginal History of Tennessee up to the First Settlements Therein by the White People in the Year 1768.* Reprint edition, 1973 by F. M. Hill-Books, Kingsport, Tennessee.

Henderson, Luana
2000 Joseph Jones Papers (Mss. 468, 534, 544, 1036, 1351, 1393, 1441) Inventory. Loui-

siana and Lower Mississippi Valley Collections, Special Collections, Hill Memorial Library, Louisiana State University Libraries, Baton Rouge.

Hilgeman, Sherri L.

1985 Lower Ohio Valley Negative Painted Ceramics. *Midcontinental Journal of Archaeology* 10:195–213.

1991 Angel Negative Painted Design Structure. *Midcontinental Journal of Archaeology* 16:3–33.

2000 *Pottery and Chronology at Angel.* University of Alabama Press, Tuscaloosa.

Hilgeman, Sherri L., and Mark R. Schurr

1990 Radiocarbon Dating of the Angel Site and Phase in Regional Perspective. Electronic document, http://www.gbl.indiana.edu/abstracts/90/hilgeman_90.html, accessed May 29, 1997 and December 31, 2007.

Hodges, Curt

2003 McCracken to Give Program on Hoax about King Crowley. *Jonesboro Sun* 7 April.

Holmes, William Henry

1903 Aboriginal Pottery of the Eastern United States. 20th Annual Report, Bureau of American Ethnology, 1898–1899. Smithsonian Institution, Washington, D.C.

Hudson, Charles M.

1976 *The Southeastern Indians.* University of Tennessee Press, Knoxville.

1985 Iconography of the Thruston Collection. In *Arts and Artisans of Prehistoric Middle Tennessee,* edited by Stephen D. Cox, pp. 19–36. Tennessee State Museum, Nashville.

1990 *The Juan Pardo Expeditions: Explorations of the Carolinas and Tennessee, 1566–1568.* Smithsonian Institution Press, Washington, D.C.

Innes, Harry

1790 Innes to Thomas Jefferson. Letter of July 8. The Thomas Jefferson Papers, Library of Congress, Manuscripts Division, Washington, D.C.

Jefferson, Thomas

1791 Jefferson to Harry Innes. Letter of March 7. The Thomas Jefferson Papers, Library of Congress, Manuscripts Division, Washington, D.C.

1800 Jefferson to Morgan Brown. Letter of January 16. The Thomas Jefferson Papers, Library of Congress, Manuscripts Division, Washington, D.C.

Johnson, Russell

2004 King Crowley. Electronic document, http://users.aristotle.net/~russjohn/art/Crowley.html, accessed January 14, 2006.

Jones, Charles C.

1873 *Antiquities of the Southern Indians, Particularly of the Georgia Tribes.* D. Appleton, New York. Reprinted 1999, University of Alabama Press, Tuscaloosa.

Jones, Joseph

1869 The Aboriginal Mound Builders of Tennessee. *American Naturalist* 3(2): 57–73.

1876 *Exploration of the Aboriginal Remains of Tennessee.* Smithsonian Contributions to Knowledge No. 259. Smithsonian Institution, Washington, D.C.

Joyce, Rosemary

1992 Images of Gender and Labor Organization in Classic Maya Society. In *Exploring Gender through Archaeology: Selected Papers from the 1991 Boone Conference,* edited by Cheryl Claassen, pp. 63–70. Monographs in World Archaeology No. 11. Prehistory Press, Madison.

Kelly, Arthur R., and Lewis H. Larson Jr.

1957 Explorations at Etowah, Georgia, 1954–1956. *Archaeology* 10(1):39–48.

Kennedy, Roger G.

1994 *Hidden Cities: The Discovery and Loss of Ancient North American Civilization.* Penguin Books, New York.

Kerr, C.

1922 *History of Kentucky.* 5 vols. American Historical Society, Chicago.

King, Adam

2001 Long-Term Histories of Mississippian Centers: The Developmental Sequence of Etowah and Its Comparison to Moundville and Cahokia. *Southeastern Archaeology* 20(1):1–17.

2003 *Etowah: The Political History of a Chiefdom Capital.* University of Alabama Press, Tuscaloosa.

2004 Power and the Sacred: Mound C and the Etowah Chiefdom. In *Hero, Hawk, and Open Hand: American Indian Art of the Ancient Midwest and South,* edited by Richard F. Townsend and Robert V. Sharp, pp. 151–165. The Art Institute of Chicago in association with Yale University Press, New Haven.

Kneberg, Madeline

1952 The Tennessee Area. In *Archeology of the Eastern United States,* edited by James B. Griffin, pp. 190–198. University of Chicago Press, Chicago.

Knight, Vernon James, Jr.

1986 The Institutional Organization of Mississippian Religion. *American Antiquity* 51(4): 675–687.

Kreisa, Paul P.

1995 Mississippian Secondary Centers along the Lower Ohio River Valley: An Overview of Some Sociopolitical Implications. In *Current Archaeological Research in Kentucky,* Vol. 3, edited by John F. Doershuk, Christopher A. Bergman, and David Pollack, pp. 161–177. Kentucky Heritage Council, Frankfort.

Lankford, George E.

2004 World on a String: Some Cosmological Components of the Southeastern Ceremonial Complex. In *Hero, Hawk, and Open Hand: American Indian Art of the Ancient Midwest and South,* edited by Richard F. Townsend and Robert V. Sharp, pp. 207–218. The Art Institute of Chicago in association with Yale University Press, New Haven.

Larson, Lewis H., Jr.

1971 Archaeological Implications of Social Stratification at the Etowah Site, Georgia. In *Approaches to the Social Dimensions of Mortuary Practices,* edited by J. A. Brown, pp. 58–67. Society for American Archaeology, Memoir No. 25, Washington, D.C.

Le Petit, Father

1900 Letter to d'Avaugour. In *Jesuit Relations and Allied Documents: Travels and Explorations of the Jesuit Missionaries in New France, 1610–1791,* Vol. 68. Burrows, Cleveland.

Lewis, Thomas M. N.

1945 A Stone Effigy. *Tennessee Archaeologist* 1(2):16–17.

1947a Missing: Two Stone Images. *Tennessee Archaeologist* 3(4):58.

1947b The Webster Collection. *Tennessee Archaeologist* 3(4):61–62.

1948a Stone Images. *Tennessee Archaeologist* 4(1–2):14–15.

1948b Guy Stack Collection. *Tennessee Archaeologist* 4(1–2):16–17.

1955 Duck River Stone Image. *Tennessee Archaeologist* 11(2):86–87.

1961 Tennessee Artifacts in the Museum of the American Indian. *Tennessee Archaeologist* 17(1):38–40.

Lewis, Thomas M. N., and Madeline Kneberg

1958 *Tribes That Slumber: Indians of the Tennessee Region.* University of Tennessee Press, Knoxville.

Lorant, Stefan

1946 *The New World: The First Pictures of America Made by John White and Engraved by Theodore De Bry with Contemporary Narratives of the French Settlements in Florida 1562–1565 and the English Colonies in Virginia 1585–1590.* Duell, Sloan, and Pierce, New York. First revised edition, 1965.

Mainfort, Robert C., Jr.

1992 The Mississippian Period in the West Tennessee Interior. In *The Obion Site: An Early Mississippian Mound Center in Western Tennessee,* by Elizabeth Garland, pp. 202–207. Report of Investigations No. 7. Cobb Institute of Archaeology, Mississippi State University, Mississippi State.

Maxwell, M. S.

1952 The Archaeology of the Lower Ohio Valley. In *Archaeology of the Eastern United States,* edited by J. B. Griffin, pp. 176–189. University of Chicago Press, Chicago.

Milner, George R.

1993 Settlements Amidst Swamps. *Illinois Archaeology* 5(1–2):374–380.

Moore, Michael C. (editor)

2005 The Brentwood Library Site: A Mississippian Town on the Little Harpeth River, Williamson County, Tennessee. Tennessee Department of Environment and Conservation, Division of Archaeology, Research Series No. 15. Nashville.

Moore, Michael C., and Emanuel Breitburg (editors)

1998 Gordontown: Salvage Archaeology at a Mississippian Town in Davidson County, Tennessee. Tennessee Department of Environment and Conservation, Division of Archaeology, Research Series No. 11. Nashville.

Moore, Michael C., and Kevin E. Smith (editors)

2001 Archaeological Investigations at the Rutherford-Kizer Site: A Mississippian Mound Center in Sumner County, Tennessee. Tennessee Department of Environment and Conservation, Division of Archaeology, Report of Investigations No. 13. Nashville.

Moorehead, Warren K.

1900 *Prehistoric Implements.* Robert Clarke, Cincinnati. Reprinted 1968, Charley G. Drake, Union City, Georgia.

1910 *The Stone Age in North America.* Vol. 2. Houghton Mifflin, Boston.

1932 (editor) *Etowah Papers.* Published for the Department of Archaeology, Phillips Academy, Andover, Massachusetts, by Yale University Press, New Haven.

Moorehead, Warren K., J. Taylor, M. Leighton, and F. Baker

1929 *The Cahokia Mounds.* University of Illinois Press, Urbana.

Morse, Dan F., and Phyllis A. Morse

1983 *Archaeology of the Central Mississippi Valley.* Academic Press, New York.

Muller, Jon D.

1966 An Experimental Theory of Stylistic Analysis. Unpublished Ph.D. dissertation, Harvard University, Cambridge.

1979 Structural Studies of Art Styles. In *The Visual Arts, Plastic and Graphic,* edited by Justine Cordwell, 139–211. Mouton, The Hague.

1997 *Mississippian Political Economy.* Plenum, New York.

Myer, William Edward

1894 An Old Shawnee Town in Tennessee. *The Archaeologist* 2(1):6–13.

1917 The Remains of Primitive Man in Cumberland Valley, Tennessee. *Proceedings of the Nineteenth International Congress of Americanists,* Washington, D.C.

1923a Stone Age Man in the Middle South. Unpublished manuscript on file, Joint University Libraries, Vanderbilt University, Nashville, Tennessee; Tennessee Division of Archaeology Library, Nashville; Smithsonian Institution, Washington, D.C.

1923b Catalogue of Archaeological Remains in Tennessee. Manuscript on file, Smithsonian Institution, Washington, D.C.; Tennessee Division of Archaeology Library, Nashville.

1928a Two Prehistoric Villages in Middle Tennessee. *41st Annual Report, Bureau of American Ethnology 1919–1924,* pp. 485–614. Smithsonian Institution, Washington, D.C.

1928b Indian Trails of the Southeast. *42nd Annual Report, Bureau of American Ethnology, 1924–1925.* Smithsonian Institution, Washington, D.C.

Nutt, Rush
1805 Nutt's Trip to the Chickasaw Country. In the *Journal of Mississippi History* 9(1), edited by Jesse D. Jennings, 1947.

Perrine, T. M.
1873 Mounds Near Anna, Union County, Illinois. *Annual Report of the Smithsonian Institution for the Year 1872,* pp. 418–419. U.S. Government Printing Office, Washington, D.C.

1874 Antiquities of Union County, Illinois. *Annual Report of the Smithsonian Institution for the Year 1873,* p. 410. U.S. Government Printing Office, Washington, D.C.

Perryman, Margaret
1966 Stone Effigy Figures from Georgia. *Tennessee Archaeologist* 22(1):40–42.
1969 Effigy Figure Found in Georgia. *Tennessee Archaeologist* 25(2):59–61.

Phillips, Philip, and James A. Brown
1978 *Pre-Columbian Shell Engravings from the Craig Mound at Spiro, Oklahoma,* part 1. Peabody Museum of Archaeology and Ethnology, Harvard University, Cambridge.

1983 *Pre-Columbian Shell Engravings from the Craig Mound at Spiro, Oklahoma,* part 2. Peabody Museum of Archaeology and Ethnology, Harvard University, Cambridge.

Phillips, Philip, James A. Ford, and James B. Griffin
1951 Archaeological Survey in the Lower Mississippi Alluvial Valley, 1940–1947. Papers of the Peabody Museum of Archaeology and Ethnology No. 25. Peabody Museum, Harvard University, Cambridge.

Prentice, Guy
1986 An Analysis of the Symbolism Expressed by the Birger Figurine. *American Antiquity* 51(2):239–266.

Putnam, Frederic Ward
1878 Archaeological Explorations in Tennessee. *11th Annual Report, Peabody Museum of American Archaeology and Ethnology* 2(2):305–360.

Reilly, F. Kent, III
2004 People of Earth, People of Sky: Visualizing the Sacred in Native American Art of the Mississippian Period. In *Hero, Hawk, and Open Hand: American Indian Art of the Ancient Midwest and South,* edited by Richard F. Townsend and Robert V. Sharp, pp. 125–137. The Art Institute of Chicago in association with Yale University Press, New Haven.

Robbins, Elaine
2005 The World in a Whelk Shell. *American Archaeology* 9(3):19–24.

Romans, Bernard
1775 *A Concise Natural History of East and West Florida.* Vol. 1. Printed for the author, New York.

Rooker, Henry Grady
 1932 A Sketch of the Life and Work of Dr. Gerard Troost. *Tennessee Historical Magazine* Series 2, Vol. 3, No. 1:2–19. Nashville.

Roosevelt, Anna C.
 1988 Interpreting Certain Female Images in Prehistoric Art. In *The Role of Gender in Precolumbian Art and Architecture,* edited by Virginia Miller, pp. 1–34. University Press of America, Washington, D.C.

Rountree, Helen C., and E. Randolph Turner
 1994 On the Fringe of the Southeast: The Powhatan Paramount Chiefdom in Virginia. In *The Forgotten Centuries: Indians and Europeans in the American South, 1521–1704,* edited by Charles Hudson and Carmen Chaves Tesser, pp. 355–372. University of Georgia Press, Athens.

Schoolcraft, Henry R.
 1845 Observations Respecting the Grave Creek Mound in Western Virginia. *Transactions of the American Ethnological Society,* Vol. 1. Bartletts and Welford, New York.

Seals, Monroe
 1935 History of White County. Electronic document, http://ftp.rootsweb.Com/pub/usgenweb/tn/white/history/1935/historyo/Chapter126nms.txt, accessed January 7, 2006.

Seeman, Mark
 2004 Hopewell Art in Hopewell Places. In *Hero, Hawk, and Open Hand: American Indian Art of the Ancient Midwest and South,* edited by Richard F. Townsend and Robert V. Sharp, pp. 57–71. The Art Institute of Chicago in association with Yale University Press, New Haven.

Seever, William J.
 1897 A Cache of Idols and Chipped Flint Instruments in Tennessee. *Antiquarian* 1(6): 141–145.

Shelby, Charmion (translator)
 1993 La Florida by the Inca. History of the Adelantado Hernando de Soto, Goevernor and Captain General of the Kingdom of La Florida, and of Other Heroic Gentlemen, Spaniards and Indians; Written by the Inca Garcilaso de la Vega, Captain of His Majesty, a Native of the Great City of El Cuzco, Capital of the Kingdoms and Provinces of El Peru. In *The De Soto Chronicles: The Expedition of Hernando de Soto to North America in 1539–1543,* Vol. 2, edited by Lawrence A. Clayton, Vernon James Knight Jr., and Edward C. Moore, pp. 25–559. University of Alabama Press, Tuscaloosa.

Smith, Bruce D.
 1986 The Archaeology of the Southeastern United States: From Dalton to de Soto 10,500–500 B.P. In *Advances in World Archaeology,* edited by F. Wendorf and A. Close, 5:1–92. Academic Press, Orlando.

Smith, Kevin E.
 1991 Mississippian Figurines and Symbolic Systems of the Southeastern United States. In *The New World Figurine Project,* Vol. 1, edited by Terry Stocker. Research Press, Provo.

 1992a *The Middle Cumberland Region: Mississippian Archaeology in North-Central Tennessee.* Ph.D. dissertation. Department of Anthropology, Vanderbilt University, Nashville. University Microfilms, Ann Arbor.

 1993a Archaeology at Old Town [40WM2]: A Mississippian Mound-Village Center in Williamson County, Tennessee. *Tennessee Anthropologist* 18(1):27–44.

1993b The 1991 Cardwell Mountain Testing Program. Report on file, Department of Sociology and Anthropology, Middle Tennessee State University, Murfreesboro.

1998 William Edward Myer. In *The Tennessee Encyclopedia of History and Culture,* edited by C. Van West. Tennessee Historical Society, Nashville.

2001 Human Figurines as Messengers: Communicating with Past, Present, and Future Cultures. Concluding chapter and discussion for *The New World Figurine Project,* Vol. 2, edited by Cynthia Otis-Charlton and Terry Stocker. Research Press, Provo.

2004 Prehistoric Art and Artisans of Tennessee. In *Creating Traditions, Expanding Horizons: A History of Tennessee Arts,* edited by C. Van West and Margaret D. Binnicker, pp. 3–15. University of Tennessee Press, Knoxville.

2005 Underworld Symbolism in Mississippian Iconography from the Nashville Basin. Manuscript on file, Department of Sociology and Anthropology, Middle Tennessee State University, Murfreesboro.

2006 The Nashville Basin Chiefdoms. Manuscript on file, Department of Sociology and Anthropology, Middle Tennessee State University, Murfreesboro.

Smith, Kevin E., and Emily L. Beahm

2005 Castalian Springs (40SU14): A Mississippian Chiefdom in the Nashville Basin of Tennessee. Paper presented at the Southeastern Archaeological Conference, Charleston, South Carolina.

2006 Archaeological Investigations at the Castalian Springs Mounds (40SU14), Sumner County, Tennessee: Report of the 2005 Summer Field Season. Report of Archaeological Investigations No. 3. Department of Sociology and Anthropology, Middle Tennessee State University, Murfreesboro.

Smith, Kevin E., Daniel Brock, and Christopher Hogan

2004 Interior Incised Plates and Bowls from the Nashville Basin of Tennessee. *Tennessee Archaeology* 1(1):49–57.

Smith, Kevin E., and Michael C. Moore

1996 On the River and Up the Creek: Contrasting Settlement Patterns in the Cumberland Valley. Paper presented at the 53rd Southeastern Archaeological Conference, November 7, Birmingham, Alabama.

2005 Commentary on Two Stone Statues Reported from the Jarman Farm Site. In Moore 2005, pp. 265–267.

2006 Archaeological Explorations of the Peabody Museum in Middle Tennessee, 1877–1882. Manuscript on file, Tennessee Department of Environment and Conservation, Division of Archaeology, Nashville.

Smith, Samuel D.

1975 *Archaeological Explorations at the Castalian Springs, Tennessee, Historic Site.* Tennessee Historical Commission, Nashville.

1998 Tennessee Archaeology Awareness Week: Some Smith County Connections. *Smith County Historical and Genealogical Society Quarterly Newsletter* 10(1):1–5.

Steponaitis, Vincas

1986 Prehistoric Archaeology in the Southeastern United States, 1970–1985. *Annual Review of Anthropology* 15:363–404.

Steponaitis, Vincas P., George E. Lankford, Vernon J. Knight Jr., David H. Dye, and Robert V. Sharp

2005 Iconography of the Thruston Tablet. Paper presented at the Southeastern Archaeological Conference, Charleston, South Carolina.

Stocker, Terry
1991 Introduction. In *The New World Figurine Project,* Vol. 1, edited by Terry Stocker. Research Press, Provo.

Strachey, William
1849 The History of Travaile into Virginia Britannia, Expressing the Cosmographie and Commodities of the Country, Together with the Manners and Customs of the People. *Publications of the Hakluyt Society,* Vol. 6. London.

Stuart, George E.
2004 The Education of an Archaeologist: The 1954 Season at Etowah, Georgia. *Southeastern Archaeology* 23(2):144–152.

Swanton, John R.
1911 Indian Tribes of the Lower Mississippi Valley and Adjacent Coast of the Gulf of Mexico. Bulletin No. 43, Bureau of American Ethnology, Smithsonian Institution, Washington, D.C.

Tennessee Archaeological Society
1963 Two Stone Figures. *Tennessee Archaeologist* 19(2):60–61.
1984 An Unusual Artifact Found While Surface Collecting in Clay County. *Newsletter of the Tennessee Archaeological Society* 29(1–2):10.

Tennessee Division of Archaeology
1981 Sellars unpublished field notes on file, Tennessee Division of Archaeology, Nashville.

Tennessee Historical Society
1880 Catalog of Collections. State Library and Archives, Nashville.
1890 Minutes, June 10, 1890. State Library and Archives, Nashville.

Tennessee State Museum
1931 Contract of Loan (for Sellars figurine). Tennessee State Library and Archives, Nashville.
2005 Featured Artifact: Limestone Ceremonial Figurine, Mississippian Period. Electronic document, http://www.tnMuseum.org/exhibitions/specialcollections/prehistoric.html#featured, accessed December 27, 2005.

Thomas, Cyrus
1894 Report on the Mound Explorations of the Bureau of Ethnology. *12th Annual Report, Bureau of Ethnology, 1890–1891,* pp. 71–72. Smithsonian Institution, Washington, D.C.
1896 Stone Images from Mounds and Ancient Graves. *American Anthropologist* 9: 404–409.

Thomas, Jane
1897 *Old Days in Nashville.* Reprinted 1969 by Charles Elder Booksellers, Nashville.

Thruston, Gates P.
1890 *The Antiquities of Tennessee and the Adjacent States,* 1st edition. Robert Clarke, Cincinnati. Reprinted 1971 by AMS Press, New York.
1897 *The Antiquities of Tennessee and the Adjacent States,* 2nd edition. Robert Clarke, Cincinnati. Reprint editions 1965, 1972 by Tenase, Knoxville.
1898 Ancient Stone Images in Tennessee. *American Archaeologist* 2(9):225–227.

Time-Life Books
1992 *Mound Builders and Cliff Dwellers.* By the editors of Time-Life Books. Time Inc. Book Company, New York.

Time Magazine
1941 Lo the Adaptable Indian. February 17, pp. 58–61.

Townsend, Richard F.

2004 American Landscapes, Seen and Unseen. In *Hero, Hawk, and Open Hand: American Indian Art of the Ancient Midwest and South,* edited by Richard F. Townsend and Robert V. Sharp, pp. 15–35. The Art Institute of Chicago in association with Yale University Press, New Haven.

Troost, Gerard

1845 An Account of Some Ancient Indian Remains in Tennessee. *Transactions of the American Ethnological Society* 1:355–365.

Varner, John G., and Jeanette J. Varner

1951 *The Florida of the Inca by Garcilaso de la Vega.* University of Texas Press, Austin.

Walker, Hugh

1947 Beyond History. *Nashville Tennessean Magazine,* April 6, 1947, pp. 14–15, 20.

Wallace, Anthony F. C.

1966 *Religion: An Anthropological View.* Random House, New York.

Walthall, John A.

1980 *Prehistoric Indians of the Southeast: Archaeology of Alabama and the Middle South.* University of Alabama Press, Tuscaloosa.

Ward, James W., Jr.

1972 A Comparative Study of the Arnold and Ganier Populations Based on Osteological Observations. In *The Middle Cumberland Culture,* edited by Robert Ferguson. Vanderbilt University Publications in Anthropology No. 3, Nashville.

Waring, Antonio J., and Preston Holder

1945 A Prehistoric Ceremonial Complex in the Southeastern United States. *American Anthropologist* 47(1):1–34. Reprinted 1968 in *The Waring Papers,* edited by Stephen Williams, pp. 9–29. Papers of the Peabody Museum of Archaeology and Ethnology No. 58. Peabody Museum, Harvard University, Cambridge.

Webb, William S., and David L. DeJarnette

1942 An Archaeological Survey of Pickwick Basin in the Adjacent Portions of the States of Alabama, Mississippi, and Tennessee. Bulletin No. 129, Bureau of American Ethnology, Smithsonian Institution, Washington, D.C.

Webb, William S., and W. D. Funkhouser

1931 The Tolu Site in Crittenden County, Kentucky. *University of Kentucky Reports in Archaeology and Anthropology* 1(5):307–410.

Webster, Hugh Lee

1931 Webster to John Trotwood Moore. Tennessee State Library and Archives, Nashville.

1945 Unusual Site in Murray [*sic*] County. *Tennessee Archaeologist* 2(1):2–3.

Wetmore, A.

1931 Wetmore to P. E. Cox. August 15, 1931. P. E. Cox Papers, Box 2, Folder 15; Box 3, Folder 14; Box 4, Folder 8. Tennessee State Library and Archives, Nashville.

Willey, Gordon R., and Philip Phillips

1958 *Method and Theory in American Archaeology.* University of Chicago Press, Chicago.

Williams, Harry Lee

1930 *History of Craighead County, Arkansas.* Parke-Harper, Little Rock. Reprinted 1970 by Rose Publishing and 1995 by Southern Historical Press.

Williams, Stephen

1977 (editor) *The Waring Papers: The Collected Works of Antonio J. Waring, Jr.* Papers of the Peabody Museum of Archaeology and Ethnology, Vol. 58. Revised edition. Cambridge.

1986 Pioneers in the Archaeology of Middle Tennessee. Paper presented at the South-eastern Archaeological Conference, Nashville.

1991 *Fantastic Archaeology: The Wild Side of North American Prehistory.* University of Pennsylvania Press, Philadelphia.

Willoughby, Charles C.

1932 History and Symbolism of the Muskhogeans. In *Etowah Papers,* edited by W. K. Moorehead, pp. 7–67. Published for Phillips Academy by Yale University Press, New Haven.

Wilson, Thomas

1898 Prehistoric Art. *Annual Report of the Smithsonian Institute for the Year 1896,* pp. 325–664. U.S. Government Printing Office, Washington, D.C.

Wolforth, Thomas R., and Lynne Mackin Wolforth

2000 Fluorite Figurines from the Midcontinent. In *Mounds, Modoc, and Mesoamerica: Papers in Honor of Melvin L. Fowler,* edited by Steven R. Ahler, 455–467. Illinois State Museum Scientific Papers No. 28. Illinois State Museum, Springfield.

Womack, Walter

1960 McMinnville at a Milestone, 1810–1960: A Memento of the Sesquicentennial Year of McMinnville, Tennessee, 1960 and Warren County, Tennessee, 1958. Standard Publishing and Womack Printing, McMinnville.

Wynne, George W.

1973 Wynnewood and Castalian Springs. Videotape interview, May 4, 1973. Volunteer State Community College Library, Gallatin, Tennessee.

Young, Bennett H.

1910 The Prehistoric Men of Kentucky. *Filson Club Publication* No. 25. John P. Morton, Louisville.

Index

Adair, James, 172

Adams County, Mississippi statues. *See*
CSS-063; CSS-078

Adam statue. *See* CSS-036; Link Farm site

Albright, Edward, 73, 76

Ancestor Shrine complex, 1–2, 157–158,
173–174; ethnographic observations,
165–173; and Tennessee-Cumberland
style statuary, 173–174. *See also* Cahokia
style statues

Ancestral Pair statues. *See* Statuary pairs

Anderson, David G., 158, 162, 166, 167, 177

Angel Negative painted pottery, 163

Angel site, Indiana, 25, 151–152, 153, 159;
radiocarbon dates, 199–120. *See also*
CSS-054

Anghiera, Pietro Martire d', 166–167

Anglea, "Rube," 73–74

Anglea, William Rufus, 73

Anna statue. *See* CSS-052

Arkansas State University Museum, 7

Arkansas statue. *See* CSS-070

Atwater, Caleb, 2–3, 4, 144, 154, 162

Baird, Ollie Rogers, 85, 86

Bartow County, Georgia statues. *See* CSS-
055; CSS-056; CSS-057; CSS-058;
CSS-059; CSS-060; CSS-061; CSS-
074; CSS-075; CSS-087

Bass, Quentin R., 83

BBB Motor site, Illinois, 15

Beasley Mounds (Dixon Springs) site, Ten-
nessee, 32, 53–67, 176. *See also* CSS-010;
CSS-011; CSS-012; CSS-013; CSS-014;
CSS-015; CSS-016; CSS-017

Bell County, Kentucky, 18, 80

Benton County, Tennessee forgeries, 210–
214. *See also* CSS-067; CSS-068; Fakes

Beverley, Robert, 171–172

Big Bigby site, Tennessee, 90. *See also*
CSS-039

Black, Glenn, 25, 152, 159, 169

Bledsoe County, Tennessee statue. *See*
CSS-028

Boudeman, Donald O., 86, 209–210

Boyer, Thomas, Jr., 76

Brain, Jeffrey P., 72, 162, 163

Brehm, H. C. "Buddy," 83, 86, 203, 214

Brentwood, Tennessee statues, 77–81. *See
also* CSS-031

Brick Church Pike Mounds site, Tennessee,
18, 38; figurines, 19

Brown, James A., 17, 157, 165, 175

Brown, Morgan, 5, 124, 126–127

Burgess Cove, Tennessee statues, 116, 118–
122. *See also* CSS-023

Bush, Sam Stone, 55

Butler, Brian, 40–41

Cahokia style statues, 14–16, 17, 20, 21, 22,
27, 31–32, 34, 158, 160, 161, 164–165,
173, 177; Big Boy statue, 27; Birger
statue, 22, 161; chronology, 15; Kellar
statue, 161

Cardwell Mound site, Tennessee, 122–123,
163; radiocarbon dates, 201. *See also*
CSS-065; CSS-066

Castalian Springs site, Tennessee, 69, 71–76,
162, 163. *See also* CSS-007; CSS-008;
CSS-009

Catoosa County, Georgia statue. *See*
 CSS-088
Catoosa Springs site, Georgia, 108–109.
 See also CSS-088
Chambers, Moreau, 154
Cheatham County, Tennessee statues. *See*
 CSS-032
Cherry Creek Mound, Tennessee, 116, 118.
 See also CSS-022
Chicora, Francisco de, 166–167
Chiefly succession, 176
Christian County, Kentucky statue. *See*
 CSS-035
Citico site, Tennessee, 136. *See also* CSS-079;
 CSS-080; CSS-081; CSS-082
Claassen, Cheryl, 26
Clark, Daniel, Jr., 127
Clark, William M., 33, 85, 204–209
Clay County, Tennessee statues. *See* CSS-
 062; CSS-077
Clifford, John, 4
Cox, Parmenio E., 42, 91
Cradleboard, 25
Cranial modification, 25–26
Crittenden County, Kentucky statue. *See*
 CSS-051
CSS (Cumberland Statuary Survey), 20
CSS-001, 21, 41–42, 44–45, 50, 57, 127, 182,
 190
CSS-002, 28, 31, 32, 42, 43, 45–50, 74, 182,
 190
CSS-003, 22, 25, 27, 28, 31, 32, 39, 43, 45–
 50, 74, 80, 145, 150, 182, 190
CSS-004, 28, 33, 43, 50–51, 99, 182, 190
CSS-005, 52, 182, 190
CSS-006, 53, 54, 182, 190
CSS-007, 73, 75–78, 182, 190
CSS-008, 31, 33, 63, 73–74, 182, 190
CSS-009, 26, 33, 73–75, 190, 192
CSS-010, 32, 56, 57–58, 182, 191
CSS-011, 32, 56, 57, 59, 183, 191
CSS-012, 56, 57, 60, 183, 191
CSS-013, 26, 29, 33, 56, 57, 60, 183, 191
CSS-014, 29, 56, 57, 60, 61, 183, 191
CSS-015, 21, 26, 29, 32, 61–63, 64, 183, 191
CSS-016, 22, 32, 61–63, 65, 104, 183, 191
CSS-017, 61–64, 66, 74, 183, 191
CSS-018, 31, 32, 67–69, 160, 183, 191

CSS-019, 31, 32, 67–68, 70–71, 160, 183, 191
CSS-020, 33, 114–116, 162, 183, 191
CSS-021, 116, 117, 120, 183, 191
CSS-022, 121, 183, 192
CSS-023, 33, 118, 120–121, 183, 192
CSS-024, 33, 184, 192, 210, 211
CSS-025, 33, 184, 192, 209, 210
CSS-026, 33, 184, 192, 210
CSS-027, 184, 192, 209, 210
CSS-028, 33, 63, 137, 138, 184, 192
CSS-029, 82, 184, 192
CSS-030, 25, 26, 29, 30, 32, 77–79, 80–81,
 160–161, 184, 192, 203
CSS-031, 29, 30, 32, 77–79, 80–81, 160–161,
 184, 193, 203
CSS-032, 124, 125, 184, 193
CSS-033, 124, 126–127, 184, 193
CSS-034, 124, 126–127, 184, 193
CSS-035, 127–130, 185, 193
CSS-036, 32, 87–89, 136, 150, 151, 161, 185,
 193
CSS-037, 32, 87–89, 136, 161, 185, 193
CSS-038, 140–141, 143, 185, 193
CSS-039, 25, 26, 33, 90–92, 143, 185, 193
CSS-040, 89–90, 185, 194
CSS-041, 145–146, 148, 152, 185, 194
CSS-042, 138–139, 185, 194
CSS-043, 29, 133, 134–136, 186, 194
CSS-044, 131–133, 186, 194
CSS-045, 26, 33, 143, 186, 194, 203–204
CSS-046, 33, 186, 194, 204–205, 206
CSS-047, 33, 186, 195, 204, 205, 207
CSS-048, 29, 33, 186, 195, 204, 205–206,
 208–209
CSS-049, 2–3, 34, 130, 131, 186, 195
CSS-050, 130–131, 186, 195
CSS-051, 26, 29, 146–147, 186, 195
CSS-052, 27, 145, 148–150, 152, 186, 195
CSS-053, 150–151, 186, 195
CSS-054, 25, 27, 29, 146, 148, 151–152, 153,
 159, 187, 195
CSS-055, 93–94, 187, 195
CSS-056, 22, 77, 94–96, 104, 187, 195
CSS-057, 32, 97–99, 104, 158–159, 187,
 196
CSS-058, 32, 97–99, 158–159, 187, 196
CSS-059, 22, 27, 28, 32, 63, 99–105, 108,
 158–159, 187, 196

CSS-060, 22, 25, 27, 28, 32, 63, 99–105, 108, 158–159, 187, 196

CSS-061, 27, 108, 187, 196

CSS-062, 29, 112–114, 187, 196

CSS-063, 4, 32, 153, 154, 155, 187, 196

CSS-064, 142, 143, 187, 197

CSS-065, 122–123, 187, 197

CSS-066, 122–123, 187, 197

CSS-067, 187, 197, 213

CSS-068, 187, 197, 213

CSS-069, 76–77, 188, 197

CSS-070, 152–153, 188, 197

CSS-071, 188, 197, 210

CSS-072, 121–122, 188, 197

CSS-073, 121–122, 188, 197

CSS-074, 32, 105–108, 188, 197

CSS-075, 32, 105–108, 188, 197

CSS-076, 109–111, 188, 197

CSS-077, 113, 188, 197

CSS-078, 33, 153, 154–155, 188, 198

CSS-079, 136, 188, 198

CSS-080, 136, 188, 198

CSS-081, 136, 188, 198

CSS-082, 136, 189, 198

CSS-083, 189, 198

CSS-084, 189, 198

CSS-085, 189, 198

CSS-086, 189, 198

CSS-087, 96–97, 189, 198

CSS-088, 108–109, 189, 198

Cult institutions, Mississippian, 157–158

Cumberland Mountain cache, Tennessee, 209–210. See also CSS-024; CSS-025; CSS-026; CSS-027

Curtiss, Edwin, 85

Daniel Mound site, Tennessee, 138–139. See also CSS-042

DeJarnette, David, 5, 13–14, 20, 139–141

DeKalb County, Tennessee statue. See CSS-021

Diaz-Granados, Carol, 21, 34, 174

Dixon Springs site, Tennessee. See Beasley Mounds site

Dodson Farm Tennessee statue. See CSS-006

Doran, Edwina, 118, 120

Dover sword, form, 162–163, 178

Dowd regional period, 38

Duck River Tennessee statues, 82–92. See also CSS-036; CSS-037; CSS-039; CSS-040

Duncan, James, 21, 34, 174

Eagle Warrior stone, 73

Earl, Ralph E. W., 71

Earth Mother. See Old Woman

Earthworks near Lebanon. See Sellars site

Eason, Joseph, 56

Elk River Tennessee statue, 138–139. See also CSS-042

Emerson, Thomas, 7, 15, 30

Engle, Nancy Lou, 14, 37

Etowah site, Georgia, 9, 13–14, 18, 20, 22, 25, 27, 28, 29, 32, 45, 63, 77, 93–108, 109, 136, 156, 158–159, 160, 162–163, 175, 176; radiocarbon dates, 200–201

Etowah site, Georgia statues. See CSS-055; CSS-056; CSS-057; CSS-058; CSS-059; CSS-060; CSS-074; CSS-075; CSS-087

Eve statue. See CSS-037; Link Farm site

Fakes, 5–6, 8, 77–78, 210–214

Falling Water, Tennessee statue. See CSS-021

Fatherland site, Mississippi, 154, 156. See also CSS-063; CSS-078

Featherstonhaugh, George William, 119–120

Fewkes, Jesse Walter, 12, 42, 79

Fewkes site, Tennessee, 38, 79–80

Figurines: contrast with statues, 164–165; definition, 17; distribution, 17–18

Fiske, Moses, 5

Fluorspar statues, 144

Ford, James A., 154–155

Forelock, beaded, 146

Forgeries. See Fakes

Fortress at the Narrows of Piney site, Tennessee. See Narrows of Piney site

Frost, Dr., 78

Funkhouser, W. D., 147–148

Garcilaso de la Vega, 167–168

Garland, Elizabeth Baldwin, 145, 163

Gender, 25; ambiguity, 29–31; hairstyle/ headgear, 22–24; and seating position, 27–28; versus sex, 26

Georgia statues. *See* CSS-055; CSS-056; CSS-057; CSS-058; CSS-059; CSS-060; CSS-061; CSS-074; CSS-075; CSS-076; CSS-087; CSS-088
Gilliam, Hugh W., 53
Gilliam statue, Tennessee. *See* CSS-005
Gorgets, marine shell, 27, 34, 72, 114–115, 162–163
Grandmother. *See* Old Woman
Grave Creek Flats, West Virginia. *See* CSS-071
Greene County, Arkansas statue. *See* CSS-070
Greenwood site, Tennessee. *See* Sellars site

Hally, David J., 37, 176
Hamilton County, Tennessee statues. *See* CSS-079; CSS-080; CSS-081; CSS-082
Haralson County, Georgia, 109–111. *See also* CSS-076
Hardin County, Tennessee statues. *See* CSS-038; CSS-064
Hariot, Thomas, 168–169
Harpeth River, Tennessee statues, 77–82. *See also* CSS-029; CSS-030; CSS-031
Hartsfield, Solomon, 145
Haywood, John, 3–4, 52, 55, 71, 73, 75–76, 82, 118–121
Henry, Ernest, 67
Henry County, Tennessee statue. *See* CSS-041
Hickman County, Tennessee statue. *See* CSS-040
Hilgeman, Sherri L., 151–152, 159, 163
Hinsdale, W. G., 105, 108
Holder, Preston, 13
Hollywood site, Georgia, 162
Hudson, Charles M., 25, 27, 166
Humphreys County, Tennessee statues. *See* CSS-036; CSS-037

Illinois statues. *See* CSS-052; CSS-053
Indiana statues. *See* CSS-054
Innes, Harry, 2, 34, 130

Jarman, W. H., 77–78
Jefferson, Thomas, statues, 2, 5, 124, 126–127, 130
Johnson, H. L., 129

Johnson, Willard, 146
Jones, Charles Colcock, Jr., 11–12, 93–95
Jones, Joseph, 11–12, 79, 120, 127, 203–204

Kelly, Arthur R., 105, 108
Kentucky statues. *See* CSS-035; CSS-049; CSS-051
King, Adam, 99, 108, 136, 159, 176
King Crowley, 6–7
Knight, Vernon James, Jr., 10, 157–158
Knox County, Tennessee statue. *See* CSS-044

Lankford, George E., 34–35
Larson, Lewis H., Jr., 99, 105, 108, 178
Le Petit, Father, 171
Lewis, Thomas M. N., 42, 43, 86, 89, 91
Lincoln County, Tennessee statue. *See* CSS-042
Link Farm site, Tennessee, 83–90, 163. *See also* CSS-036; CSS-037
Long Island of the Holston site, Tennessee, 133–136. *See also* CSS-043
Louisville Polytechnic Society, 62–63
Loy site, Tennessee, 132

Marshall County, West Virginia statue. *See* CSS-071
Martin Farm (Riddleton), Tennessee site, 67–68, 176. *See also* CSS-018; CSS-019
Maury County, Tennessee statue. *See* CSS-039
Mayfield Station, Tennessee statue. *See* CSS-029
McKelvey Mound site, Tennessee, 139–141, 159. *See also* CSS-038
Middle Cumberland culture/region, 37–39
Miller, James V., xv–xvi
Milner, George R., 148
Mississippi statues. *See* CSS-063; CSS-078
Montgomery County, Tennessee statues. *See* CSS-033; CSS-034
Moorehead, Warren K., 32, 97–98, 150, 159, 162, 209
Muller, Jon, 14, 166
Murphy Farm site, Georgia, 109, 111
Murphy Farm site, Tennessee, 124, 126–127, 129. *See also* CSS-033; CSS-034
Myer, William Edward, 12–13, 55, 56, 67,

71–72, 79–80, 114–115, 118, 136, 211, 214

Narrows of Piney site, Tennessee, 89–90. *See also* CSS-040
Natchez statues, 153–156, 171
Nutt, Rush, 82

Obion site, Tennessee, 144–146, 163; radiocarbon dates, 201. *See also* CSS-041
Old Woman, 33–36, 174. *See also* CSS-004; CSS-013; CSS-020; CSS-023; CSS-024; CSS-025; CSS-028; CSS-039; CSS-045; CSS-046; CSS-047; CSS-048; CSS-049

Pairs, Statuary. *See* Statuary pairs
Payne, Edward, 86
Perrine, Thomas M., 148
Perry County, Tennessee statue. *See* CSS-048
Perryman, Margaret, 105, 108, 109
Phillips, Philip, 14, 37, 72, 162–163
Pipers Ford, Tennessee statue. *See* CSS-020
Prentice, Guy, 34, 105
Putnam, Frederic Ward, 39–41, 78–79, 85–86, 162
Pygmies, 4, 112, 118–120

Raccoon Creek site, Georgia, 108. *See also* CSS-061
Radiocarbon dates, 199–201
Red Horn, 27
Reilly, F. Kent, III, 15
Roane County, Tennessee statue. *See* CSS-043
Rockefeller, Nelson, 86, 129
Rogan, J. P., 96–97, 105, 159
Rogers, Jeff, 42–43
Rogo the Chief. *See* CSS-003
Rowland, Dentler, 6
Running Lake Mounds site, Illinois, 148, 150. *See also* CSS-052

Sandy. *See* CSS-003
Sargent, Winthrop, 3
Schoolcraft, Henry R., 210
Schugtown Mounds site, Arkansas, 152–153. *See also* CSS-070
Seals, Monroe, 116, 118

Seever, William J., 83–84, 136
Sellars family, 41–43
Sellars site, Tennessee, 39–51, 162; radiocarbon dates, 199. *See also* CSS-001; CSS-002; CSS-003; CSS-004
Sequatchie Valley, Tennessee statue, 138. *See also* CSS-028
Shamanism, 30–31
Shannon, Larry, 143
Shrines. *See* Ancestor Shrine Complex
Shrine sacra, 157–158, 175–176. *See also* Ancestor Shrine Complex
Smith County, Tennessee statues. *See* CSS-010; CSS-011; CSS-012; CSS-013; CSS-014; CSS-015; CSS-016; CSS-017; CSS-018; CSS-019; CSS-020
Spiro Mounds site, Oklahoma, 18
Sponemann site, Illinois, 15
St. Cosme, 171, 174
Stack, Guy, 42, 44
Statuary: anecdotal information, 160–161; archaeological evidence, 158–160; chronology, 162–163, 177–178; curation location, 190–198; definition, 17; entering the archaeological record, 174–177; ethnographic/historic observations, 165–173; general observations, 164; significant studies, 11–16; summary of key features, 182–189; summary of provenance, 190–198; wooden, 18–19. *See also individual statue descriptions;* Statuary features; Statuary pairs
Statuary features: abdomen, 29, 33, 63, 80, 132, 134, 147; appendages, 28–29; arms, 28–29; breasts and nipples, 26–27, 29, 31; clothing, 21, 26, 29, 50, 167; collarbone, 29, 31, 63, 74, 96, 98, 138, 205, 208; cranial modification, 25–26, 57, 63, 67, 87, 138, 146, 148, 204; dimensions, 182–189; ears, 22; eyes, 21; face and head, 21–25; facial inclination, 21; feet, 28; genitals, 26, 29, 30, 33–34, 57, 63, 75, 80, 91, 138, 143, 147, 154, 204, 209; hairstyle/headgear, 22–25; hands, 28; mouth, 21, 22; nose, 21–22; pigments/paint, 18, 21, 22, 26, 29, 44, 50, 51, 95, 105, 108, 109, 169, 204; seating position, 27–28; shoulders, 29; torso and body, 26–29; vertebra, 29, 57, 139, 152, 208; wrinkles, 22, 31, 50, 127,

129. *See also individual statue descriptions;* Statuary; Statuary pairs

Statuary pairs, 14, 21, 27, 31–33, 156, 158–160, 162, 163, 164, 167, 173, 174, 176–177; chronology, 178–179; CSS-002/CSS-003, 45–50; CSS-010/CSS-011, 57; CSS-015/CSS-016, 63; CSS-018/CSS-019, 67–68; CSS-030/CSS-031, 80–81; CSS-033/CSS-034, 127; CSS-036/CSS-037, 87–89; CSS-057/CSS-058, 97–99; CSS-059/CSS-060, 99–105; CSS-074/CSS-075, 105–108

Stilesboro site, Georgia, 108. *See also* CSS-061

Strachey, William, 169–170

Strawberry Plains, Tennessee statue. *See* CSS-044

Sumner County, Tennessee statues. *See* CSS-007; CSS-008; CSS-009

Swanton, John R., 12, 115, 171

Sycamore Creek, Tennessee statue. *See* CSS-032

Taylor, Rufus, 56

Temples. *See* Ancestor Shrine Complex

Temple statuary. *See* Shrine sacra

Tennessee-Cumberland Style, 17, 20–36, 31–32, 182–189. *See also* Statuary; Statuary features; Statuary pairs

Tennessee Historical Society, 62, 76–77, 78, 96, 211, 214

Tennessee Man. *See* CSS-036; Link Farm site

Tennessee River Valley statues, 131–143

Terry Statue. *See* CSS-023

Thomas, Cyrus, 133–135

Thruston, Gates P., 12, 62, 73, 76, 78, 115, 127, 129

Thruston regional period, 38

Thruston tablet, 34, 36

Tolu site, Kentucky, 146–148. *See also* CSS-051

Tonti, Henri de, 170–171

Trigg County, Kentucky statue, 130–131. *See also* CSS-050

Troost, Gerard, 26, 32, 62–63, 138

Trousdale County, Tennessee statue. *See* CSS-069

Union County, Illinois statue. *See* CSS-052

Vanderburgh County, Indiana statue. *See* CSS-054

Vulvar motif, 33–34

Walker, Hugh, 43

Wallace Farm site, Tennessee, 127–130. *See also* CSS-035

Ware site, Illinois, 148, 150. *See also* CSS-052

Waring, Antonio J., 13–14

Warren County, Tennessee statues. *See* CSS-024; CSS-025; CSS-026; CSS-027; CSS-065; CSS-066

Webb, William S., 13, 139–141, 147–148

Webster, Hugh Lee, 90, 91

West Virginia statue, 210. *See also* CSS-071

White County, Tennessee statues. *See* CSS-023; CSS-072; CSS-073

Wilke, Ulfert, 86

Williams, Stephen, 129

Williamson County, Tennessee statues. *See* CSS-029; CSS-031; CSS-046; CSS-047

Willoughby, Charles C., 13, 93, 96, 108

Wilson, Thomas, 61, 62, 96, 108, 132, 205

Wilson County, Tennessee statues. *See* CSS-001; CSS-002; CSS-003; CSS-004; CSS-005; CSS-006

Womack, Walter, 122

Wynne, George W., 73

Yeaman, Lillard, 42

Young, Bennett H., 18, 61–62, 80, 130–131

Younglove, John E., 73